Art

A Beginner's Guide

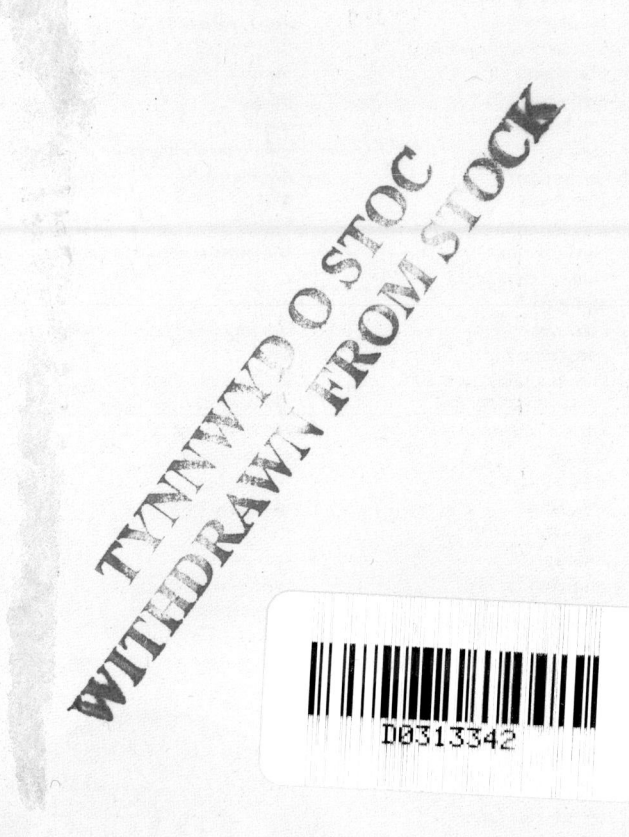

ONEWORLD BEGINNER'S GUIDES combine an original, inventive, and engaging approach with expert analysis on subjects ranging from art and history to religion and politics, and everything in between. Innovative and affordable, books in the series are perfect for anyone curious about the way the world works and the big ideas of our time.

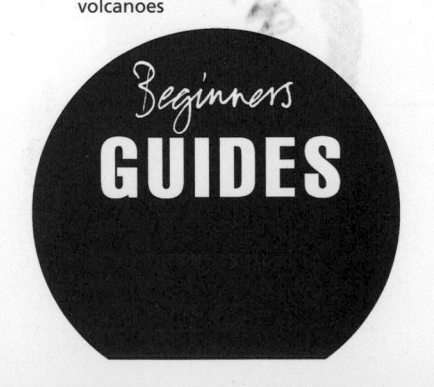

Beginners
GUIDES

Art
A Beginner's Guide

Laurie Schneider Adams

ONEWORLD

A Oneworld Paperback Original

Published by Oneworld Publications 2012

Copyright © Laurie Schneider Adams 2011

The moral right of Laurie Schneider Adams to be identified as the Author
of this work has been asserted by her in accordance with
the Copyright, Designs and Patents Act 1988

ISBN 978-1-85168-853-1

Typeset by Glyph International Ltd., Bangalore, India
Cover design by vaguelymemorable.com
Printed and bound in Denmark by Nørhaven, Viborg

Oneworld Publications
185 Banbury Road
Oxford OX2 7AR
England

Learn more about Oneworld. Join our mailing list to
find out about our latest titles and special offers at:
www.oneworld-publications.com

Contents

Acknowledgements

At Oneworld Publications, I would like to thank Mike Harpley for proposing that I write a beginner's guide to art, Paul Boone for his skill in obtaining the illustrations, Rachel Beaumont for her careful editing and helpful suggestions, Kirsten Summers, and Kathleen McCully. Prof. Mary Bittner Wiseman has been particularly helpful in matters of philosophy and Prof. Larissa Bonfante came up with a few excellent ideas and was always available to answer questions on antiquity. I am grateful to John Adams and Caroline Adams for reading the entire manuscript and providing many useful editorial comments.

List of illustrations

Plates

Figures

Introduction

Art is one of the most important and useful expressions of human civilization. Works of art reflect the creativity, skill, and talent of individuals and of entire cultures; art provides sources of beauty, of intellectual challenge, of change and development, and of formal, analytic perception. Like the ability to read and write, the arts distinguish the human race from the other species that populate the earth, and the categories of art, as well as the ideas that inspire them, are numerous. This book deals with the major visual arts – pictures, sculptures, and buildings – and more recent art forms such as installation and video. It also incorporates the ideas of artists, occasionally reinforcing them with direct quotations from artists themselves. Artistic themes, some that are universal and found throughout the world, and others that may be specific to a particular culture or to a particular time in history, are threaded throughout the text.

Works of art are reflections of the artists who produce works and thus can provide a window onto the character of an individual artist as well as onto the creative process. As a lens through which to view a culture, works of art are invaluable. What, for example, do the cave paintings tell us about prehistoric people? What does a colossal pyramid tell us about ancient Egypt? What do the human scale and idealized forms of most Classical Greek sculptures tell us about fifth-century BC Greece? How did Classical Greece become a foundation of Western civilization?

Why does the Classical tradition persist to the present day? Why do some cultures produce portraits, landscapes, and still lifes, whereas others do not? How do works of art reinforce the power of rulers? What do they tell us about the religious beliefs and practices of certain cultures? These and other questions can be raised and often answered by studying art and its history.

In a beginner's guide, it is possible to cover only a few of the ways in which viewers can approach the vast subject of art, and what they can teach us about ourselves, our history, and our culture. The creation of art, like new scientific inventions, requires analytic independent thinking and foresight, and so it is often the case that artists sense certain truths before they become clear to most people. For example, the imagery of many German artists working between 1900 and 1939 indicates that they understood the inevitability of World War I and World War II before the general public realized what would happen.

Since the greatest works of art often reflect the fact that an artist may be more attuned to his or her cultural ambience (the *zeitgeist*) than the viewing public, they have frequently aroused controversy. In so doing, reactions to works of art are sometimes heated, ranging from perplexity and outright rage to acts of vandalism. The proverbial 'my six-year-old could paint that' reflects a misunderstanding of what is new and unfamiliar, especially as regards abstraction; but objections to imagery can also be aroused for political, religious, and even delusional reasons. Since imagery can exert a powerful force on viewers, whether it evokes appreciation, misunderstanding, or rage, it is important to know how to read an image as well as how to evaluate one's response to it.

The visual arts constitute a kind of language, a means of communicating within generations as well as between the past and the present. Understanding that language requires several levels of approach to a work of art. One can approach an image,

a building, or an installation formally – that is, in terms of its formal elements: line, shape, space, color, light, and dark – and consider its aesthetic impact on the viewer. Formal elements constitute style, which consists of similarities that make up a distinct group of works. The narrative meaning contained in a work can be discerned from its context and history, as well as by grasping the message contained within it. Being able to 'read' and interpret the imagery of a work can reveal its meaning on more than one level; it can provide us with the underlying symbolic message that the artist is trying to convey. Reinforcing the various levels of meaning in a work is the process by which a work is made and what it is made of; sometimes the very material of a work contributes to its meaning. For example, in the ancient world stone denoted power and stability because it was likely to last longer than lighter-weight materials, and as a result, stone was often the preferred material for representing royal figures and gods. But in the case of the twentieth- and twenty-first-century temporary environmental installations of Christo and Jeanne-Claude, the materials are recyclable and the sites are always returned to their original condition.

All major civilizations have produced a history of art, in which form and content evolve over time. This book will focus on only one art-historical narrative, that of Western art – though by no means is it the only narrative. At some points in Western history art has been influenced by the art of other cultures, especially as the result of travel, trade, and diplomatic contact between nations. When these cross-cultural influences can be demonstrated, they are briefly described to remind readers that other art-historical narratives do exist.

Philosophers, critics, artists, poets, historians, and others have tried over the centuries to define art. But despite the crucial importance of works of art in the history of human civilization, it has proved difficult to produce a consensus on just what art is. Attempts to define art, from Plato to the present, are influenced

by the personal bias, aesthetic preference, and cultural context of the viewer. Perhaps all would agree, however, that works of art are created to express something, whether one likes it or not, and that such expression contributes to our understanding of ourselves and our history.

1

What is art?

The answer to the question 'What is art?' is both simple and complex. As we will see, attempts to define traditional art have been difficult enough, but today's discussions also have to deal with the enormous variety of new art categories. Traditional categories include *pictures* (two-dimensional images), *sculptures* (three-dimensional images), and *architecture* (the art and science of building for human use). More recent categories, beginning in the twentieth century, include 'found objects', performance art, environmental art, earth art, body art, video and digital art, and in our rapidly changing world newer categories are continually being developed. There are also many subcategories of art – children's art, outsider art, graffiti art, folk art, naïve and self-taught art, good art and bad art, offensive art, beautiful art, challenging art, frightening art, religious art, political art. When someone asks 'But is it art?' he or she usually means 'Is it *good* art?' or 'Is it *great* art?' Such questions raise the issue of *aesthetics*, that is, the quality of beauty conveyed by a work of art.

The nature of art has been a vexing question for centuries, and it has been discussed by artists, poets, philosophers, and others. Their views have given us insight into the creative process, but they have not produced a universally accepted definition of art. In nineteenth-century France, the poet and critic Charles Baudelaire proposed the following definition of artistic genius: 'childhood recovered at will – a childhood now equipped for self-expression, with manhood's capacities and a power of analysis that enables it to order the mass of raw material that it has involuntarily accumulated'.[1] Instead of giving a definition of art

as static, Baudelaire has described a dynamic creative process, which is appropriate in so far as the making of art is, in fact, an ongoing activity.

Baudelaire is not alone in approaching art as a process. In 1936, the German Expressionist painter Oskar Kokoschka posed and replied to the question 'What is Art?' 'It is not', he said, 'an asset in the stock-exchange sense, but a man's timid attempt to repeat the miracle that the simplest peasant girl is capable of at anytime, that of magically producing life out of nothing'.[2] In 1948, the German-born American Abstract Expressionist painter Hans Hofmann defined a work of art as 'a world in itself reflecting senses and emotions of the artist's world'.[3] In the mid-twentieth century, the French artist Henri Matisse asserted that an artist's true function is creation, which begins with vision. The artist, according to Matisse, 'has to look at life as he did when he was a child, and, if he loses that faculty, he cannot express himself in an original, that is, a personal way.'[4] All of these statements describe a process rather than a finished product called 'art', speaking instead to the act of creating works of art.

Some definitions assume that visual images replicate the real world and are recognizable. Others, especially since the early decades of the twentieth century, take into account *non-figurative abstraction*, in which familiar forms are not recognizable. But most definitions assert that a work of art is expressive in some way, whether the image is recognizable or not. That expressiveness communicates to viewers and reflects the artist and culture that produced it.

One could argue that there can be no definition of art, since it is in a continual state of change and development. The subject matter of art, its materials and contexts, and the ideas that inspire it, are infinitely varied and open, adding to the difficulty of pinning down a definition of art. As the twentieth-century American graphic designer Milton Glaser tersely stated in one of his posters, one could simply say: *Art Is*. Slightly less concise, but

no more informative, the Conceptual artist Joseph Kosuth declared in 1966 that 'Art is the definition of art'.[5]

For more help we turn to some philosophers, who have addressed the interpretation and evaluation of art as well as its definition.

Art as imitation

For the ancient Greek philosopher Plato (428–347 BC), in Book 10 of *The Republic*, art is *mimesis* (roughly translated as 'imitation'). But because art (in particular, painting) is a copy and not the real thing, Plato did not consider art useful. You can't smoke the image of a pipe or sleep in the image of a bed. (He did not discuss architecture, which typically *is* useful.) Plato's term *techne* refers to the technique or skill of the person who makes the useful, actual thing – but he distinguished that from art. He believed in the existence of a timeless, unchanging world of ideas, the forms of things that exist in the physical world. The 'real' bed is the form that exists timelessly. The bed you sleep on is a copy or an example of the real bed. A painted bed is even farther from the truth than the real bed – and in Plato's view is dangerous because of that distance.

In 1928, the Belgian artist René Magritte painted his famous *The Betrayal of Images* (**Figure 1**), which seems to speak to Plato's argument. At first glance it is a straightforward, convincing representation of a pipe. Below the image, however, Magritte has written 'This is not a pipe' (*Ceci n'est pas une pipe*), as if to remind viewers that what is painted is not the real thing – that a space separates art and reality. The 'betrayal' of the title is consistent with Plato's notion that such an image can be dangerous. To Plato, essential truth and beauty reside only in the realm of ideas and actual works of art are a danger to society. Since art (along with poetry and music) can incite dangerous passions, Plato banished

Figure 1 René Magritte, *The Betrayal of Images*, 1928, oil on canvas, 23½ x 28½ in. (55 x 72 cm). Los Angeles County Museum of Art, California. (© Christie's Images/Corbis)

artists, poets, and musicians (although he did allow martial music) from the Republic – his ideal state ruled by philosopher kings.

The early twentieth-century Romanian artist Constantin Brancusi believed his sculptures represent the 'essence' of things – an approach that seems to be consistent with Plato's ideal forms, though Brancusi was not necessarily influenced by Plato's philosophy. Brancusi's marble sculpture of 1912 entitled *Mlle. Pogany*, for example, was for him the essence of the Hungarian woman, Margit Pogany, whom he met in Paris and of whom he made portraits in bronze as well as in marble (**Figure 2**). Brancusi detached the hands from the body and showed Mlle. Pogany resting them against her cheek. He emphasized her large eyes, and gave her a slim nose and mouth. To some viewers, Brancusi was an

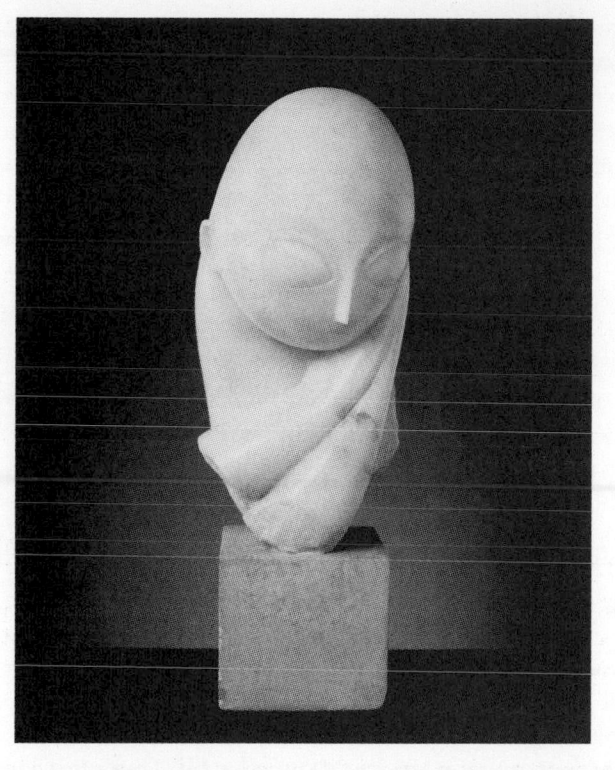

Figure 2 Constantin Brancusi, *Mlle. Pogany Version I*, 1912, white marble; limestone base, 17½ in. (44.8 cm) high. Private collection. © Artists Rights Society (ARS), New York/ADAGP, Paris. (Image: © Institute of Contemporary Art/Corbis)

'abstract' artist, but Brancusi regarded such observers as 'imbeciles' who failed to recognize the essential truth of his images.[6]

Art as form

In the *Poetics*, Plato's student Aristotle (384–322 BC) identified form as the quality to which a viewer responds in a work of

visual art. Form, by his definition, was produced by the artist's control of material and his ability to capture the essence of a thing – much as Brancusi aimed to do. Distinct from Plato, for Aristotle the essence of a thing is immanent in the thing, and can be conveyed by material, by form, and by the physical skill (*techne*) of the artist. Consequently there was no loss inherent in artistic representation, and so none of the danger that Plato saw. For Plato, the essence of a thing exists only in the realm of ideas and is independent of the thing itself. There is, for example, the form Man, the men and women who exist in the physical world and who are copies of the form, and paintings of men and women. The paintings are nothing but copies of copies of the form. They are dangerous because they lead the viewers too far from the ideal form of the painted thing. For each philosopher – Plato an idealist and Aristotle an empiricist – his bias dictates his view of what art is.

The scale of an image, according to Aristotle, should be appropriate, conveying a sense of unity and wholeness, so that viewers respond to the significance of a perfectly understood geometric form. Thus, a figure or object should not be too small to be easily comprehended or so large that it cannot readily be seen as a whole. Aristotle thought that the parts of any figure must be proportional; they must have *summetria*, roughly translated as *symmetry*.

Aristotle believed that a good work of art was capable of imparting knowledge, and expanding our experience and understanding of the natural world. The more such a work provides a convincing imitation of the real world, the more it delights the viewer. An interesting confirmation of this view can be seen in popular reactions to certain works of Photo-Realism and Super-Realism – mid-to-late twentieth-century styles that are particularly true to life (e.g. **Figure 3**). Such works generally *do* delight viewers, especially when they realize that they have been fooled into mistaking a work of art for the real thing.

Figure 3 Duane Hanson, *Policeman*, 1993, autobody filler, fiberglass and paint with accessories. 72 x 17.9 x 15 in. (183 x 45.4 x 38 cm). Estate of Duane Hanson/VAGA, New York. (Image: © Christie's Images/Corbis)

In the *Physics* Aristotle discussed the causes of things, a theory which was to have a major influence on Western aesthetic philosophy. He said that everything has four causes – a material cause, an efficient cause, a formal cause, and a final cause – and that to know a thing completely one must know its four causes. In art, the material cause is the medium, such as the bronze, marble, or paint with which a work is made. The efficient cause is the transformative activity of the artist in giving shape to an unformed material. The formal cause is the form or essence of the work. The final cause is the reason the work is made.

Both Aristotle and Plato were writing about *figurative art* – art that consists of recognizable images rather than abstraction. The viewer's response is thus informed by the appearance of the represented thing in the real world. Citing the example of a *portrait* (a likeness), Aristotle claimed that if viewers take pleasure in looking at the actual person, then they will also take pleasure in looking at the portrait. Like the author of a tragedy, the good painter will represent people as better than they are. Arguing for figurative over non-figurative art, Aristotle asserted that a surface smeared with color will not produce as much pleasure as a form clearly outlined in plain black and white.

Art as object

The eighteenth-century German philosopher Immanuel Kant (1724–1804), in his 1790 *Critique of Judgment*, asserted that to qualify as art an image must be endowed with the imaginative powers of the artist and, at the same time, evoke an imaginative response from the viewer, thus creating a kind of harmonious 'dialogue' between them. Like Plato and Aristotle, Kant assumed art to be figurative and with a recognizable subject matter. But he also considered whether the work was 'beautiful', a quality he believed to be dependent on the genius of the artist. He believed

that art has moral as well as aesthetic levels of meaning, which stimulate the mind, are original and contain the spirit of genius, and are distinct from nature. From this argument Kant distinguished what became known in the eighteenth century as 'fine art' from merely 'pleasing art', which may be entertaining and decorative but which is not endowed with the spirit of genius – and consequently does not contain expressive ideas or moral qualities. A good work of art, according to Kant, produces a harmonious synthesis of form and content.

For Georg Wilhelm Friedrich Hegel (1770–1831) the main purpose of art was to expand self-knowledge and understanding of the world.[7] The value of art for Hegel, as for Aristotle, resides in its ability to convey truth. Like Kant, Hegel asserted that art evokes imagination and comprehension through beautiful form and evocative content.

Art history had come into its own as a separate discipline around 1800, and consequently Hegel's discussions of art began to take account of historical context and the importance of the physical reality of the material of art. In his view, a work of art is not only imbued with aesthetic and spiritual quality, but is also an artifact reflecting a particular period of history and a cultural context. Hegel identified three major historical eras – ancient Egypt, which he called the Symbolic; fourth-century-BC Greece; and the Christian period. Of these three, Hegel believed that the Greeks produced the most spiritually and physically harmonious art – especially sculpture.

Changing approaches to art in the twentieth century

With late nineteenth- and early twentieth-century developments in the approach to a picture's surface, critics and philosophers began to address abstraction, first in Western Europe and then in

the United States. The French Post-Impressionist painter Paul Cézanne was the foremost figure in this new approach to the picture surface. The two contemporary critics most convinced of Cézanne's revolutionary importance were the American Roger Fry (1866–1934), who coined the term 'Post-Impressionist', and Clive Bell (1881–1964), a member of the Bloomsbury Group in England. Both Fry and Bell considered Cézanne to be the most perfect painter, ushering in a new artistic era. Fry was instrumental in promoting Post-Impressionist artists, and having them exhibited and accepted in London; and Bell coined the phrase 'significant form' to express his notion of the quality that defines art. In Bell's view, subject matter takes a back seat to form, and form, if it is significant, is the content of art.

The idea of form as content became a prominent feature of twentieth-century art criticism and philosophy of art, consistent with the trend towards non-figurative abstraction. The American champion of abstraction (especially Abstract Expressionism, which developed in New York from the 1940s on) was the art critic Clement Greenberg (1909–94), who opposed Plato's idea of art as *mimesis*. For Greenberg, modern abstract art had achieved a new purity: it was no longer about creating recognizable images such as Magritte's pipe, but about the actual space of a picture. This included its surface (e.g. canvas, paper, or a wall) and its material (e.g. paint, ink, crayon). Narrative subject matter had given way to the forms and processes of art. The picture surface was no longer conceived of as the fourth wall of a stage or a window through which one views the world, but became the equivalent of a curtain pulled across a stage. In other words, as Greenberg wrote in 1961, 'Pictorial space has lost its "inside" and become all "outside".'[8]

The seminal American-born artist among the Abstract Expressionists was Jackson Pollock, who is best known for his dynamic drip paintings – hence his occasional nickname, 'Jack the Dripper'. Pollock typically placed a canvas on the ground and

dripped housepainter's paint in a circular motion from a stick, thereby creating vivid images of energetic, rhythmic motion (**Plate 1**). Pollock did not use traditional perspective systems to create the illusion of depth; instead he focused the viewer's attention on the activity of the paint on the surface of the painting. The visible paint action in the finished image forces viewers to be aware of the artist's creative process in producing the work of art.

As styles evolved beyond Abstract Expressionism, radical changes emerged with increasing speed. Pop artists challenged Greenberg's views of what art had become; in the late 1950s and early 1960s they resumed depicting recognizable objects and figures, now taking as their subject matter everyday items and the products of mass consumerism. Conceptualists, in turn, reacted to Pop Art by valuing the concept or idea of art over the finished work. According to Conceptualism, notably as expressed in the writing of the American artist Sol LeWitt, the execution of a work could be carried out by anyone following the artist's written instructions. The work could then be made more than once, depending on the wishes of the owner of the instructions. Therefore, LeWitt often (though not always) sold instructions for making a work, rather than the work itself. Minimalists departed from the focus on nature, from the dynamic brushwork of the Abstract Expressionists, and from the Pop Art depiction of everyday objects by creating geometric shapes and by using manufactured materials such as glass and steel instead of traditional art media. Dan Flavin made sculptures of fluorescent light bulbs, and Donald Judd arranged metal boxes on a floor or wall.

Art and theory

These twentieth-century developments opened the way for new definitions of art. In 1964, the American philosopher Arthur C. Danto (b. 1924) looked at the work entitled *Brillo Boxes* by the

American Pop artist Andy Warhol in a New York gallery in 1964 and asked what the difference is to the eye between Warhol's boxes and those on a supermarket shelf (**Plate 2**). What is the difference, that is to say, between a work of art and a mere real thing? According to Danto, it is not something that you can see; the difference lies in there being a background of art theory within which an object is defined as art.[9] Danto believes that a work is not art by virtue of universal qualities such as beauty, significant form, imaginative power, or truthfulness; instead, a work becomes art when it fits a theory of art. He believed Andy Warhol's Pop Art marked the end of the traditional art historical narrative: what was called art could now be almost anything.

If one considers Danto's views of art historically, however, they are more consistent with developments *before* Warhol, when the boundaries of art began to expand in the early twentieth century. Out of the devastation of World War I and the fragmentation of society the Dada movement emerged. Dada coalesced into an international movement at the Cabaret Voltaire in Zurich, and it included art forms such as film, performance, 'found objects', and poetry recitations. Exemplifying Danto's notions of what makes something art is the work of the innovative Dada artist, Marcel Duchamp. He invented the Readymade – a manufactured object which became art by being declared as such by the artist.

Duchamp was born in France in 1887 and emigrated to the United States early in the twentieth century. His first Readymade was created in 1915 when he purchased a shovel in a hardware store and entitled it *In Advance of a Broken Arm*. The shovel became art because the artist said it was art and gave it a title, reflecting Danto's view that it is not the essence of a thing that makes it art, but rather what is added to it. However, a work is not generally considered art, Danto argues, until it has been accorded membership in the institutional art world 'club'. Duchamp's Readymades were not all immediately admitted to the club: his *Fountain (Urinal)*, which was an actual urinal he turned upside down, dated 1917, and signed *R. Mutt*, was rejected when he

submitted it to an exhibition in New York in 1917. As is often the case, it took the art world some time – and the general public even longer – to consider Duchamp's works to be art.

Art as response

In a 1963 symposium on Pop Art, the American critic and art historian Leo Steinberg (1920–2011) addressed the issue of whether Pop Art is art from a different perspective.[10] Steinberg noted that the question 'Is it art?' is 'regularly asked of Pop Art, and that's one of the best things about it, to be provoking this question'. He noted that a decade earlier the same question might have been asked about Abstract Expressionism, which at the time was new and unfamiliar and thus 'provoked serious doubts as to what it was'.

Steinberg asked whether we define art by 'general character-istics' or by our reaction to it. He replied by reference to Victor Hugo's response to Baudelaire's volume of poetry entitled *Les Fleurs du Mal* (*The Flowers of Evil*) – 'You create a new shud-der'. In this response, according to Steinberg, Hugo 'summed up a system of aesthetics'. The artist, Steinberg concluded, does not merely create an object – or a poet a poem – but rather 'a provo-cation, a particular, unique and perhaps novel relation with reader or viewer'.

Art as human activity

More recently, in the twenty-first century, the British philosopher Denis Dutton (1944–2010), like Steinberg, approached the nature of art differently from Danto. For Dutton art is a universal human phenomenon that helps to define what is human. Because humans naturally appreciate beauty, art contributes to the very survival of the human species. Dutton rejected Danto's idea that art is a

social construct. He believed instead in the innately human value of art. In his book *The Art Instinct*,[11] Dutton defined art from an evolutionary point of view as an integral part of being human; and, in fact, there is no record of art being made before the appearance of our own species (*Homo sapiens*), for the early Neanderthals do not seem to have made works of art. 'Human beings', Dutton stated, 'are born image-makers and image-enjoyers'.[12] Instead of producing a single definition of art, Dutton called for a philosophy of art that treats art 'as a field of activities, objects, and experience that appears naturally in human life'.[13] To this end, Dutton identified several 'characteristic features found cross-culturally in the arts'.[14] In every culture and context, Dutton found that art produces pleasure and is an intellectual challenge. Art arouses the imagination, requires the development of technical skill, and develops powers of focus and concentration.

The value of art

Modern definitions of art follow the work of esteemed artists – but some artists are ignored by their contemporaries only to be posthumously honored as geniuses. A famous example can be seen in the changing reputation of the nineteenth-century Dutch Post-Impressionist painter Vincent van Gogh. He sold at most one painting during his lifetime and lived in poverty, dependent on support from his brother, Theo van Gogh, who was an art dealer in Paris.

Although from the point of view of the nineteenth-century art market paintings by van Gogh were worthless, they brought millions of dollars in the later twentieth century. Today they are among the most expensive pictures in the world. The work hasn't changed; only its valuation has. Clearly it would be risky to judge whether or not something is art based on its cost in any given market at any given time.

Changing market values raise another issue – namely, forgery. If a forger creates a convincing forgery of an artist's work, why isn't the forgery as 'good' as the original? One answer to this is that we value original work over copies and consider the original artist to have greater talent that the copyist. Similarly, in science, we esteem the original inventor or discoverer more highly than scientists who copy and repeat experiments that have already been done.

A COPY OF *LA BELLE FERRONIÈRE*

Copies of famous works of art may not always be intended to defraud the public. Leonardo da Vinci's portrait *La Belle Ferronière*, now in the Louvre in Paris (**Figure 4**), became involved in an authenticity trial in 1929. A similar picture of the same subject was offered to the Kansas City Art Institute as the original Leonardo for something over $250,000 (equivalent to a little more than $3,100,000 today). Joseph Duveen, a prominent art dealer, pronounced the picture a fake. The owners sued Duveen for libeling their 'Leonardo', and the case went to court. The members of the jury knew very little about art and had difficulty following the arguments. When they failed to arrive at a verdict, Duveen settled out of court for $60,000, a considerable sum in 1929.

Eighty years later, in 2009, a member of the owner's family brought the picture to the Getty Museum in California for testing. The conservators concluded that it had probably been painted before 1750, and admired the quality of the work. On 29 January 2010, the *New York Times* (Art Section, p. 21) ran the headline 'Mona Lisa She Is Not, But Coveted Nonetheless'. Estimated at $500,000, the painting was auctioned by Sotheby's for $1,500,000.

Even though the picture was not an original Leonardo, indeed was a copy of an original Leonardo, it was highly valued for its own qualities. The original, of course, would have sold for a much higher price.

Figure 4 Leonardo da Vinci, *La Belle Ferronière*, 1490–6, oil on wood, 24 x 17 in. (62 x 44 cm). Musée du Louvre, Paris, France. (Source: The Yorck Project/Wikimedia Commons)

Though we do not know the intentions of the person who painted the copy of *La Belle Ferronière*, most forgers hope to exploit the market value of a particular artist. Such forgers can be very clever: in addition to outright copies, forgers have some-times made original works in the style of a known artist, present-ing their works as 'new discoveries'. A famous example of this

type of fraud took place during and after World War II in Holland, when Han van Meegeren painted a *Christ in the House of Emmaus* and offered it for sale as an early work by the esteemed Dutch seventeenth-century artist Jan Vermeer. Since Vermeer's early style was little known, van Meegeren was not forging his known mature works but rather creating works purporting to have been painted early on in the artist's career.

Van Meegeren was himself a second-rate artist, although he succeeded in fooling a number of experts who authenticated his forgeries. His intention to defraud was clear, for he signed the work with one of Vermeer's signatures. Van Meegeren was aided in successfully perpetrating his fraud by the fact that most Vermeers then in Holland had been placed in hiding to protect them from the Nazis. This meant that they were not available for comparison with the van Meegerens. Certified by one of Holland's leading art experts – although declared a fake by Duveen – and hailed as an example of Vermeer's unknown early style, *Christ in the House of Emmaus* was restored, cleaned, and purchased for a large sum by the Boymans Museum in Rotterdam.

Prior to that sale, van Meegeren had painted another supposed 'early work' by Vermeer, *Christ and the Woman Taken in Adultery* (sometimes called *The Adultress*), and signed it *I. V. Meer*. After the war, a unit of the Allied forces known as the Monuments Men was assigned to recovering stolen works of art. They discovered that none other than Hitler's Reichsmarschall, Hermann Goering, had purchased *The Adultress* in 1942 for the equivalent of several million dollars at today's prices. The Allies investigated and traced the provenance of the picture to van Meegeren, who claimed to have acquired it from an Italian aristocrat in need of funds. He was promptly arrested and jailed for treason – for having sold a Dutch national treasure to Goering. The Allies wanted more information and to obtain it they deprived van Meegeren, who by now was a serious drug addict, of morphine. Finally, to save himself from the charge of treason, which was a

capital offense, van Meegeren shocked his captors and the art world by announcing that he, and not Vermeer, had painted the picture – along with several other purported seventeenth-century works.

At first no one believed van Meegeren's claim, and he countered by offering to paint another 'Vermeer' under supervision in prison. Experts then performed tests on the paintings, searched van Meegeren's studio where they found evidence that he had artificially aged the works, and established that they were, in fact, forgeries. In 1947, van Meegeren was convicted, but he died before going to jail.

Viewing the forgeries today, and being able to compare them with genuine Vermeers, it seems obvious that Vermeer did not paint them. And it is hard to believe that experts at the time would have authenticated them. They were duped by a wish to be convinced, by financial gain, by a certain amount of nationalism, and by the failure to check the provenances and perform tests on the works. One characteristic of forgeries is that even though many no doubt escape detection, they often do not hold up over time. As with van Gogh, what one generation sees and values in a body of work may not be what a later generation sees and values.

'Is it art?' goes to court

The trial of Han van Meegeren was not only about fraud and forgery; it also highlighted the difficulty of determining what art is – or at least what good art is. Two other notorious court cases revolved around other aspects of the question 'What is art?' in the nineteenth century – the libel trial of 1878 between the reigning English art critic John Ruskin and the American Impressionist painter James Abbott McNeill Whistler, who lived in London, and the 1927 trial *Brancusi v. United States*, in New York.

During the course of the nineteenth century in Western Europe, a series of styles developed that challenged accepted views of what art is. The libel trial between Whistler and Ruskin exemplified the struggle for primacy between the English Realist style produced by the Pre-Raphaelite group formed in 1848 and the newer Impressionist style.

As a champion of the Pre-Raphaelites, Ruskin had used his influence as a critic and helped to establish an appreciation of their work. When in 1877 he first saw Whistler's painting of fireworks on the Thames, *Nocturne in Black and Gold: The Falling Rocket* (**Plate 3**) in a London art gallery, Ruskin was outraged. The dealer, he said, should not exhibit such works 'in which the ill-educated conceit of the artist so nearly approached the aspect of wilful [sic] imposture. I have seen, and heard', he declared, 'much of Cockney impudence before now; but never expected to hear a coxcomb ask two hundred guineas for flinging a pot of paint in the public's face'. (At today's values, two hundred guineas is the equivalent of about $13,500.) By publishing these remarks, Ruskin opened himself up to a charge of libel, which Whistler soon filed. Leaving aside the personal antagonism between the critic and painter, as well as their psychological issues, the trial exemplified the larger conflict over whether Impressionism could seriously be considered art.

Accustomed to the clear edges and recognizable forms of Realist painters, the public had trouble understanding the newer style. Whistler's *Nocturne* irritated Ruskin on the grounds that its forms were unclear, its subject matter difficult to discern, and its musical title misleading and provocative. Whistler responded that his work was an 'arrangement of line, form, and color first' and that he had painted his impressions. Witnesses for Whistler testified that his pictures were original rather than 'eccentric' as Ruskin's attorney claimed, and that Whistler's poetic observation of nature and sense of color were conveyed in his art. Witnesses testifying for Ruskin asserted that Whistler's paintings suffered

from a 'lack of finish', were 'bewildering in form', and were not much better than 'tinted wall paper'. At two hundred guineas, the *Nocturne*, they agreed, was overpriced. In addition, one witness testified that the proliferation of such work would lead to the general degradation of art in England. The jury found in favor of Whistler, but awarded him only a farthing (a quarter of a penny) in damages.

In 1947 the *Nocturne* was sold to the Detroit Institute of Arts, where it remains today. The museum reportedly paid about $12,000 for the painting – roughly equivalent to $115,000 at today's prices. However, if sold now, the painting would almost certainly bring a multiple of that figure.

By the 1870s, Realism and the Pre-Raphaelite style had been officially accepted as art, whereas Impressionism was still rejected by the majority of viewers. So when does something become art? By Danto's reasoning, Impressionism would have become art when accepted by the art establishment. Others, notably the aestheticians, would say that if Impressionism was *ever* art, it was *always* art, and that art has intrinsic value which does not change with the vagaries of taste and theory.

Another heated conflict over taste and the question 'What is art?' occurred in the early decades of the twentieth century between modernism – the *avant-garde* – and more traditional figurative art. In this case, the plaintiff, the American photographer Edward Steichen, had to prove that Brancusi's highly polished bronze sculpture entitled *Bird in Space* (**Figure 5**) was art in order to avoid paying customs duty when he brought it to the United States in 1926. In American law, there is no customs duty payable on original works of art as long as their value is declared on entering the country. Steichen had purchased the work from Brancusi's Paris studio for $1400 and declared it at customs; but he was charged $600 in tax on the grounds that the work was not art. The *Bird* was admitted to the United States under the category of Kitchen Utensils and Hospital Supplies.

Figure 5 Constantin Brancusi, *Bird in Space*, 1924, polished bronze; marble base. 50 5/16 in. (127.8 cm) high. Base 6 5/16 in. (16 cm). © Artists Rights Society (ARS), New York/ADAGP. (Image: © Institute of Contemporary Art/Corbis)

The following year Steichen went to court to prove that Brancusi's sculpture was a work of art. He had to establish that it had been made by a recognized artist, that its title, *Oiseau*, was French for 'bird', that it was original, and that it had aesthetic value. Witnesses for Brancusi confirmed the artist's reputation in the art world. Witnesses for the United States claimed that the *Bird* was not art because it did not resemble the appearance of a

bird in nature – that is, it lacked wings, feet, and tail feathers and therefore an ornithologist would not recognize it as a bird. It was a misuse of sculpture, another said, because it was too abstract.

Essentially, as with the trial between Whistler and Ruskin, the Brancusi trial reflected the conflict between traditional and modern views of art – in this case, between naturalism and avant-garde abstraction. Steichen testified that the *Bird* suggested flight and appealed to the imagination. He said that it had form and balance, as well as harmonious proportions, all of which made it a work of art. He pointed out that the difference between a mechanic and an artist lay in the concept; a mechanic could not conceive the work as an artist would. An opposing witness, although admitting that Brancusi was a wonderful polisher of bronze, testified that that did not make him an artist or his work art. When asked to define art, another witness declared that it would be a man-made product arousing an emotional reaction inspired by aesthetics and a sense of beauty. But, he added, the *Bird* did not meet those criteria.

The judge ruled in favor of Steichen, declaring that Brancusi's sculpture was indeed beautiful, even though it did not resemble a bird in nature. He concluded that one had to take into account new trends in art, and that *Bird in Space* was an original work by a professional sculptor. Steichen won his case, and he was refunded the customs duty. The *Bird* was now legally a work of art.

This trial was not the first time that a work by Brancusi had been misunderstood in the United States. In 1913, an exhibition of over a thousand avant-garde works of art was held in the Sixty-ninth Regiment Armory in New York. Opponents of the Armory Show feared that the moral as well as the artistic fabric of America was in jeopardy from what they saw as a dangerous decline in standards. One critic called the version of *Mlle. Pogany* in the show 'a hardboiled egg balanced on a cube of sugar'

and the *Evening Sun* published a satirical poem that concluded as follows:

> Ladies builded like a bottle,
> Carrot, beet or sweet potato –
> Quaint designs that Aristotle
> Idly drew to tickle Plato –
> Ladies sculptured thus, I beg
> You will save your tense emotion;
> I am constant in devotion,
> O my egg![15]

In 1974, before the art market boom of the 1980s, a sculpture by Brancusi entitled *Blonde Negress II* was sold in New York for $750,000 (comparable to a little over $3,250,000 today), at the time a world record auction price for a sculpture.

Art, subject matter, craft, and new media

When is a craft considered art? People who made what we consider art today were sometimes accorded the status of craftsmen in certain periods of history. During the Middle Ages people who carved sculptures and created stained glass windows for cathedrals were viewed as craftsmen and artisans rather than artists. Nor do we know the names of the medieval manuscript illuminators or tapestry makers; since few painters or sculptors signed their work in the Middle Ages, most of it is anonymous. In Classical Greece, by comparison, artists signed their works and were discussed by historians as individuals, reflecting their status as artists. The same became true during the Renaissance, from which time artists' biographies have become better known. But in the Middle Ages, the notion of art as distinct from craft was

not current. Does that mean we should not consider the great cathedrals of Europe as art?

It was not until around 1300, at the dawn of the Italian Renaissance, that an artist became distinct from a craftsman in the cultural imagination. As the period developed through the sixteenth century, the notion of artistic genius became current and the intellectual status of the artist, especially if educated as a gentleman, was elevated. Reflecting their status as 'artists', Renaissance painters, sculptors, and architects – like those of ancient Greece – signed their works.

THE FRENCH ACADEMY OF PAINTING AND SCULPTURE

Categories of subject matter in art have also been valued in different ways at different times. In seventeenth-century France under Louis XIV, for example, the French Academy of Painting and Sculpture was founded to regulate the arts. Among its rules was a hierarchy of subject matter; the most important was the Christian Sacraments. Then, in descending order of importance, came history painting, *genre* (everyday activities), landscape, and still life. What, one wonders, would Louis XIV and his court have thought of Duchamp's urinal, shovel, and hat racks, or of Warhol's *Brillo Boxes*?

In nineteenth-century England, with the rise of the Arts and Crafts Movement, the issue of crafts versus art re-emerged. For William Morris (1834–96), leader of the movement, a craft (that is, the skilled production of an object of ceramic, glass, or metal ware, a tapestry or woven cloth) could be a beautiful product with aesthetic qualities – hence, according to some philosophers, a work of art. Morris further defined crafts as useful and cited wallpaper as an example. He believed that crafts should be both useful *and* beautiful, which would open the way for wallpaper

and other aesthetic household decorations to be considered artistic products. From a slightly different angle, a corresponding comment is made by the hero of Saint-Exupéry's *Little Prince*: 'It is truly useful since it's pretty' (*C'est veritablement utile puisque c'est jolie*).

Photography (literally 'drawing with light') was another nineteenth-century development that both influenced the visual arts, especially painting, and had to struggle for admission to the status of art. As soon as the technology for fixing images permanently had been developed, photographs, which were based on the medium of film, were used for portraiture, fashion, science and industry, documentation and journalism, anthropology, and so forth. But in 1839, an article appeared in the *New Yorker* in 1839 asserting that 'photography would stifle art',[16] and beginning around 1850 the specific question 'Is photography art?' was raised.

Photographs were not directly made by the hand of an artist, and so, it was argued, they were mechanical products rather than artistic ones. In the early decades of the twentieth century, the American Surrealist photographer Man Ray defended photography, noting that it was a new medium that expanded the artist's vocabulary. But being a Dadaist punster, Man Ray also made fun of the question; he wrote the essay 'Photography can be art' and two books – one entitled *Photography Is Not Art*, and the other *Art Is Not Photography*.

Today photography is a well-established art form. It is not only considered an art form in its own right, but as technology has evolved it is now also the basis of video and digital imagery. Visual artists are constantly expanding their subject matter, their media, and their techniques. The example of photography illustrates the fact that it is not only styles and tastes that change; it is also technology, and this impacts the media, the imagery, and the approach to works of art.

2

A brief history of Western art: ideas and themes

Works of art, like all human products, are created in certain cultural contexts: times and places that determine their character. Every work of art is a window onto our history, our human development, and our creative spirit; but it is difficult, if not impossible, to understand an art object, or any object for that matter, without knowing its original context and its history. We begin our brief survey of Western art with the longest period of human development: prehistory.

The Stone Age in Western Europe

The history of art as it is presently known begins with artworks created during the Old Stone Age, the *Paleolithic* Period, which lasted over a million years – from *c*.1,500,000 BC to *c*.1800 BC. The Middle and New Stone Ages marked significant cultural changes that are evident in the subject matter and technology of art. All three periods together are referred to as Prehistoric, because they pre-date the invention of a writing system, leaving us without written documents that explain the meaning and function of works of art. Nevertheless, these works give us the earliest surviving access to the history of our artistic legacy.

The Old Stone Age was a time when people were nomadic, moving from place to place in search of food and shelter. Animals were hunted for food and skins, and their bones served a variety of other purposes. People made weapons and tools out of stone, and they gathered what grew naturally rather than producing their own food. Old Stone Age artists created two main types of art that have survived: small-scale sculptures of women and animals, and paintings on cave walls depicting naturalistic animals and human stick figures. The sculptures of women appear to have had symbolic meaning associated with fertility since they exaggerate the breasts and pelvis, the most visible areas of the female body involved in reproduction and the nourishment of infants.

The best-known Paleolithic sculpture of a female figure is the *carved* limestone *Venus of Willendorf* (**Figure 6**) of around 25,000 BC, which was discovered in Willendorf, in modern-day Austria. The arms of the sculpture are minimized, the face, except for the mouth, is covered, and the legs seem to have broken off mid-calf. The artist who carved this work conveys a sense of rhythmic, bulbous ovals, with curved *contours* (edges or outlines) that flow elegantly from one shape to another. The figure, an example of *sculpture-in-the-round* (that is, it is completely carved on all sides from its original material), faces front and is so small, around $4\frac{3}{8}$ inches (11.5 cm) in height, that it can be held in the palm of one's hand. Despite its small scale, however, the *Venus of Willendorf* has a quality of *monumentality* (that is, of appearing large), which the artist achieved by compressing space and enlarging shapes within the contours of the figure. There are no open spaces inside the contours, and this focuses the viewer directly on the large, oval forms of the body. Areas of red *pigment* (color) on the limestone surface may be a reference to the blood of childbirth.

The modern assumption that the *Venus of Willendorf* and other similar Paleolithic sculptures of women symbolized fertility and reproduction is indicated by their titles, which refer to the

Figure 6 *Venus of Willendorf*, c.25,000 BC, limestone, 4 3/8 in. (11.3 cm) high. Naturhistorisches Museum, Vienna, Austria. (Source: Matthiaskabel / Wikimedia Commons)

Roman goddess of love and beauty. The monumental quality of the 'Venus' figures is also consistent with the child's view of the mother (and father) as very big. The sculptor who created the *Venus of Willendorf*, therefore, exemplifies Baudelaire's definition of artistic genius: the artist evokes his impressions of childhood

and transforms them into an aesthetic form that is understood and appreciated by a cultural audience.

The oldest currently known Paleolithic cave paintings found in Western Europe are located in the Chauvet cave complex in southeastern France. They date to between 30,000 and 17,000 BC and primarily represent animals in a relatively naturalistic style. Whereas the sculptures of females are thought to symbolize fertility, the prevalence of animal imagery in cave art is widely assumed to reflect the importance of hunting for human survival. The naturalism of the animals indicates that they were carefully studied by the painters who depicted them and that there must have been groups of trained artists throughout Paleolithic society. Human figures in cave art, by contrast, are usually minimal and schematic in form.

The Middle Stone Age (c.8000–4000 BC), the *Mesolithic* era, witnessed the beginning of a transition to settled communities. By the New Stone Age (the *Neolithic* era: c.4000–1800/1500 BC) – when people had learned to grow their own food – this transition had been completed and it led to a new art form: monumental stone architecture. The most famous architectural work of the Neolithic period in Western Europe is Stonehenge (**Figure 7**), located on Salisbury Plain, in the county of Wiltshire, England. Begun around 3000 BC as a circular mound of earth on a large, flat area of land, Stonehenge was a sacred site, although its exact purpose is unknown. With the addition of burial mounds and a pathway dug out of the earth running from east to west with the upright Heel Stone at the end of the pathway, Stonehenge began its evolution into a major example of Neolithic architecture. The final stage of Stonehenge (completed c.1800/1500 BC) was the creation of the *cromlech*, the impressive structure made of huge stones arranged in a series of circular patterns.

Known as *megalithic* architecture after the large scale of the stones, the cromlech consisted of a circular outer wall composed of upright stones connected at the top by horizontals. Inside the

Figure 7 Stonehenge, c.3000 to 1500 BC, Salisbury Plain, Wiltshire, England. (Source: garethwiscombe/ Wikimedia Commons)

outer wall was a second circle of smaller single upright stones (*monoliths*); these surrounded a horse-shoe shape consisting of five large individual *trilithons* (sets of three stones, in which two vertical stones support a horizontal stone). Inside the five trilithons was a second horse-shoe shape formed by smaller monoliths. A so-called Altar Stone stood at the center of the structure.

The *post-and-lintel* structural system of elevation used for the outer circle and the five trilithons consists of verticals (the posts) supporting either end of a horizontal (the lintel). Since the builders created open spaces between the posts, they made it possible for people to move in and out of the structure, possibly for ritual dances and processions. The stones at Stonehenge are roughly shaped and of even height to create a sense of harmony and balance and to ensure that the structure is sound. The basic form of the post-and-lintel system used at Stonehenge would be elaborated in later Western cultures into more complex forms endowed with a variety of symbolic meanings.

MYSTERIES OF STONEHENGE

Stonehenge has been a subject of fascination for centuries. Built by the Men of Wessex, who once inhabited southwestern England, it is thought to have been used for agricultural rituals by the ruling class of Druid priests. Since the cromlech is a circle and the stones cast shadows in much the same way as a sundial, some scholars believe that Stonehenge was used to predict changes in seasons and possibly certain astronomical events such as eclipses and comets. The Heel Stone is placed so that on the summer solstice, 21 June, the sun rises directly over it, and its rays would hit the upright Altar Stone. Today this has become a kind of cult event with visitors from around the world congregating at Stonehenge to watch the dawn.

One of the unanswered questions about Stonehenge is how the biggest stones, some weighing up to 40 and 50 tons, were transported before the invention of the wheel from quarries up to 20 miles (32 km) away. The smaller monoliths inside the outer ring came from an even greater distance – a quarry in Wales over 100 miles (160 km) away. Nor is it known how the horizontal stones were raised onto the vertical stones without a wheel-based pulley system.

Over the years, people have invented fanciful theories of how Stonehenge was constructed. These range from aliens with advanced technology to a feat of architectural conjuring by Merlin, King Arthur's magician. Today, archaeologists and other scholars are continuing their study of the structure in an effort to solve some of these mysteries.

The ancient Near East: the dawn of written history

Following the Stone Age in Western Europe, a group of important civilizations arose around the Mediterranean Sea. They occupied five major geographic areas: the ancient Near East,

Egypt, the Aegean islands, the Greek mainland and its islands, and the Italian peninsula. Because of trade, wars, and other cultural contacts between these civilizations, there is some overlapping of dates; Greece, for example, did not cease to exist when Rome became an empire and the Near East did not disappear when conquered by Alexander the Great in 323 BC. Nonetheless, each of these regions had periods of greater or lesser power and they produced their greatest art at the height of their influence in the world. In all of these areas, the predominant art forms were determined by the nature of their cultures. We begin with the ancient Near Eastern civilizations that date from around 7000 BC to 331 BC.

The ancient Near East includes the area from modern Turkey and southern Russia south to modern Israel, Jordan, and Saudi Arabia, and east to Iran. It was a region of many different cultures, belief systems, terrains, and art forms. The area generally reckoned to be central to the development of civilization was Mesopotamia, literally 'the land between the rivers' (the Tigris and the Euphrates in modern-day Iraq). Mesopotamia has been called the 'cradle of civilization' because, sometime between 3500 BC and 3000 BC, it produced the world's first known writing system – called *cuneiform* after its wedge-shaped characters – and also produced the first literary epic, the *Epic of Gilgamesh*. Because of the invention of writing, which occurred in Sumer in southern Mesopotamia, a great deal more is known about the ancient Near Eastern and other literate cultures than about prehistoric societies.

There was also innovation in the visual arts, including the first use of the round arch in architecture and the development of the *ziggurat*. As in most ancient Western cultures, Mesopotamian religion was *polytheistic*; people believed in many gods, and each god had specific functions. The purpose of religious architecture in all societies is to connect people with their gods, and Mesopotamia was no different. Ziggurats were monumental stepped towers

symbolizing mountains, where the gods were believed to live. The ziggurat was a unique form of architecture, often surmounted by a shrine dedicated to the god that protected the city. The oldest surviving ziggurat, located at the ancient Mesopotamian site of Uruk, dates to between 3500 and 3000 BC.

In addition to monumental stone architecture, the ancient Near Eastern cultures produced a great deal of royal art designed to project the power and piety of their kings. One such king, Gudea, ruled the city-state of Lagash at the edge of the Euphrates River during the Neo-Sumerian period (c.2150–1800 BC). A strong ruler able to maintain peace during his reign, Gudea (**Figure 8**) is shown in a *frontal* (facing front) pose, holding a vase from which flowing water and leaping fish descend to the end of his long robe. This imagery confirms that Gudea wished to be viewed by his subjects as a source of life – for which water was particularly important in a desert climate – and implies that he, as the ruler, guaranteed the prosperity of Lagash. Like the *Venus of Willendorf*, the statue of Gudea is monumental in style, though not in scale at only 29 inches (73.7 cm) high. He is compact, his arms are muscular, his head rests directly on his shoulders, and there are no open spaces within his outer contour. His cap, which he wears in several of his 20 surviving statues, is pulled down to his ears and decorated with circular patterns.

Gudea's robe is covered with cuneiform inscriptions that record details of his reign. He was known as a builder of temples, and he claimed that the gods sent him dreams instructing him what temples to build and how to plan them. Like most ancient rulers, Gudea is depicted in stone – in this case diorite – to symbolize long-lasting power and immortality. His bare shoulder and long robe are conventional Mesopotamian signs of piety and show him in the role of a priest as well as a ruler. His wide-eyed gaze indicates that he is in the presence of a deity. As with the Mesopotamian ziggurats, kings were seen as intermediaries between people and their gods.

Figure 8 *Gudea with a Vase*, c.2029 BC, diorite, 29 in. (73.7 cm) high. Musée du Louvre, Paris, France. (© Adam Wodfitt/Corbis)

Not all Mesopotamian rulers were as peace-loving as Gudea, and their war-like natures were reflected in their royal imagery. The Akkadian dynasty in northern Mesopotamia was founded around 2332 BC by Sargon I. A bronze head, probably the king's portrait, was found in a trash heap with the left eye gouged out, suggesting that the image was mutilated when Sargon's power declined. His grandson, King Naram-Sin, was commemorated in

a limestone *stele* (boundary marker) with a *relief sculpture* (in which one side has not been carved away from its original material). The stele depicts Naram–Sin conquering his enemies as he and his army march up the side of a mountain. Symbols at the top of the stele stand for the gods who protect the ruler.

By around 1000 BC, a new empire began to arise in northern Mesopotamia – the powerful Assyrian Empire. Assyrian kings were known for their war-like character and for constructing huge palaces lined with relief sculptures chronicling their victories in battle. A prominent theme on the Assyrian palace reliefs is the king as a hunter of lions, which were kept in royal parks for that purpose. Such hunting scenes, in which a well-guarded king is shown killing lions, are intended to project the king's image as a strong, skilled warrior, mightier than the king of beasts.

A unique expression of royal power in Assyria can be seen in the colossal statues guarding the palace gateways (**Figure 9**). Called lamassu, these depicted human-headed winged lions or bulls and were monumental in both form and scale. They typically had five legs so that two stood still facing visitors approaching the gate and four seemed to be walking as visitors passed them. These and other combined animal forms are found throughout the Near East and usually represent deities. They were intended to remind viewers of the divine power of the kings as well as of the notion that the gods are ever-present.

The last great empire in the ancient Near East before the death of Alexander the Great in 323 BC was the Persian Empire, located in modern-day Iran. Its main palace at Persepolis was a vast structure designed to show the ruler's earthly dominion. Visitors to the royal audience hall (*apadana*) at Persepolis ascended a stairway lined with reliefs showing the Persian army and foreign dignitaries bringing tribute to the king. This imagery reflected the notion that the entire world was subject to the Persian king. Decorating the apadana were a hundred huge *columns*, which elaborated the more basic form of the post-and-lintel

Figure 9 Lamassu from the Palace of Assurnasirpal II, 883–859 BC, alabaster, 10 ft 3½ in. (3.11 m) high. Metropolitan Museum of Art, New York, USA. (© The Metropolitan Museum of Art/Art Resource/Scala, Florence)

elevation system used at Stonehenge. At Persepolis, the column consisted of three main sections: a circular *base*, a vertical *shaft*, and a *capital* at the top. Many of the capitals (the 'heads' of the columns) were carved in the shape of monumental bulls, transforming them into a metaphor for the king as the head of state. The image of the bull, like that of the lion, embodied the king's power.

Egypt: the art of kings

In contrast to the cultural diversity of the ancient Near East, Egypt was unified around 3100 BC into a single civilization, ruled by *pharaohs*, which lasted some 3000 years. The stability of Egyptian society was reflected in its large-scale art forms and preference for stone, both of which echoed the ruler's wish for power and immortality. Perhaps more so than elsewhere on Earth, in ancient Egypt the universal wish to live forever was given concrete form, particularly in royal art. Embodying this wish in architecture was the *pyramid*, a colossal burial monument containing the pharaoh's *mummified* (embalmed) body and all his earthly possessions. The structure itself consisted of a square floor plan and four inwardly sloping triangular sides that met at a point directly above the center of the square. Inside was a maze of secret passageways and trap doors blocking access to the burial chamber, where the pharaoh's mummy was located. The pharaoh's body had to be physically preserved in order to insure a successful journey to the afterlife, where he (or she) would become one with the sun god. Reflecting these beliefs was not only the imposing visual impression made by the pyramid, but also the imagery added to the exterior of the structure. Constructed of huge, precisely cut limestone blocks, the pyramid was capped with gold, replicating the sun, and diagonals of gold (reminiscent of the sun's rays) streamed from the cap down the sides of the building. Today most of the pyramids have been plundered, but originally they were filled with paintings of the king's everyday life and vast numbers of objects made of precious materials such as gold, silver, carnelian, and lapis lazuli.

Three Old Kingdom pyramids at Giza, along the Nile at the edge of Cairo, belonged to three different generations of pharaohs. The pyramid in **Figure 10** was built for Khafre, who ruled from around 2520 to 2494 BC. Guarding the pyramid complex was a huge limestone sphinx, a human-headed lion, whose

ANCIENT EGYPT: THE CONTEXT

Geographically, Egypt was primarily desert and, aside from a few oases, depended on the annual flooding of the Nile – the world's longest river – to fertilize the soil. Reflecting the cultural continuity of ancient Egypt, its history is divided into three major periods: Old Kingdom (c.2575–2150 BC), Middle Kingdom (c.1991–1640 BC), and New Kingdom (c.1550–1070 BC), with Intermediary Periods in between. Each period is divided into *dynasties* (families of kings).

Gods, in Egypt as in Mesopotamia, were thought to be everywhere and their goodwill to be necessary for prosperity. Power in ancient Egypt was concentrated in a single pharaoh, who was identified as the sun god, Ra, on earth. Rather than being viewed as an intermediary between gods and people, as Gudea was, the Egyptian pharaoh was considered to be literally a god. Since most Egyptian art was created at the behest of the rulers, it reflects their divine power, as in Mesopotamia and other ancient Near Eastern cultures. Fortunately for our understanding of history, modern scholars can read Egyptian picture writing – *hieroglyphs* – which appears in texts and on the walls of tombs and temples. An important record that survives is the king list of ancient Egypt, which tells us the chronology (though not the exact dates) of the pharaohs. The first pharaoh, credited with unifying the two parts of the country, Upper and Lower Egypt in the south and north, respectively, is Narmer (or Menes), whose achievement was commemorated in the so-called *Palette of Narmer*, discovered in a temple and now in the Egyptian Museum in Cairo.

interior served as a temple. As at the Assyrian palace gates, the lion was a traditional guardian whose power lay not only in its role as king of the beasts, but also in its vigilance. Its eyes were always open and watchful.

The theme of the pharaoh as protector of his people recurs in Egyptian temples, which were lined with royal statues parallel to the vertical columns (**Figure 11**). In Egypt, the post–and–lintel system was revised not with capitals showing the king in animal

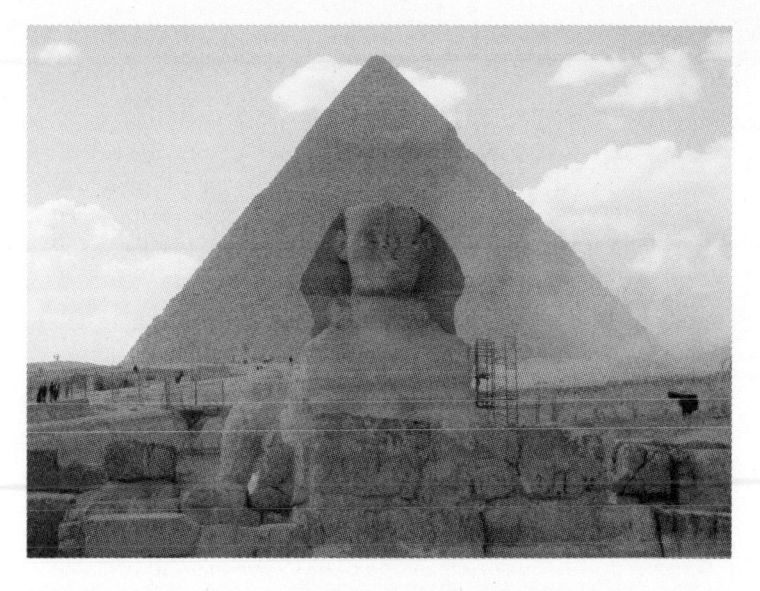

Figure 10 View of Khafre's pyramid with the Great Sphinx in the foreground. (© Paolo Gianti / Shutterstock.com)

form, as at Persepolis, but rather in the shape of plants growing along the Nile. The imagery and repetition of the capitals signified the abundance of vegetation created by the flooding of the Nile and by the pharaoh's ability to preserve prosperity throughout Egypt.

From kingship to democracy: Aegean myths and the Greek ideal of human form

The ancient Aegean world included the islands in the Aegean Sea, which lies between the Greek mainland and the west coast of modern Turkey (ancient Anatolia). It flourished from around

Figure 11 Egyptian temple interior showing columns and statues of standing pharaohs. (Source: Daniel Csörföly/Wikimedia Commons)

3000 to 1200 BC and reached a high point on the island of Crete, which lies north of modern-day Libya and south of the Cyclades. For centuries, until its discovery by archaeologists during the twentieth century, Aegean civilization was known only through myths and legends.

The *Bull-Leaping Fresco* (also called the *Toreador Fresco*) in **Figure 12** is one of the major works of art found on Crete in the Palace of Knossos. It may have been associated with the myth of the Minotaur, since it shows three youths somersaulting over the back of a charging bull. Characteristic of Minoan art, this painting shows an interest in graceful, curvilinear movement in contrast to the relatively static, rectilinear quality of royal Egyptian art.

THE MYTH OF THE MINOTAUR

In Greek mythology, Crete was ruled by King Minos, the son of the supreme god, Zeus, who had disguised himself as a bull and abducted the mortal girl Europa from mainland Greece. He carried her over the sea to Crete and mated with her. But Minos offended the sea god, Poseidon, and was punished accordingly. His wife was made to fall in love with a bull and gave birth to the monstrous Minotaur – part man and part bull. The Minotaur demanded tribute every year from Athens, which was required to send seven boys and seven girls to participate in a dangerous ritual that involved leaping over the back of a charging bull. The youths invariably died until the Greek hero Theseus killed the Minotaur.

Figure 12 *Bull-Leaping (Toreador) Fresco*, from the Palace of Knossos, *c.*1500 BC. Crete. (Source: Wikimedia Commons)

Minoan civilization declined around 1450 BC, when Crete was occupied by the Mycenaeans, a warrior culture from the Greek mainland. As an island, Crete was protected by the sea and did not require fortified palaces. But at Mycenae, the mainland site for which the culture is named, protection was needed and was provided by walls built of enormous stone blocks. Because of their huge size, the ancient Greeks believed that they were the work of the Cyclopes, a mythical race of one-eyed giants – hence the term *cyclopean masonry*. Mycenae was also the home of Agamemnon, who led the Greek army against Troy during the ten-year Trojan War memorialized in Homer's *Iliad*.

The entrance to the Mycenaean *citadel*, a city built on a hilltop, was composed of a single post-and-lintel structure (a trilithon), cut into the cyclopean wall and leaving a small opening that made it difficult for invaders to storm the city (**Figure 13**). Surmounting the lintel is a pair of limestone lions flanking a Minoan column and framed by a *corbel arch* constructed of stones projecting gradually inward toward the top. The presence of the lions, like the sphinx and the pyramid complex at Giza and the winged lamassu at the Assyrian palace entrances, shows their continuing role as protective guardians.

With the decline of Mycenaean civilization, around 1100 BC, ancient Greece entered a period of obscurity, or Dark Age. Then, around 800 BC, a new alphabet adapted from the Near East entered the mainland along with a Greek-speaking people from the North who called themselves the Hellenes. These people had an entirely different view of themselves and their civilization from the inhabitants of other Mediterranean regions. Their art reflected the idea that man was the center of the universe, and it contrasted with an emphasis on monstrous animal forms such as the sphinx and lamassu, and from colossal architecture such as the ziggurat and pyramid, toward a human ideal and human scale. The literature, history, and theater of ancient Greece explored psychological motivation and character. The Greek gods were

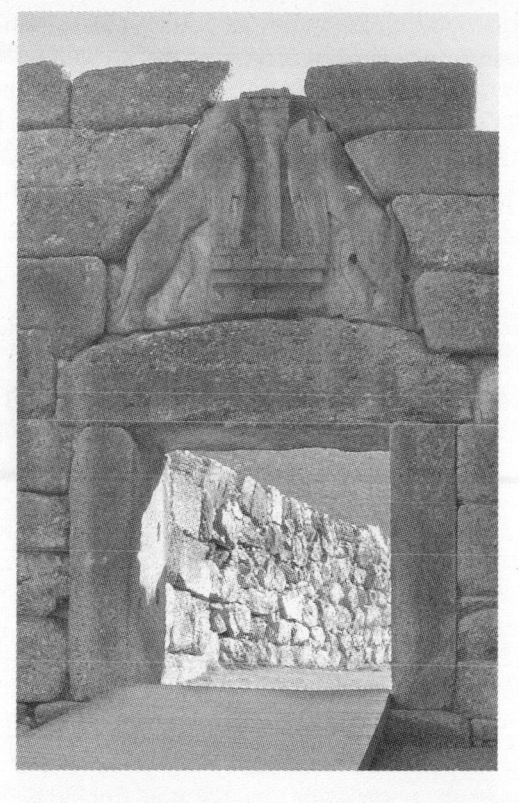

Figure 13 Lion Gate, c.1250 BC, Mycenae, Greece. (Source: Andreas Trepte/Wikimedia Commons)

immortal and larger than life, but at the same time anthropomorphic and endowed with human personalities.

At first influenced by Egyptian royal sculpture, Greek art soon took on its own cultural meaning, especially the ideal of the male nude. The relatively rapid development of Greek art toward an unprecedented emphasis on human form is reflected in its stylistic terminology from the eighth through the first century BC.

Greek styles that best exemplify the progression toward idealization of human form are the three Classical styles: Early Classical (*c*.490–450 BC), High Classical (*c*.450–400 BC), and Late Classical (*c*.400–323 BC).

The Greek interest in human form is demonstrated in Early Classical images of male youths. The *Discus Thrower* in **Figure 14**

Figure 14 Myron, *Discus Thrower*, c.460 BC, Roman marble copy of an original Greek bronze. National Museum, Rome, Italy. (© John Baran/ Alamy)

is actually a Roman copy of a lost bronze by the Greek sculptor Myron. The statue represents a perfectly formed male nude in the act of pivoting as he prepares to hurl a discus. His body, which works as a unified whole, is clearly the product of an artist who had studied human form in action. But despite its naturalism and anatomical accuracy, the figure is idealized. It is an unusual combination of dynamic energy and a calm demeanor. There is no sense of strain or struggle, and no facial expression or personality. The head is a smooth, domed shape that corresponds to the circular discus and base, and the geometry of the conception is evident in the two arcs of movement that converge at the neck. Myron's statue thus satisfies Aristotle's criteria for a work of art; its scale is appropriate, and its structure is a unified whole, which is both geometric and proportional.

From the Early through the Late Classical periods in Athens, which lasted well into the fourth century BC, the first known form of democratic rule was instituted. Leaders were elected by male citizens, each of whom was required by law to serve in the army and in the assembly. Characteristic of Greece, in contrast to other regions at the time, was a hatred of tyranny and kings, and a conviction that citizens (that is, male citizens) should be responsible for electing and serving in their own government.

After the devastation of the Persian Wars in 479 BC, Perikles, the Greek general elected to govern Athens, undertook a program designed to rebuild temples and other structures destroyed when Persians sacked the city. The final defeat of the Persian invaders brought about the rise of Classical style, in which human form was idealized and temples were relatively human in scale. The centerpiece of the new building program was the Athenian acropolis, a citadel containing temples, sanctuaries, museums, and statues. The Greeks did not believe in the physical afterlife that inspired the elaborate Egyptian burial practices and colossal pyramids, and their funerary structures were modest by comparison.

The Greeks marked graves with a single upright stele bearing an inscription and sometimes carved with a relief sculpture memorializing the deceased.

The most brilliant architectural achievement of the Periklean age was the Parthenon (**Plate 4**), located on the Acropolis. This was a temple dedicated to Athena, goddess of war, wisdom, and weaving, and the patron of Athens in her aspect as a virgin (*parthenos* is the Greek word for 'virgin'). The Parthenon, today in ruins and being restored, was built entirely of marble apart from a wooden roof and metal rods holding sections of the columns in place. It consisted of two rectangular rooms, one to house the *chryselephantine* (gold and ivory) cult statue of Athena, and the other to house the Athenian treasury.

Greek architects elaborated the post–and–lintel system of elevation into three so-called Orders of architecture, using the *Doric Order* (**Figure 15**) for the Parthenon. Rather than emphasizing the might of kings as in ancient Persia, or the vegetation of a prosperous Egypt, the Doric Order was composed of geometric sections designed to represent Classical Greek ideals of harmony and unity of form. As with the anatomy and movement of the *Discus Thrower*, each individual section of the Doric Order – which begins with three steps and ends with the *cornice* – responds formally to a corresponding line or shape in another section. For example, taken together the steps at the base create a trapezoid shape that is visually 'completed' as a triangle in the *pediment* at the top of the cornice on the two short sides of the temple. The horizontal *entablature*, containing the plain *architrave*, the three vertical *triglyphs* and carved square *metopes* (which comprise the *frieze*), and the projecting cornice, echoes the horizontal steps and the square *abacus*. The triglyphs, in turn, echo the vertical *flutes* (concave indentations in the columns), and the curved *echinus* under the abacus echoes the curve of the column shaft. There is thus a series of repeated verticals and horizontals that create corresponding forms and enhance the sense that the building is a unified structure.

Figure 15 Labeled diagram of the Doric Order, with the pediment indicated.

Although the forms of the Doric Order are geometric, it is characteristic of Classical Greece that architecture was conceived of in human terms. Whereas the Persepolis columns expressed the power of the king and the Egyptian columns signified the pharaoh's role in making the land fertile and prosperous, Greek Doric columns were associated with phalanxes of citizen-soldiers. The sturdy horizontal formed by repeated verticals conveyed a feeling of steadfast strength and stability.

A number of so-called refinements designed by the Parthenon architects contributed to the appearance of unity and proportionality that create the aesthetic effect of the temple. Among these are the fact that what appears to be horizontal actually forms a slight upward curve that corrects for the tendency of the eye to read extended horizontals as dipping at the center; as a result each line appears straight. All the columns lean inward and the corner columns are placed closer together than the central columns, imperceptibly creating the impression of a frame at the corners of the building.

In addition to the interior cult statue of Athena showing her armed and victorious, the exterior of the Parthenon was decorated with four groups of sculptures whose narratives expressed the Classical sense of Greek superiority and human reason. The relief sculptures on the metopes represented four battles, one on each side of the building. These depicted four Greek victories endowed with symbolic religious and political meaning: the victories of Greece over Troy and the Amazon women symbolized the triumph of Western over Eastern civilizations; the victory of the Greek gods over the pre-Greek Giants, or Titans, stood for the evolution from primitive, cannibalistic gods to more humanized ones; and the defeat of the drunken and violent centaurs (part man and part horse) indicated the power of Greek rationality over animal instincts. Another set of relief sculptures, directly behind the metopes, on the outside of the (now missing) inner wall, represented the Panathenaic Procession, which celebrated

Athena's birthday every four years and in which the entire city participated.

Finally, the two pediments (which are not part of the Doric Order), each containing sculptures-in-the round, illustrated two myths in which Athena emerged triumphant. On the west pediment, Athena vied with Poseidon for patronage of the city and defeated him by giving Athens the olive tree. The east pediment showed the myth of Athena's birth, according to which she emerged fully grown and armed from the head of Zeus, her father and the ruler of all the gods. Athena was thus born, like an idea, from the head of the supreme god, and she embodied the Greek Classical notion of intellectual primacy.

The Late Classical Period in Greece ended in 323 BC with the death of Alexander the Great and was followed by the Hellenistic Period, in which art forms became less idealized. Figures moved more freely in space, their actions were often violent, they had distinct personalities, and artists depicted a wide range of character types. Figures were no longer always young and in perfect physical condition; they could be young or old, struggling or at rest, relaxed or contorted. The Hellenistic period, during which much of the Mediterranean world was Hellenized by the imposition of the Greek language and its culture, lasted until the rise of the Roman Empire beginning in 27 BC. By that time, the center of power in the region had shifted to Rome.

Rome: Republic to Empire

The legendary founding of Rome by the twins Romulus and Remus, descendants of the Trojan hero Aeneas, himself a son of the goddess Venus, is dated to 753 BC. At that time, the Italian peninsula was dominated by the Etruscan civilization and ruled by kings. In 509 BC the last Etruscan king was expelled from

power and Rome became a republic, ruled by a senate consisting of upper-class citizens.

Octavian, the adopted son of Julius Caesar, came to power in Rome in 31 BC, by which time the Romans had conquered a huge amount of territory. But the government had been weakened by years of unrest and civil war. Octavian took advantage of the instability and, in 27 BC, he changed his name to Augustus and declared himself emperor. In the course of the next 400 years, the Roman Empire expanded to include territory from Britain in the north to North Africa in the south, Spain in the west, and east to Assyria and beyond.

To accommodate the inhabitants of its expanding empire, the Romans produced a large body of architecture, constructing buildings out of brick, concrete, and travertine. They developed the round arch that had been invented in Babylon and used it for many types of architecture, both public and private. They built forums, which contained *basilicas* housing law courts and shops and where public announcements informed citizens of decisions made by the senate; public baths for physical exercise, bathing, games, socializing, and reading; aqueducts for transporting water over long distances; markets; arenas, such as the Colosseum, for athletic events, chariot races, mock naval battles, and gladiatorial contests; country villas for the wealthy; city houses for the upper-middle class; apartment blocks for the middle and lower classes; and temples. The interiors of Roman buildings were decorated with sculptures, paintings, and *mosaics* (pictures made by arranging small colored stones on a floor or wall).

Augustus became a great patron of the arts, commissioning statues and buildings designed to project his political image as a strong but benevolent ruler. He improved the appearance of Rome by facing its buildings with marble, which was scarcer and more expensive than in Greece. In a daring political gesture to celebrate peace between Rome and the Gauls (inhabitants of the region that is France today) and to show that he was a man of

peace, the first emperor commissioned the *Ara Pacis* (Altar of Peace) and had it constructed on the Field of Mars (the Roman god of war).

A major statue of Augustus, the *Augustus of Prima Porta* (**Figure 16**), represents the emperor as a powerful general whose conquered territories bow to his will. Stylistically the work

Figure 16 *Augustus of Prima Porta*, early first century AD, marble, 6 ft 8 in. (2.03 m) high. Musei Vaticani, Rome, Italy. (Source: Till Niermann / Wikimedia Commons)

reflects both the influence of Greek idealized naturalism and a new Roman character in art. The figure of Augustus, like the *Discus Thrower,* is both calm and energetic as he assumes a relaxed stance but carries a lance and extends his right arm to address his troops. The *Augustus of Prima Porta* has the dome-shaped head of its Classical Greek predecessors, but the ears and physiognomy convey the impression of a specific, though idealized, portrait. Whereas Myron's figure has no identity beyond athletic skill and a perfect form, the *Augustus* contains elements that relate him to the history of Rome. His armor is decorated with relief sculptures, including a figure of Mother Earth as a sign of plenty under his rule and a defeated enemy presenting him with a military standard. The little figure of Cupid by the emperor's right leg is a reminder of the legendary founding of Rome; Aeneas, like Cupid, was a son of Venus and this coincidence provided Rome and its rulers with a way of tracing their lineage to the Greek gods.

Under the emperors, Rome invented new architectural forms consistent with their political aims and expanded the use of the established classical style. An important new building type was the colossal free-standing marble column decorated with a spiral frieze commemorating and illustrating imperial victories. Another architectural type was the triumphal arch: a rectangular structure having one, two, or three round-arched openings through which a victorious general or emperor would re-enter a city following a successful military campaign.

In the course of Roman imperial rule, a new religion was born that would change the course of history. This was the Christian faith, which expanded throughout the Mediterranean after the Crucifixion of Jesus in AD 33. Although Rome was relatively tolerant of different religions, some emperors persecuted Christians for refusing to worship the emperor as a god. The growing influence of Christianity, however, along with other disruptions to Roman stability, led to a decline in imperial power over the following three centuries.

When Constantine the Great became emperor in AD 306, he reinforced Roman power in the East by founding a new capital city, Byzantium (modern-day Istanbul), located on the Bosphorus – the strategically important strait between Europe and Asia Minor. He renamed the city Constantinople after himself. In AD 313, he issued the Edict of Milan, granting tolerance to all religions, including Christianity.

Based on the Jewish monotheistic tradition, Christianity celebrated the belief in a single, all-powerful god. Christians also believed that Jesus was the Son of God, who had selected the Virgin Mary to give birth to Jesus. Saints, martyrs, Christian rulers, the life of Christ, and complex symbolism, as well as the Holy Family (Mary, Jesus, and Joseph, Mary's earthly husband), all became prevalent subjects in art.

With the Edict of Milan Christians could build and decorate large-scale churches. Whereas Greek and Roman temples had been built mainly to house the cult statue of a god or goddess, Christian churches were congregational and had to be large enough to accommodate crowds of worshipers. For this purpose, Christian architects adopted the form of the Roman basilica, which contained a long *nave*, side aisles, and an *apse* at the end where the law court was located. To this structure, the Christians added a cross-section, the *transept*, with the result that the Western church plan resembled the shape of a cross and was a reminder of Jesus' Crucifixion. The Christian nave housed the congregation, and the apse housed the altar. Often scenes of Christ's Last Judgment (his Second Coming) are represented in the apse, where it replaces the secular judgments rendered in the apse of the Roman basilica.

If we compare the remains of Constantine's colossal marble statue that once dominated the law court in his basilica (**Figure 17**) with the *Augustus of Prima Porta*, we can see the evolution of the imperial image. Rather than showing himself as a general communicating with his troops and continuing the naturalistic

Figure 17 View of the remains of Constantine's marble statue, AD 313, now in the Palazzo dei Conservatori in Rome, Italy. (© Vincent Abbey/Alamy)

idealization of the Classical style, Constantine has become an enormous figure – the head alone measures eight feet six inches (2.59 m) in height – with portrait-like features such as a slight frown and an aloof character. The emperor was now an image of divine power. In the course of the next century, however, Rome would decline despite efforts to maintain its imperial supremacy. It fell to invaders and in AD 476, the official date of the fall of

Rome, the city was sacked by the Goths, a Germanic tribe from Western Europe.

Byzantine style: power, spirituality, and symbolism

With the fall of Rome, the Christian Roman Empire in the East came to prominence – its capital city, Byzantium, is the origin of the term Byzantine, which in art refers to the style that dominated the fifth century in territory held by the emperor. In contrast to Roman naturalism, Early Christian and Byzantine artists emphasized spirituality. This led to a change in the representation of space and in the characterization of human figures, although it in no way eliminated political meaning. These qualities are apparent, for example, in the Byzantine-style mosaic (composed of colored tiles, rather than pebbles as in Rome) of the emperor Justinian and his court on the apse wall of the Church of San Vitale in Ravenna (**Plate 5**). The figures are frontal; they stand in a flattened space against a gold background. They do not turn freely in space, as the *Discus Thrower* does, or make commanding gestures like the *Augustus of Prima Porta*. Instead, they are confined within a flatter, more spiritual space and they seem to communicate directly with viewers. The central figure is Justinian himself, the sixth-century Byzantine emperor who ruled from his capital at Constantinople.

Justinian's large scale and centrality denote his importance. He is visually elevated by the flat halo behind his crowned head, and the purple he wears was the color reserved for the exclusive use of Roman emperors. Clergymen in white robes flank Justinian, indicating that his right to rule is supported by the Church. At the far left, a group of soldiers carries a shield decorated at the center with the Chi Rho sign, based on the first two Greek letters of Christ's name. This became the symbol of

Constantine after he led his army to victory against a rival emperor. According to Christian tradition, Constantine carried a small crucifix as he rode into battle and easily routed his enemy. Impressed with the power of the Cross, Constantine placed the Chi Rho on his shield and it came to symbolize his connection with Christ. When Justinian used the same monogram, he was proclaiming his divine right to rule by association with Constantine and the Christian God. The abundance of jeweled forms in the frame emphasizes the wealth of Justinian's court, just as the presence of the clergy and the army and their direct confrontation with viewers convey his political, religious, and military power.

Medieval art and the age of cathedrals

As the Byzantine Empire declined, especially in Western Europe, new types of Christian art evolved. The Middle Ages, or medieval period, began during the seventh century and continued through the thirteenth, fourteenth, and fifteenth centuries in various parts of Europe. New churches, monasteries, convents, and abbeys sprang up. In the *scriptoria* (literally 'writing rooms') of the monasteries, monks and nuns *illuminated* manuscript pages of biblical texts in order to beautify the Word of God. The pages of sacred texts were decorated with elaborate calligraphy and figurative images as well as with abstract designs. *Altarpieces*, many with paintings and sculptures illustrating Christian events, adorned the altars of churches.

In the course of the seventh century, Muslim invasions conquered the regions from Saudi Arabia across North Africa and into Spain. France repulsed the invaders in 732 at the city of Tours on the Loire River, but Muslims continued to occupy parts of Spain until 1492. As a result, elements of Islamic art infiltrated

styles in Europe; mosques were built in Spain, and the elegant interlace patterning of Islamic pictorial art is evident in Byzantine and medieval forms.

In Cordoba, a spectacular mosque, commissioned by the first Muslim ruler of Spain, was constructed from 786 to 987. The architects used a unique system of double arches supported by short columns to enliven the interior. Their curved forms and patterns create the illusion of movement through the flowing space. Elaborate, geometrically designed mosaics adorn the central domed ceiling and the *mirhab* bay, a niche set behind the *qibla* – the prayer wall aligned with Mecca. Unfortunately, when the Muslims were expelled from Spain in 1492, large parts of the mosque were destroyed to make way for a Christian church.

Conflicts between Christianity and Islam in Europe extended eastward to Jerusalem and gave rise to the Crusades – military campaigns waged by Christians from the late eleventh to the fifteenth century to recover the Holy Land from the Muslims. Pilgrimages in search of miracles or to atone for one's sins took faithful Christians to Jerusalem, Rome, and other holy sites throughout Europe, leading to an increase in the construction of churches. Sculpture, which had declined during the Byzantine Empire, also revived. Beginning around the year 1000, the earliest of the great cathedrals were built in the Romanesque style, which was named for its use of round arches that had characterized Roman structures. Typically built with thick walls and dark interiors, many Romanesque churches were crusade or pilgrimage churches. The exteriors were decorated with relief sculptures, especially over the entrances, often with scenes of the Last Judgment – a warning to worshippers and a reminder of their future in eternity.

The rise in architectural activity during the Romanesque period paralleled a rise in the economy of Europe, which was based on the stratified feudal social system. By the twelfth century, Romanesque style began to evolve into Gothic style.

The key monuments of the Gothic era were the towering stone cathedrals that dominated towns across Europe. Typical of these buildings is the great cathedral at Amiens, north of Paris (**Figure 18**).

A cathedral is the seat of a bishop and therefore, in accordance with Catholic hierarchy, a much larger structure than a parish church, a convent, or an abbey. The vertical emphasis of the towers at Amiens leads the viewer's eye upward, a symbolic

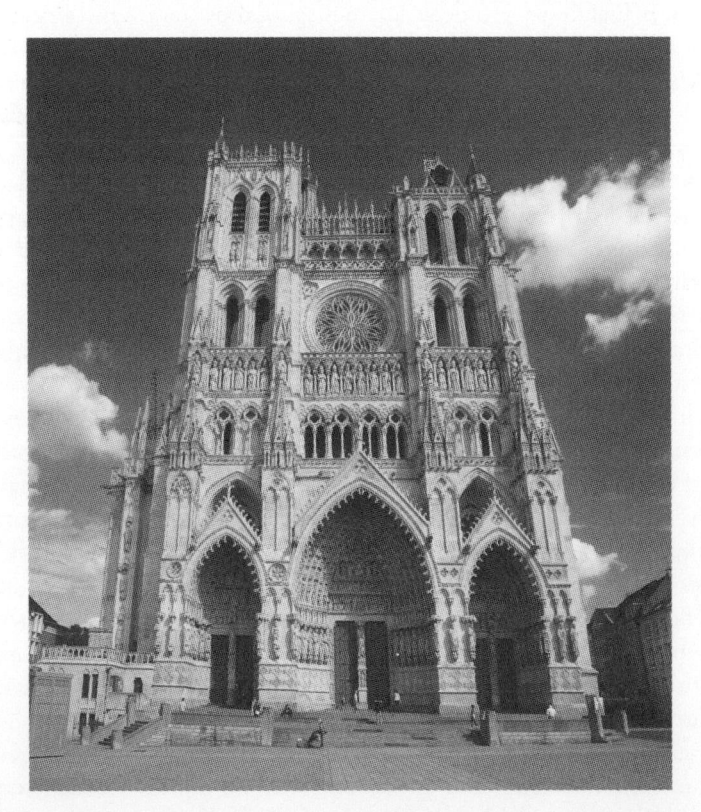

Figure 18 Façade of Amiens Cathedral, c.1220–40, Amiens, France. (© Pecold/Shutterstock.com)

allusion to the belief that paradise is located in the heavens. The round arches of the Romanesque style were supplanted by Gothic-style pointed arches to reinforce the verticality of the façade. Along the side walls, supporting the increased height of the cathedral were exterior *flying buttresses*. In Romanesque cathedrals, in contrast, the buttressing had been placed inside the thick walls.

Decorating the Gothic exteriors were hundreds of sculptures of saints and martyrs, as well as biblical figures and events. Carved on the stone slab (the *trumeau*) between the two center doors of Amiens is a teaching Christ known as the *Beau Dieu* (*Beautiful God*) (**Figure 19**). He stands in a frontal pose under a stone canopy, raising his right hand in a gesture that denotes teaching, and in his left hand he carries a book that denotes the textual basis of Christianity. Beneath his feet are two small monsters representing the forces of evil – an arrangement that signifies the triumph of Christ's message over Satan. Stylistically, the folds of Christ's drapery are rendered with more variety and in greater depth than those in the Byzantine *Court of Justinian*. Thus, while maintaining the spirituality and symbolic character of previous Christian art, Gothic art began to evolve from the rigid verticality and narrow spaces of Byzantine and Romanesque style to a new emphasis on nature.

Compared with Romanesque cathedrals, Gothic artists expanded sculptural decoration and enlarged the space allocated to windows. This reflected the increased use in the Gothic period of *stained glass*, colored windows depicting biblical scenes, Christian legends, and saints and martyrs that could be understood by a largely illiterate population. To Christians, cathedrals such as Amiens were a microcosm of the universe and symbolically a heavenly Jerusalem on Earth.

The entire surface of the façade of Amiens Cathedral is filled with architectural design patterns, as well as with sculptures of biblical figures and saints. The circular shape of the enormous *rose*

Figure 19 *Beau Dieu*, trumeau sculpture from the west façade of Amiens Cathedral, *c*.1225–30. Amiens, France. (© Sites/Photos/Alamy)

window above the central door symbolizes the never-ending character of the Christian universe. On a sunny day, the windows would have produced a blaze of colorful light, which filtered out the natural light of the earthly world. The windows at Amiens were destroyed when the town was bombed during World War II, but the windows of other Gothic cathedrals, notably those at Chartres, southwest of Paris, are intact. The north rose window at Chartres is illustrated in **Plate 6**.

From spirituality to humanism: the Renaissance in Italy and northern Europe

The waning of the Middle Ages in Europe coincided in Italy with the beginning of a new way of conceiving of the world and man's place in it – namely, humanism, and its revived interest in ancient Greek and Roman language, art, and culture. Although the subjects of art remained primarily Christian, the nude figure reappeared during the Renaissance and content became increasingly secular. The invention of scientific perspective around 1400 changed the way space was depicted in paintings. Sculptures depicted figures moving more freely in space than they had in medieval art. Renaissance architects revived the round arches of Roman and Romanesque buildings. They related the scale of architecture to human scale, rather than constructing the soaring, heavenward towers of Gothic cathedrals. In place of colorful stained glass, Renaissance architects typically preferred plain glass windows, which admitted natural light into the interiors and reflected the new interest in the reality of nature.

As part of the Classical revival, Renaissance humanist artists began portraying mythological subject matter – such as in Botticelli's *Birth of Venus*, painted around 1480 (**Plate 7**). The artist depicted a nude Venus, born from the waves, gliding ashore

THE HUMANIST MOVEMENT

Beginning in fourteenth-century Italy, the humanist movement marked a renewed interest in the Classical world. This 'rebirth' was perhaps the most significant intellectual aspect of the Renaissance period, which continued into the sixteenth century. During the Renaissance, first in Italy and then in northern Europe, ancient texts were translated and studied. The economy of western Europe evolved from feudalism to mercantilism, allowing some families, such as the Medici in Florence, to build huge personal fortunes. As a result, new private sources of art patronage developed. There was also a gradual rise in literacy, as well as in the status of artists and of women.

As in Classical Greece, the notion of man's centrality in the universe led to art styles that emphasized human form and revealed a new interest in human nature. Some Italian states, such as Florence, modeled their government on the republics of Greece and Rome. The Renaissance view of the world expanded as, starting in the late fifteenth and sixteenth centuries, global exploration led to the discovery of hitherto unknown civilizations. Financed by Spain, for example, Columbus sailed on Medici ships in 1492 in search of a new route to India. Instead, he found the Americas.

on a large scallop shell. She is propelled forward by the breath of personified wind gods at the left and awaited by a woman carrying a pink robe at the right. Compared with the narrow space and gold background of the *Court of Justinian* (see **Plate 5**), Botticelli's background consists of a natural landscape and a sea that extend toward a distant horizon. The interest in naturalism also affected the representation of form in the Renaissance; whereas the figures in Justinian's mosaic are outlined, Botticelli's Venus is defined by gradually shaded changes in light and dark. This technique, referred to as *chiaroscuro* (literally 'light/dark'), was developed in fifteenth-century Italy and creates the impression that the form is rounded and occupies natural, three-dimensional space.

Another major Renaissance work reflecting humanist thought is Michelangelo's monumental marble *David*, carved from 1501 to 1504 (**Figure 20**). Although essentially a Christian figure,

Figure 20 Michelangelo, *David*, 1501–4, marble, approx. 13 ft 5 in. (4.09 m) high. Galleria dell'Accademia, Florence, Italy. (Source: Rico Heil/ Wikimedia Commons)

the *David* was imbued with political as well as religious meaning. Originally commissioned for the Cathedral of Florence, the statue was instead placed at the entrance to the city's town hall, the Palazzo della Signoria, called the Palazzo Vecchio. Traditionally, Christians thought of David as a precursor of Jesus and his victory over Goliath as a victory over Satan. But in Florence, David also stood for the city's republican government and freedom from tyranny. The location of his image in front of the seat of government, therefore, made him a symbolic guardian of Florence itself. Michelangelo has shown David as tense and watchful, holding a stone and sling as if preparing to fight Goliath. Stylistically, the *David* is a naturalistic portrayal of a young nude male. His proportions are not those of Myron's *Discus Thrower*, but the tree trunk support behind his right leg is a reminder of ancient Roman copies of Greek sculptures. Although the subject is biblical, the pose and nudity of the figure were influenced by Classical style and reflect the humanist revival of Greek and Roman antiquity.

Renaissance painting in Venice, a city built on water and therefore imbued with a reflective atmosphere, had a somewhat different quality than in other parts of Italy. Venetian figures are fleshy, especially in the late fifteenth and sixteenth centuries, and their proportions less Classical than in Florence and Rome. In Venice, artists placed greater emphasis on rich color and textured brushwork than their contemporaries in other cities. These qualities are particularly pronounced in the style of Titian, whose nudes are typically bathed in soft light and whose flesh has a sensual quality. Like other humanist painters, Titian produced mythological work, as well as Christian pictures, allegories, and portraits. His towering genius, and the fact that he lived into his nineties, made him the dominant sixteenth-century artist of the Venetian Renaissance.

Despite the turmoil engendered by the Reformation and the Catholic Reform movement, humanism spread northward to

MARTIN LUTHER, THE PROTESTANT REFORMATION, AND THE COUNCIL OF TRENT

As the Renaissance in Italy reached its height in the early sixteenth century, religious and political ferment was developing to the north – notably in Germany. In 1517, Martin Luther (1483–1546), a German Augustinian monk, protested against the Church practice of selling indulgences – papal letters promising to shorten the time spent by the deceased in Purgatory. Tradition has it that Luther nailed a document containing ninety-five theses to the door of the Castle Church in Wittenberg, in Saxony, in which he outlined his objections to indulgences and other forms of corruption. He also objected to the rule of celibacy for the clergy and to the complex Church hierarchy, and he argued for a return to the simple tenets of the Bible. This led to religious turmoil throughout Europe as Catholic rulers attempted to quell the dissension. Several countries renounced the Catholic Church and embraced Protestantism. The Protestant countries were mainly in the north – Britain, the Netherlands, Scandinavia, Switzerland, and northern and western Germany. Southern Germany, Italy, Spain, France, and Flanders remained Catholic. Martin Luther married a nun and was excommunicated in 1520.

The Catholic response to Luther and the Protestant Reformation is known as the Counter-Reformation or Catholic Reform movement. This was an attempt by the Catholic Church to reassert its doctrines in Europe. To this end, the Council of Trent met three times between 1545 and 1563 in Trento, Italy, to redefine orthodoxy and impose certain rules on the arts. Books were banned, and the visual arts were required to portray religious subjects in a way that evoked identification with the suffering of Jesus and the Christian martyrs. Opposing the principles of humanism, the Catholic reformers insisted that art be emotional and mystical rather than rational and that it strictly obey the rules of the Church. Heretics were summarily dealt with and the power of the Inquisition (a religious body established in the thirteenth century to try cases of heresy) was increased to permit torture.

The Catholic Church opposed new developments in science and denied the truth of discoveries in astronomy that disproved the age-old view of the Earth as the center of the universe. Several prominent scientists demonstrated the opposite – the heliocentric view that the Earth and other planets revolve around the sun, which in fact is the center of the solar system. For these discoveries, a number of scientists – including Galileo – were either excommunicated or placed under house arrest, or worse. Artists also came up against the Inquisition and on occasion major works of Western art were threatened or altered at the demands of the Inquisitors (see chapter 6).

the Netherlands, where it had a different flavor than in Italy, but reflected a similar interest in nature and in Greek and Roman antiquity. As in Italy, the North was a center of commerce and had a growing mercantile class. The Netherlandish affinity for nature can be seen in Pieter Bruegel the Elder's cycle of six paintings of 1565 depicting the seasons of the year, which reveals his sympathy with everyday life and work. One painting in the cycle, *The Harvesters* (**Plate 8**), represents peasants in late summer working and relaxing, eating and drinking. The predominance of rich yellows warms the atmosphere, with rows of wheat occupying the foreground and human figures moving freely in three-dimensional space. Beyond the wheat field in the middle ground is a sharp spatial thrust into a distant landscape, the sea, and the horizon.

Baroque style in the seventeenth century

In Catholic countries during the seventeenth century the impact of the Counter-Reformation can be seen in the emotional spirit and iconography of art commissioned by the Church. One such

work is Gian Lorenzo Bernini's *St Longinus*, which is located on a pedestal under the dome of St Peter's Basilica in Rome (**Figure 21**). Longinus, the Roman soldier who pierced Jesus' side with his lance while he was on the Cross, is shown here in the act of renouncing paganism and embracing Christianity. His outstretched arms form a broad diagonal and his gaze is directed toward the monumental dome of St Peter's. His pose echoes that

Figure 21 Gian Lorenzo Bernini, *Saint Longinus*, 1635–8, marble, approx. 14 ft 6 in. (4.40 m) high. Saint Peter's Basilica, Rome, Italy. (Source: Use the Force/Wikimedia Commons)

of Jesus on the Cross, evoking the viewer's identification with the suffering of martyrdom. Longinus extends his lance to his right while at his left foot is the Roman helmet he has rejected along with his pagan past. The deeply carved, agitated folds of his robe, the animation of his hair and beard, and the taut musculature reveal the saint's inner turmoil at the moment of conversion. The psychological drama conveyed by Bernini, together with the mystical, emotional power of Longinus, is characteristic of Baroque style and also satisfies the requirements of the Council of Trent.

Despite the influence of the Council of Trent, even in Catholic countries patronage was not confined to the Church. The courts of Louis XIV at Versailles, south of Paris, and of Philip IV of Spain were major centers of artistic activity. These kings were absolute monarchs ruling by divine right and they commissioned works of art depicting Christian as well as mythological subject matter. In either case, the iconography of the art they commissioned was designed to demonstrate their political power and aesthetic taste, as well as their piety.

The often secular content of royal Spanish and French art in the Baroque period notwithstanding, Protestant countries were more likely than Catholic countries to commission secular works. Religious subjects tended to be the personal choice of an artist or a private patron than of the Protestant Church, which generally preferred less ornamentation than the Catholic Church. In Protestant Holland, the leading Baroque painter, Rembrandt van Rijn, depicted landscapes, Greek and Roman mythology, and Christian scenes; but he was best known for individual and group portraits commissioned by private patrons or official organizations. He also painted many self-portraits, beginning at a young age and continuing to the end of his life. He thus produced a record of his own aging process, a kind of visual autobiography consistent with the Dutch proclivity for the observation of nature and for science.

In addition to paintings, Rembrandt produced many *etchings*, in which he used the print medium to create subtle textures and soft lights and darks. His *Self-Portrait with Hat and Hand on Hip* (**Figure 22**) was made when he was in his twenties, shortly after he moved from his native Leiden to Amsterdam. The artist shows himself as jaunty, self-confident, well-dressed, and prosperous. Accentuating his figure is the glow of light around him where the paper is untouched by the *hatching* and *cross-hatching* marks of

Figure 22 Rembrandt, *Self-Portrait with Hat and Hand on Hip*, 1631–3, etching, 5.8 x 4.1 in. (48 x 130 mm). Rijksmuseum, Amsterdam, Holland.

the shaded areas. His face is half in darkness, his eyes are deeply set, and his expression appears somewhat pensive. He is the very image of a young man on the rise but perhaps uncertain of his future. Enhancing a sense of elegant flourish is the curvilinear flow of the hat, which is set at a diagonal and adds spatial movement to the self-portrait. The energy implied in the position and contours of the hat reflects both Rembrandt's mood and the dramatic flair often associated with Baroque style.

ETCHING

Etching is a printing technique designed to create multiple images from a single copper plate. The artist uses a stylus to draw through an acid-resistant substance covering the plate; the plate is then placed in acid, which eats away the parts of the copper that the artist has exposed. When the acid-resistant substance is wiped off, the artist inks the plate and makes an impression on a paper surface. The resulting image can convey a sense of energy and movement, as in Rembrandt's self-portrait. The slight blurring of his costume creates the impression of softly textured material and the fluidity of the technique contributes to the jaunty quality of the figure.

The eighteenth-century Age of Enlightenment

The nature of society changed during the course of the century that followed Baroque Europe, and these changes are reflected in art styles and in sources of patronage. The beginning of industrialization during the eighteenth century opened up new possibilities for large segments of society, and social and political philosophers concerned themselves with opportunities for better living conditions for workers. In this context 'Enlightenment'

refers to a new interest in human rights and social progress, as well as in science, leading to the period that would become known as the Age of Enlightenment. In art, revival styles reflected an awareness of the past; paintings depicting everyday life gave rise to a new kind of realism, a renewed sense of Christian spirituality inspired a Gothic revival, and excavations at the ancient Roman towns of Pompeii and Herculaneum revived a taste for antiquity.

There was also a shift in patronage during the eighteenth century. The powerful courts of the seventeenth century were no longer the art centers they had been. Now intellectual activity revolved around the Paris Salon, a private house belonging to a wealthy individual – often a woman – where artists, writers, philosophers, and scientists gathered to exchange ideas and socialize in an elegant ambience. The new passion for social change, fueled by growing opposition to the abuses of traditional absolute monarchy, culminated in two revolutionary wars – one in America in 1776 and the other in France in 1789. Revolutionary sentiment on both continents was inspired by the ideals of the Athenian democracy and the Roman republic and opposed the tradition of the divine right of kings.

In France, as in America, the style that was associated with the desire to establish democratic governments and to topple monarchy was the Neoclassical style. A work that has been interpreted as a prelude to the French Revolution, Jacques-Louis David's *Oath of the Horatii* (**Figure 23**) exemplifies Neoclassicism, which was in part a revival of ancient Greek and Roman subject matter and Classical clarity of form. David's *Oath* was ironically commissioned by Louis XVI, the unpopular French king who was beheaded in 1793. The story of the *Oath*, which had been the subject of a play by the seventeenth-century French author Pierre Corneille, is based on a Roman legend in which two sets of triplets agree to single combat rather than all-out war. Here, one set of triplets, the Horatii, swears allegiance to Rome as their

Figure 23 Jacques-Louis David, *Oath of the Horatii*, c.1785, oil on canvas, 10 ft 8 ¼ in. x 14 ft (3.26 x 4.27 m). Musée du Louvre, Paris, France. (Source: Wikimedia Commons)

father raises their swords. At the right is a group of swooning female relatives of both factions, bewailing the fact that some of them will lose their loved ones. The revival of antiquity, implied in the very name of the style, is evident in the Roman dress of the figures, the stoicism of the soldiers whose poses create a series of forceful diagonals and sturdy pyramidal forms, and the architecture. David has set the scene in a clear, three-dimensional space, which contains a triple round arch reminiscent of Roman triumphal arches and columns in the Doric Order.

The Neoclassical style overlapped the turn of the next century, when it was adopted by Napoleon Bonaparte. Although he

rose to power claiming to support the French Revolution, Napoleon changed his political course and crowned himself emperor of France in 1804. He thus diverted the original Neoclassical revival from its republican inspiration to a reflection of his own imperial ambitions, and he set about commissioning works of art inspired by ancient Rome for this purpose. For example, at the center of the Place Vendôme in Paris, he had a monumental, freestanding single bronze column constructed to celebrate his victory over the Prussians. Inspired in form and content by imperial Roman marble columns, Napoleon's column was made of the melted-down artillery captured from his defeated enemy. Napoleon also adapted the triumphal arch, a version of which appears in the background of David's *Oath of the Horatii*. Napoleon's Arc de Triomphe, commissioned in 1806 for the Place de l'Étoile in Paris, was intended, like his Vendôme Column, to show the legitimacy of his identification with the Roman emperors. The theme of the triumphal arch has persisted in Western consciousness, as seen, for example, in London's Marble Arch and in New York's Washington Square.

In colonial America, opposition to foreign rule by the unsympathetic English king, George III, in the late eighteenth century also culminated in revolution. As in France, the styles of ancient Greece and Rome became an inspiration for a new art style as well as for a new government. This was the conception of Thomas Jefferson, the framer of American democracy and principal draftsman of the United States Constitution. An architect as well as a statesman, Jefferson developed the Federal Style, the American version of Neoclassicism. During his tenure as ambassador to France, Jefferson collected Neoclassical sculptures and traveled to Rome, studying ancient ruins. His own buildings – notably Monticello (his home near Charlottesville, Virginia), the Rotonda and other buildings at the University of Virginia, and the Virginia State Capitol in Richmond – were influenced by Greek and Roman architecture.

The nineteenth century: a parade of stylistic 'isms'

In the nineteenth century, Paris was the center of the Western art world and remained so for over a century. It was a city of political, social, and artistic transformation, with art styles developing more rapidly than ever before and overlapping each other in time. These styles mirrored ongoing cultural developments as each subsequent generation of artists responded to new preoccupations and sought original approaches to creating works of art.

Neoclassicism in Western Europe and the United States was followed by the Romantic Movement, which flourished from the late eighteenth through the mid-nineteenth century. It encompassed developments in art, music, and literature. Romanticism was not so much a formal style as a philosophical point of view that aspired to an aesthetic taste for atmospheric landscapes, the past, and distant, exotic locales. The attraction to the exotic can be seen in the imagery of Orientalism, in which artists were drawn to North Africa and the East. This inspired paintings of Moors, odalisques, and Arabic architecture.

Politically, the Romantics identified with freedom and the rights of the individual. Embodying this ideal in France is Eugène Delacroix's *Liberty Leading the People* of 1830 (**Plate 9**). Painted during the rebellion of July 1830 against the French monarchy (which had been restored after the 1789 revolution), the work represents people from all walks of life joining the uprising. Towering over those who have taken up arms is Liberty herself, a partially nude allegorical figure who raises the French flag and rallies her followers against tyranny. Spreading across the sky behind her is the smoke of gunfire, through which the Paris skyline is dimly visible in the distance. The expansive character of the figures, with their broad diagonals and forward movement, is consistent with the dynamic application of paint that combines the clear edges of *silhouetted* forms with the hazy textures of the background.

The Romantic interest in social justice inspired anti-slavery imagery. One of the most famous examples of this is Turner's *Slave Ship*, exhibited in London in 1840. In that painting, the passionate depiction of nature – the swirling sea, the sunset, the vivid color and visible brushwork – is typical of Romanticism. Turner revealed his opposition to the slave trade by his depiction of the slaves, thrown overboard to make a profit on insurance, struggling to survive. The painting is not only an emotionally charged political image in defense of human rights, but also of the theme of man against nature that is characteristic of the Romantic Movement.

Realism, which became a significant art style around the middle of the nineteenth century, was concerned with the observation and depiction of everyday life and the social changes taking place at the time. The emergence of the style coincided with increased trade with Japan, beginning in 1853, and with the growing popularity of Japanese woodblock prints of the Edo Period.

EDO AND THE ART OF UKIYO-E

Beginning in 1853, Japan was forced to end its isolation and begin trading with the West. This led Western artists to develop contacts with the Japanese school of woodblock artists from the Edo Period (1600–1868). A woodblock print is made by creating individual blocks for each color shape, carefully matching their outlines, and printing them on a paper surface. The most important woodblock printers in Japan were the artists of the Ukiyo-e (literally, 'the floating world') school. Ukiyo-e refers to the world of entertainment: theater, music, dance, and erotica. In Europe, during the nineteenth century, artists were attracted to similar subject matter and many collected woodblock prints. Aspects of Ukiyo-e style, such as patterning, scenes of everyday life, and showing the effects of natural light at different times of day, in different seasons, and in different weather conditions, also inspired artists in the West.

A painting that has become an icon of nineteenth-century French Realism is Édouard Manet's *Olympia* (**Plate 10**), first exhibited in Paris in 1865 when it caused a huge scandal for its frank representation of a prostitute. By virtue of the title, the artist thumbed his nose at the Classical tradition and confronted the French public with an image of contemporary reality. The nude, who is receiving flowers sent by a male client, stares directly out of the picture and challenges viewers to look at a segment of society that many would have preferred to keep out of sight. Furthermore, although Olympia is based on Renaissance reclining nudes, her proportions are not Classical – she is rather thin and bony – her bed is somewhat rumpled, and she is literally 'up front' in her placement within the picture.

Photography was another new influence on Western art in the nineteenth century, and one that was related to Realism in that it could be used to document social conditions. Social ideas inherent in Realism also influenced architecture in the second half of the nineteenth century. Many such ideas became reality with technological advances that changed the nature of structural types. Prefabrication, first used in the Crystal Palace in London, made building more rapid and less expensive; the use of wrought iron led to such structures as the Eiffel Tower in Paris; steel cables were used in suspension bridges – for example, the Brooklyn Bridge in New York; and the invention of the elevator and the use of steel-frame construction made tall buildings a practical reality. At the end of the nineteenth century, in and around Chicago, the first skyscrapers, pioneered by Louis Sullivan, appeared on the urban scene. Sullivan's view that in architecture 'form follows function' expressed the notion that the form or style of a building should depend on how the building will be used.

Realism was followed by Impressionism, which emerged in France during the 1860s. Impressionists, like Realists, painted scenes of everyday life, but they were more interested in leisure

and entertainment. They changed the way painters approached their subjects, often leaving their studios to paint outdoors – hence the term *plein air* (outdoor) painting sometimes used to describe Impressionism. The Impressionist interest in the reality of light and color and in depicting things the way they are actually seen partly supplanted the Realist preoccupation with social class.

Claude Monet's *Impression: Sunrise* (**Plate 11**), which depicts the port of his native Le Havre, is the origin of the name of the style. Originally a pejorative term, 'Impressionism' was used by critics to convey the view that Impressionist artists carelessly applied their first 'impressions' to the canvas without the clear forms and advance planning of earlier styles, particularly Neoclassicism. Monet's painting did in fact embody a new style that took a generation to catch on. It has a wider range of color than the *Olympia* and reflects an interest in outdoor light at a particular time of day. The haze and the distant smokestacks allude to the Industrial Revolution. Monet has thus created a sense of transition, both in society and in the time of day. With the shifting character of his brushstrokes, he conveys the passage of time from night to day and from a pre-industrial society to an industrial one. Monet's use of so-called broken color in the sun's reflection captures the slow, horizontal motion of the water; and the wash effect of the oranges in the sky echoes the colors of the sun and the water. For the first time in Western art, the Impressionist style presented viewers with the material of paint as an aspect of a work's content.

Post-Impressionism began in the late 1870s, roughly a gen-eration after the emergence of Impressionism, and continued to depict similar subjects – entertainment scenes, scenes of leisure, street scenes, portraits, and landscapes, as well as references to industry. The brushstrokes are prominent and often quite distinc-tive; but, in contrast to the Impressionists, Post-Impressionists imposed more structure on their forms. The surface of van Gogh's

famous *Starry Night* (**Plate 12**), for example, is filled with thick, dynamic, curved, and spiraling brushstrokes, but they do not blend, as Monet's do. Each form is distinct and its energy bound by a clear edge. The result is a more monumental character than that of *Impression: Sunrise*, which has the leisurely quality of the sun gradually rising over the slow-moving waters of the port.

From Cézanne to Modernism: the turn of the twentieth century

Paul Cézanne was the Post-Impressionist painter who, as Roger Fry and Clive Bell predicted, had the most profound influence on early twentieth-century art. At first his pictures were dark and often depicted violent scenes; but, after meeting the Impressionists, he changed during the 1870s to bright color, and invented a new concept of pictorial space. He used broken color arranged into rectangular brushstrokes, giving his surfaces the appearance of having been constructed out of solid forms – hence the term 'constructive brushstroke', used to describe his characteristic handling of paint. Cézanne thought of his work as an accurate portrayal of nature, which he described in geometric terms as consisting of a 'cone, a sphere, and a cylinder'. One subject that he painted many times was Mont Sainte-Victoire, the mountain visible from his studio in Aix-en-Provence (**Plate 13**). If we compare this version of Mont Sainte-Victoire with Botticelli's *Birth of Venus* (see **Plate 7**), we recognize that the Renaissance picture is conceived of as a window, through which we see nature as relatively stable, with clear edges and precise form. In contrast, Monet's *Impression: Sunrise* depicts the changing character of nature with fluid, visible brushstrokes, and Cézanne's picture seems to have been constructed from solid blocks of paint.

Post-Impressionism, as is evident in the work of van Gogh and Cézanne, combined structure with prominent, colorful

paint texture. These two aspects of painting recur in the early twentieth century in two major trends – Expressionism, which organized picture surfaces through the use of bright color and dynamic, visible brushstrokes, and Analytic Cubism, in which Cézanne's constructive brushstrokes evolved into a new way of representing space. Instead of the traditional use of air space – for example, the room in which the scene of the *Oath of the Horatii* (see **Figure 23**) takes place or the landscape in Botticelli's *Birth of Venus* – Cubists transformed space into solid geometric form.

Both of these early twentieth-century trends – Expressionist color and Cubist geometric space – were influenced by continuing contact with non-Western art. Just as Impressionists and Post-Impressionists had studied Far Eastern and South Pacific art, so the Expressionists and Cubists turned to Africa as well as to the South Pacific for new sources of inspiration.

THE INFLUENCE OF SOUTH PACIFIC AND AFRICAN ART ON THE AVANT-GARDE

By the end of the nineteenth century, Western artists had become familiar with non-Western art through colonization, travel, and international exhibitions held in Europe. Japanese prints and Chinese patterns appeared in Western art from the 1850s and 1860s. Toward the latter part of the century, the art of the South Pacific and Africa also began to make an impact on the West. Artists who assimilated forms from these cultures generally were part of the avant-garde – that is, they were at the forefront of stylistic innovation. Although Western artists did not necessarily understand the cultures whose forms they adopted, they were attracted by their unfamiliar, often geometric character, which suggested ways of breaking from the idealized Classical tradition. African art, in particular, appealed to the Cubists, and its influence can be seen in the geometric quality of Brancusi's *Mlle. Pogany* (see **Figure 2**).

1900 to the present: innovation and change

Among the major artists influenced by the exuberant, mood-creating color of Post-Impressionism were Henri Matisse, a pioneer of French Fauvism, in which color created form; the German Expressionists; and the Russian Vassily Kandinsky, who is the first known artist to have created works that are entirely non-figurative. The youthful work of the Spanish artist Pablo Picasso, who moved to Paris as a young man, also reflects the trend, with his early Blue and Rose Periods (1901–3 and 1903–6 respectively). The blue tones of the former created a depressive mood; the later pictures, composed mainly of rose colors, created a more optimistic mood.

In 1907, Picasso radically changed his style and produced his ground-breaking proto-Cubist work, *The Women of Avignon* (**Plate 14**), in which he departed from mood created by color and introduced a new concept of space and distorted human form. Five prostitutes and a still life of fruit are represented as geometric structures composed of angular shapes and sharp edges. The features of the women have been disrupted so that their faces are not symmetrical as they appear to be in nature; the two at the right show the influence of geometric African masks. The foreground table top supporting pieces of fruit tilts, defying the laws of gravity, and the background air space is solidified and broken into abstract shapes. Picasso shows the seated figure at the lower right from the front and back simultaneously, thereby altering the way one would perceive her in reality.

Picasso's new compositional approach, influenced by the spatial structures of Cézanne, led to the development of two new techniques, namely *collage* and *assemblage*. In collage, lightweight materials, especially paper, are cut up, rearranged, and pasted to a surface; in assemblage, heavier materials and objects are assembled and attached to each other to create a sculpture.

In both techniques an artist might make use of everyday objects as well as more traditional materials such as paint, charcoal, or bronze. And in both collage and assemblage, the representation of space, as in Cubism, no longer adheres to the traditional distinction between foreground and background.

Perhaps Picasso's most famous assemblage is his *Bull's Head* of 1943, which is composed of a bicycle seat and handle bars cast in bronze. Characteristic of his imagination and visual wit, Picasso detached the seat and handlebars from the bicycle, turned around the seat, and attached it to the handle bars. The resulting image, which resembles the head of a bull, also has the geometric quality and elongated facial form of certain African masks.

As in the nineteenth century, artists in the twentieth century produced a procession of styles, but at an even greater pace. With the increase in technology, in the speed of communication, and in new types of artistic media, styles evolved more quickly than ever before. Today, with the internet, those changes are ever more rapid. Computer technology, which has made much of the world into a digital universe, generated video-based digital art.

Cubism evolved into Futurism, which glorified the energy of machines and industry and for a time appealed to the Fascist movement in Italy. Dada developed partly as a protest against the destruction of World War I and, like Surrealism, was influenced by developments in psychoanalysis, especially Sigmund Freud's analysis of puns, jokes, and dream symbolism. Duchamp invented the Readymade and the Readymade Aided, regional styles emerged in different parts of the United States, and in the 1920s Alain Locke, the leading philosopher of the Harlem Renaissance in New York, encouraged black artists to draw on their African heritage.

With the onset of World War II, many artists left Europe and emigrated to the United States. The center of the Western art world shifted from Paris to New York, where artists from Europe and America gathered to form the New York School of painting

and developed the Abstract Expressionist style. Jackson Pollock's *Convergence* (**Plate 1**) is a classic example of Abstract Expressionism, which took the spatial revolution of Cubism to an extreme. The very notion of foreground and background seems to have disappeared as the paint weaves in and out of itself. On occasion, Pollock trimmed the edges of his canvases to create an impression of paint flowing in and out of the work, thus expanding the potential space and heightening the illusion of movement. In *Convergence*, he placed the canvas on the floor of his studio in The Springs, on Long Island, and moved around the canvas as he applied the paint. In so doing, he allowed the paint to extend past the edges of the canvas to create the same effect of dynamic movement. Today, the Springs studio is a museum, and the paint that dripped past the canvas onto the floor remains where Pollock left it − a painted frame without its canvas surface or the final image.

The reaction against Abstract Expressionism descended on the art world in the late 1950s and 1960s in the form of Pop Art. Artists returned to the object with a vengeance, particularly to American icons such as the United States flag and comic book characters such as Superman, Mickey Mouse, and Donald Duck, as well as to celebrities such as Elvis Presley, Marilyn Monroe, Elizabeth Taylor, and Jacqueline Kennedy. The *Brillo Boxes* of Andy Warhol (**Plate 2**), whose flamboyant personality and unconventional behavior established him as an icon of the movement, were among the earliest Pop Art works. They reflected the appeal of consumer culture as a new subject of art, not only in the *Brillo Boxes*, but also in paintings of Campbell Soup cans, Coca-Cola bottles, and dollar bills.

The second half of the twentieth century witnessed a new round of styles, from Minimalism and Conceptualism to body art, performance, feminist art, graffiti art, installation, Post-Modern architecture − in which traditional styles were recombined in untraditional ways − and video and digital art. There was

also an increase in collaborative art projects – between artists and dancers, artists and poets – and in cross-cultural awareness that is manifest in the arts.

The Korean-born Nam June Paik, a pioneer of video art, worked with musicians, and created installations out of television monitors, fish tanks, and moving video. His *Piano Piece* of 1993 (**Plate 15**) is an installation consisting of a player-piano (a piano that plays automatically) and television monitors. Paik's piano plays music by John Cage, a friend and collaborator to whom Paik dedicated the work. Visible on the screens are images of the hands of Cage and Paik playing the piano and of Merce Cunningham, the modern dancer who also collaborated with Paik. In the top four monitors at the center, a digital disk triggers the program, which plays music by Richard Teitelbaum.

Paik has been called the 'father of video art' and, as such, he embodied a collaborative spirit between artists, musicians, and other performers working in new media that characterizes an important segment of contemporary art. Born in 1932, Paik left Korea to study in Tokyo and Berlin, where he became interested in the combinations that are typical of his work and of his international outlook. In 1964, at the age of thirty-two, he moved permanently to New York. By embracing new media, especially electronic media, which can rapidly disseminate images over the internet, Paik participated in, and to a great extent spearheaded, the trend toward globalization that influences all the arts today.

3
Origins of art

The question 'Where does art come from?' can be as vexing as the question 'What is art?' and it has been a subject of discussion by philosophers and poets, as well as by artists, for centuries. The issue can be approached from several different perspectives: the factual historical origins of art, the mythical origins of art, the artist's inspiration to create art, and the spaces, surfaces, and media that provide a context for works, as well as the materials from which to make the works. Although most would agree that the making of art requires giving aesthetic form to an idea that evokes a response by viewers – Victor Hugo's 'shudder' that Leo Steinberg discussed in connection with Pop Art – there is no such consensus on where art comes from. In fact, it comes from many different sources – depending on the talent, available materials, education, personality, and environment of the artist. This chapter will consider some of the real and mythic sources of artistic inspiration.

Discussions of the historical origins of art are dependent on the works that have survived, a group that itself depends on chance and circumstance. As far as one can tell, the earliest works of art date to the Paleolithic period and to the species *Homo sapiens*. Although recent research suggests that Neanderthal man mated with *Homo sapiens*, it appears that works of art were not produced by Neanderthals. However, as new prehistoric discoveries come to light, we continue to expand our knowledge of the earliest artistic history of the human race. The jury is still out on when and where art began from a purely historical point of view. As far as we know now, Paleolithic artists were the first to paint on rock surfaces and carve small-scale sculptures of humans and

animals, and Neolithic artists produced the first known examples of monumental stone architecture.

In ancient texts and legends, the historical and mythical origins of art are often intertwined. In the oldest surviving literary epic, the ancient Near Eastern *Epic of Gilgamesh* written around 3000 BC, the heroic act of Gilgamesh that ensured his fame was building the walls of the city of Uruk, in Mesopotamia. In ancient Egypt, tradition had it that the first person to build in stone was Imhotep, who designed the great step pyramid at Saqqara around 2600 BC. For this achievement Imhotep was worshiped as a god. The walls of Rome, according to legend, were built by Romulus and Remus, descendants of the Trojan hero Aeneas. Building in stone, which originated in the Neolithic period, is thus associated with heroic accomplishments and the founding of civilizations.

Mythical and legendary origins of art

Ancient Greece produced several origin myths involving the visual arts. Greek sources speak of the architect and sculptor Daedalus, who was known for his illusionistic skill. According to one account, Daedalus was the first architect. He reportedly built a maze on the island of Crete to conceal the monstrous Minotaur, who, as we saw in chapter 2, ritually caused the deaths of seven boys and seven girls from Athens each year. So complex and deceptive were the passages in the maze that once inside, it was impossible to find one's way out – until the Greek hero Theseus traced his route in with a ball of thread and could then escape, after killing the Minotaur. Another branch of the myth credits Daedalus with being the first sculptor; this tells the story of Daedalus fashioning wings out of wax for himself and his son, Icarus, so that they could fly out of the maze where they were held prisoner by the Minotaur. The wings were so effective that

Daedalus and Icarus succeeded in escaping, but Icarus failed to heed his father's warning not to fly too close to the sun. His wings melted and he drowned in the Aegean Sea.

Two other Greek myths that deal with the origins of art exemplify the human fascination with reflections and shadows in nature, the doubles of ourselves. The myth of the beautiful Greek youth Narcissus recounts the young man's obsession with his own image in a pool of water. So enamored was he of himself that he fell into the pool and drowned. The nymph Echo, who was in love with Narcissus, pined away until she became nothing more than a sound continually repeating itself. This myth inspired the fifteenth-century Renaissance art theorist Leon Battista Alberti to trace the origin of painting to seeing one's reflection. In this view, art comes partly from the natural environment and partly from the artist's 'narcissism'. We can see evidence of the fascination that reflections hold for us by watching young children when they first realize that what they see in a mirror is really themselves and not another child.

People are also fascinated by their own shadows, which are silhouetted rather than reflected self-images. The myth of the Corinthian maid describes the origin of sculpture as follows: a young woman from the Greek city of Corinth caught sight of her lover's shadow on a wall. She drew a line around the shadow and her father made it into a clay likeness. Both of these myths – one attributing the beginning of painting to reflections and the other attributing the beginning of sculpture to shadow – can be related to portraiture and self-portraiture, and the wish to pre-serve the likeness of someone. On this, too, Alberti had some-thing to say; he asked artists to include *his* likeness in their scenes so that he would live a long life in the cultural memory. In ancient Greece, the cultural memory was also preserved in likenesses of famous men and women; statues were made to honor the win-ners of Olympic Games and poetry contests, as well as military

heroes – a tradition we still see in the statues of important people occupying public spaces around the world.

In 1947, the American painter Barnett Newman stated the following about the origins of art, which he set in the mythical past of human history. 'Undoubtedly', he wrote, 'the first man was an artist'.[1] In Newman's view, art, like poetry, precedes utilitarian communication and defines what is human. Man, he declared, created 'an idol of mud before he fashioned an ax. Man's hand traced the stick through the mud to make a line before he learned to throw the stick as a javelin … The artistic act is man's personal birthright'.[2] In this notion of the nature of art, Newman approaches Denis Dutton's argument that art is inseparable from what is human. But Newman reverses his opening idea, which is the more expected and more traditional view that the first men were artists. He concludes instead that 'the artists are the first men',[3] which is a more profound philosophical idea.

Another 'origin' myth, invented by the nineteenth-century American artist James McNeill Whistler, describes the first artist as living in the prehistoric era. Whistler's first artist was a man who did not want to hunt with the other men. Instead, he stayed by the tents with the women and was fascinated by shapes arising in the fire. Using a stick, this first artist traced shapes in the ground, creating images rather than killing animals to survive.

In Whistler's account of the origins of art, fire creates images that inspired the first artist. This notion can be related to smith gods, such as the Greek Hephaestus, who was the god of the forge and, in myth, embodied the civilizing power of the arts. Whistler's association of the artist with women can, in turn, be related to the idea prevalent among artists that creating art is like giving birth. Indeed a number of artists have compared their work to children and some, like Whistler himself, acted as if their works *were* their children. On occasion, Whistler irritated the buyers of his work because he literally considered his paintings his, even after he had sold them. When the fourteenth-century

Italian artist Giotto di Bondone was asked how it was that his children were so ugly and his paintings so beautiful, tradition has his reply as follows: 'I create during the day but I procreate in the darkness of night'. And Michelangelo once said that he had no children because he made art instead, which approximates Kokoschka's view (see p. 2) comparing the process of making art to a peasant girl giving birth. This feeling that many artists describe of giving birth to a work of art confirms the sense that they conceive of them as created off-spring – born of the union of eye, hand, conception, and material. This notion also reflects the view of Freud, who wrote of the artist's heightened bisexuality – hence his ability to create.

Whistler does not tell us what kind of images his first artist made. But shapes found in nature or in the man-made environment need not be figurative. What the artist must do, according to Leonardo da Vinci, is take these shapes, which may occur in nature or on a wall, and transform them into art. To do so requires a kind of metaphorical thinking, which, according to Leonardo, is a talent characteristic of the visual artist. Leonardo compares the artist's mind to a mirror, thus bringing us back to the mythic origins of painting.

Leonardo's theory relating the artist's mind to a mirror is borne out by the work of many well-known artists whose art is readily associated with their personal experience. The twentieth-century Spanish artist Antoni Tapiès, for example, produced dark – often gray, black, and brown – images that resemble real walls damaged by gunshots or walls that are crumbling after being struck by grenades and bombs. Tapiès used sharp instruments to cut through the canvas, which he covered with thickly painted (*impasto*) or gravel surfaces. These were intended to evoke memories of the Spanish Civil War and executions of prisoners lined up in front of a wall. In a different vein, lively, figurative autobiographical urban street scenes populate the pictures of Romare Bearden, who recalled his childhood neighborhood in

colorful collages. Abstractions of nature appear in the work of the West Coast painter Richard Diebenkorn, who depicted vibrant expansive California landscapes and Pacific seascapes. He transformed the natural landscape into broad rectangular shapes and textured brushstrokes. Abstractions of nature in a different context can be seen in Islamic architecture, since the Qur'an forbids human and animal figures in religious art – hence the dynamic floral and foliate patterns on the domes of many mosques.

Personal origins of art

Inspiration for art comes from many sources. Aristotle wrote of the pleasure produced by a good imitation, locating inspiration in a drive on the part of artists to produce an accurate likeness. For Giorgio Vasari, the sixteenth-century biographer of Italian Renaissance artists, art was divinely inspired; he called Michelangelo *il divino* (the divine one) and he wrote that Raphael, Michelangelo's contemporary and rival, was, like Jesus, 'born under a star'. For Kant, art was also divinely inspired; for the eighteenth-century British philosopher Edmund Burke, art had a sublime quality that was both exhilarating and terrifying; and for nineteenth-century Romantic poets such as Wordsworth and Coleridge, art was inspired by the sublime in nature. For the twentieth-century German philosopher Martin Heidegger, art sprang from the soil and the physical environment of the artist. But for Freud, creativity was essentially unanalysable, and the psychoanalyst had to 'lay down his arms' when confronted with the mystery of artistic genius.

Origins of the artistic impulse

One has only to observe children to realize that the wish to create images is innate. Children will make marks on any available

surface as long as they are permitted to do so. Although most adult artists are formally trained, some are self-taught. Among the best known self-taught artists are the twentieth-century Americans Grandma Moses (Anna Mary Robertson) and Horace Pippin, the Dutch artist Vincent van Gogh (who attended art school only briefly), and the French customs official Henri Rousseau, who was a Sunday painter until he retired to paint full-time.

The wish to make an image, like the wish to compose music, write fiction, or perform, is primarily a desire to communicate – usually to an audience. People make art to express emotions such as love, fear, anger, protest, and so forth. Their choice of what to create can be individual, or influenced by the requirements of a *patron* (someone who commissions art). During the Italian Renaissance most works of art were made on commission according to a written contract, mainly for courts, wealthy individuals, or authorities of the Church, including the popes. Leonardo's *Belle Ferronière* (see **Figure 4**) is thought to have been commissioned by Lodovico il Moro, the duke of Milan, and to represent one of his young mistresses. Rembrandt also worked on commission, particularly when painting portraits of individuals or group portraits for organizations. He tried to capitalize on the name he had established for himself, selling self-portraits and other works on a speculative basis for their value as 'Rembrandts'. Architects almost always work on commission, since the nature of their work requires not only a sizeable investment but usually is needed to serve a public purpose. They are not alone as artists influenced by their environment: the natural environment has inspired landscapes and seascapes, while the growth of cities has led to images of urban life. Religion, myth, visions, and dreams have motivated spiritual, imaginary, and psychological images. Botticelli's *Birth of Venus* (see **Plate 7**) illustrates a well-known Greek myth with both a landscape and a seascape in the background. Since Venus was born from the sea, the scene of her

floating ashore on a shell has become conventional. Van Gogh's *Starry Night* (see **Plate 12**) is a dream-like vision of a Dutch town with a turbulent sky, in which the painted environment reflects both an observed reality and an inner state of mind, or emotional landscape. Romare Bearden's colorful depictions of his childhood environment portray the lively, crowded energy of his African-American neighborhood.

In the case of architecture, especially religious architecture, the site can assume an important role in the decision to build. For example, the Parthenon was located on the Acropolis, a fortified elevated site, as a tribute to the triumph of Greek Classical civilization. Most Gothic cathedrals were also built on a high point in a town, where they could be seen from great distances. Stonehenge almost certainly was inspired by some form of ritual, but without written records we cannot be sure what its exact purpose was. Its setting on a flat plain and its original circular mound suggest a significant religious idea.

Materials and surfaces of art

Works of art are physical products, even if sometimes temporary or not made to last, and as such the materials (*media*) and surfaces of art are an integral part of the work. They naturally depend on what is available to a given artist, and over time the range of media used, and their significance, has expanded. In 1948, the Abstract Expressionist painter Hans Hofmann said about the artist's material: 'The medium becomes the work of art, but only when the artist is intuitive and at the same time masters its essential nature and the principles which govern it'.[4] And in the opinion of the American sculptor and art critic Sidney Geist, the choice of medium is determined by its meaning for the individual artist.

The surfaces used by artists, like the media, vary enormously and these, too, can have symbolic meaning. Among the earliest

material used by the Paleolithic sculptors, for example, was stone, from which small figures, such as the limestone *Venus of Willendorf* (see **Figure 6**), were carved. Paleolithic painters used natural earth pigments, ground them to a powder, and mixed them with a liquid to make paint, which they applied to cave walls. Stone architecture predating the Neolithic period has not been found, but there is evidence of structures made of bones and before that structures were probably made of animal skins. One meaning of stone building, like the stone statues of ancient kings, was that it would last and thus was associated with eternity. But it is not known whether Paleolithic media had specific significance for their artists or whether they were used simply because they were available. Nevertheless, we can assume that, because the Paleolithic paintings are generally located deep within cave complexes and because there is evidence that ritual dancing took place in the vicinity of the paintings, the site of the images had symbolic meaning.

Starting in the Bronze Age, which began around 1500 BC in Western Europe and earlier in the ancient Near East and Egypt, artists made works out of metal. Gold was the most precious metal and in royal art it conveyed the wealth and power of kings. Egyptian pyramids were capped with gold and gold rays imitating those of the sun descended the side walls and identified the pharaoh with the sun god. Similarly, the typical backgrounds of Byzantine mosaics were composed of small gold tiles (*tesserae*) – as in the *Court of Justinian* – which were tilted slightly to increase the intensity of the gold light signifying God's presence inside the church.

For Michelangelo and Bernini, marble was the preferred material because it endowed their statues with a sense of heroic strength. Brancusi used both marble and bronze for his sculptures and he polished them, as well as other stone materials and wood, to a high degree of shine. But bronze had a particularly personal meaning for Brancusi because with enough polishing it can shine like gold. To Brancusi, this transformation was a kind of

alchemy – on one occasion he actually depicted himself as an alchemist – in which the process of creating art metaphorically transmutes base materials into precious objects.

Painting, like sculpture, has a long history, beginning with cave art. Later civilizations painted on architectural walls, and the meaning of the pictures varied with the nature of the building and its inhabitants. In Egypt, painters used a type of water-based paint called *fresco secco* (dry fresco), which they applied to the walls and ceilings of pyramid chambers, temples, and palaces. The Egyptian tomb paintings depicted a variety of subjects, from the journey of the deceased to the next world to scenes of every-day life. Because of the dry climate and the fact that the tombs were sealed, many of these paintings are well preserved. In the Aegean civilizations, a new type of fresco, *buon* (or true) *fresco*, was developed which bonded with the wall and was thus more durable than *fresco secco*. In *buon fresco*, paint is applied to damp limestone and absorbed into the surface of the wall as it dries. On Crete, wall paintings at the Palace of Knossos illustrated religious rituals as well as landscape forms and scenes inspired by the sea, on which the culture depended for much of its food and protection from invasion. In ancient Rome and nearby Pompeii, middle- and upper-middle-class houses were decorated with frescoed wall paintings of ancestors, perspectival landscapes, and architectural vistas, as well as mythological events. With the development of Christianity and its expansion throughout Western Europe, the walls of cathedrals, churches, and chapels provided surfaces for paintings (and sculptures) that transmitted the Christian message to worshippers.

Another popular type of ancient paint medium was *encaustic*, which was made by mixing pigment with hot beeswax and burning it into a surface. Mummy cases from Hellenistic Egypt were often painted with encaustic to produce a startlingly life-like portrait of the deceased. These pictures were brighter than fresco, because of the rich texture created by the wax. Encaustic was also

used to paint the Greek statues that we are used to seeing in white marble; originally they, too, were given a lifelike appearance by the addition of vivid color.

During the Middle Ages and Renaissance, in addition to fresco, artists used *tempera* (a water-based paint thickened with egg yolk) for painting on wood panel. Tempera, like encaustic, creates rich color and was the preferred medium for altarpieces, but it can take a long time to dry. Another medieval and Renaissance use of tempera was for illuminated manuscripts, usually made by monks and nuns. These were pages of a Christian text, often the Bible, which was decorated with richly colored, imaginative images designed to glorify the Word of God. In Islam, as well, artists illuminated the Word of God with ink, gold, and paint in the calligraphic pages of the Qur'an, but, instead of figurative images, Islamic artists used highly decorative letters and words to embellish their texts.

By the later fifteenth century, canvas began to replace wood panel as the preferred surface for a painting. Oil paint, which dries slowly like tempera, but produces richer color than either tempera or fresco, is typically applied to canvas. But it did not become widely used until the fifteenth century in the Netherlands and the sixteenth century in Italy. Oil can be applied thickly or thinly, depending on the effect an artist wants to create. In the case of Bruegel's *The Harvesters* (see **Plate 8**), the canvas would have been placed on an easel, and the paint – like tempera and fresco – applied with a brush.

Painting is not the only form of picture-making. Artists also draw and make prints, which are multiples of an image. Drawing is generally more linear than painting and made with more pointed instruments, such as pens, pencils, and crayons, than brushes. Artists produce drawings that are finished works in their own right, but they also draw in preparation for a painting. Such drawings can be a window onto the artist's creative process, for they often reveal the visual planning for a final work.

LEONARDO'S *MADONNA AND CHILD WITH ST ANNE*

One famous example in which the artist changed his mind between the drawing and the final painting is Leonardo's *Madonna and Child with St Anne* (**Figure 25**). Today the painting is in the Louvre and the preparatory drawing (called a *cartoon*) (**Figure 24**) is in the National Gallery in London. Both the formal character of the two versions and their meaning differ in important ways. In the painting, for example, in addition to color, Leonardo has used the technique of *sfumato*, which creates a 'smoky' quality in the misty background. In the painting as well as in the drawing, Leonardo shows Mary posed rather uncomfortably on the knees of her mother and in both pictures the setting is a rocky landscape. But in the drawing the infant Jesus raises his right hand in a gesture of blessing over his second cousin, John the Baptist. John stands in a relaxed pose and gazes up at Jesus. In the painting, however, John has been removed. He has been replaced by a lamb, which Jesus mounts as he turns back to look at his mother. Clearly Leonardo rethought the arrangement of the figures and their relationship to each other.

Several explanations for the changes have been proposed, although there is no consensus as to their meaning. What can be said is that the lamb is a double symbol; it represents both Jesus as a sacrifice and stands for St John as one of his traditional *attributes* (identifying features). It is also the case that the nature of Mary has changed. In the drawing she is on the same level as her mother, who gazes at her with an odd, almost leering expression. In the painting, Mary leans forward so that her head is below Anne's, and she now reveals her ambivalent feelings about her son's future sacrifice. On the one hand, she seems to be urging him forward onto the lamb and, on the other, she could just as well be pulling him back. Jesus, too, has an ambivalent pose, for he is at once mounting the lamb and turning back toward his mother. St Anne, by contrast, is the more upright and stable of the figures, which is reinforced by the assertive gesture of placing her hand on her hip. Her formal parallel with the distant rocky mountains may associate her – like her grandson Jesus – with the future Church: the Rock of Ages. By altering the picture as he did, Leonardo reduced its specificity and created a mythic image of female power, psychological insight, and Christian meaning.

Figure 24 Leonardo da Vinci, Cartoon for the *Madonna and Christ with Saint Anne*, 1499–1500, charcoal, black and white chalk on tinted paper, 55.7 x 41.2 in. (141.5 x 104.6 cm). National Gallery, London, England. (Source: Wikimedia Commons)

Figure 25 Leonardo da Vinci, *Madonna and Child with Saint Anne*, c.1503–6, oil on wood, 5 ft 6 1/8 in. x 3 ft. 8 in. (1.68 x 1.12 m). Musée du Louvre, Paris, France. (Source: C 2RMF/Wikimedia Commons)

Etchings, such as Rembrandt's self-portrait in **Figure 22**, are made by covering a metal plate with an acid-resistant substance and scratching out the image with a sharp instrument. The earliest surviving examples of printed images date to ninth-century China, but many other print techniques have developed

since then. The advantage of printing is that it makes multiples of the same image available at lower cost than a unique drawing or painting. Among the types of prints developed since the Renaissance are *woodcuts* printed on paper, made with ink on wood; *linocuts*, made by cutting lines into linoleum; *engravings* on metal or wood and *lithographs* made by printing on stone, both of which are then transferred to paper.

Another type of picture-making appears in fiber art. *Tapestries*, for example, include images made by weaving. In the Middle Ages and Renaissance, tapestries were used to decorate castle and palace walls. The best-known medieval tapestries are the six Unicorn Tapestries, now in the Cluny Museum in Paris. They illustrate the legend of the Lady and the Unicorn on rich red and green backgrounds filled with foliage, fruit trees, forest animals, and heraldry. Five of the panels have been interpreted as an allegory of the five senses; the sixth panel, in which the Lady stands in a blue tent flanked by a heraldic rampant lion and unicorn, remains unexplained.

The so-called *Bayeux Tapestry* is actually an eleventh-century Romanesque *embroidery* over 230 feet (seventy metres) long. Commissioned by Bishop Odo of Bayeux, the work chronicles the Norman conquest of England in 1066 by William the Conqueror, Odo's half-brother. The artists, possibly women, 'drew' the scenes with colored wool threads on a linen surface. They illustrate battles, court scenes, and the Viking long boats that carried the Norman army across the English Channel. Figures and events are identified by accompanying text in Latin.

Images in glass were produced in the Middle Ages, the most spectacular being the stained glass windows of Gothic cathedrals. The medium of colored glass served symbolically to transform the interiors into a rich, divinely inspired space. This use of stained glass continues to the present day, especially in religious buildings. In the mid-twentieth century, Matisse created a set of

windows for the Dominican Chapel of the Rosary, in Saint-Paul de Vence, in the south of France. Matisse was not only a colorist throughout his life, but he also made collages of paper cutouts, which is essentially the same principle as creating sections of colored glass used in stained glass windows. His windows at Saint-Paul de Vence are composed of green and yellow foliate designs, which are abstractions of the Tree of Life described in the Bible, set into a dark blue background. The Russian-born artist Marc Chagall also made stained glass windows for, among others, Metz Cathedral in Germany, the Hadassah University synagogue clinic in Jerusalem, and the United Nations in New York.

Beginning in the nineteenth century, a wider range of media came into use. Still photography developed into moving film and was later largely replaced by digital images. Collage can be applied to almost any surface although it is usually applied to paper. Picasso used colored paper, charcoal, chair caning, and newspaper in many of his early collages. Later, in his assemblages, as we have seen, he used various materials, including a bicycle seat and handlebars. With the Readymades of Duchamp, urinals, bicycle wheels, kitchen stools, hat racks, and Kleenex boxes became art materials. The invention of plastic led to new kinds of paint, notably *acrylic*, which is easier to use than oil and richer in color and texture than water paint. In the work of the American Dan Flavin, fluorescent light fixtures became sculptural media, filling interior spaces with sprays of colored or white light. Minimalists used manufactured materials. Graffiti artists made images on subway walls or outdoor urban surfaces such as buildings and lampposts. 'Found objects', such as driftwood and natural stones, began to appeal to artists for their aesthetic form. Nature itself became both a material and a surface of art in the work of earth artists such as Robert Smithson, and the natural and urban environment inspired the vast installations of Christo and Jeanne-Claude.

Figure 26 Andy Goldsworthy, *Striding Arch*, 2008, 31 blocks of hand-dressed red sandstone, 4 meters high, span of 7 meters, 27 tons. Bail Hill, Moniaive, Dumfries and Galloway, Scotland. (© South West Images Scotland/Alamy)

The contemporary British artist Andy Goldsworthy creates outdoor installations out of such media as leaves, stones, wood, and ice. In the work shown in **Figure 26**, he created a traditional architectural form – the arch – and placed it upright in the landscape. But his arch stands alone, rather than being part of a larger structure, such as a wall, as is usually the case. Goldsworthy's arch frames a space, marks a section of landscape, and seems to grow from the earth, connecting it visually with the sky. It also has an organic quality, reflected in the title, *Striding Arch*, which conveys the impression that the arch is capable of motion. The fact that it is made of stone endows the arch with a more permanent character than some of Goldsworthy's other works made of leaves or

icicles, which he, like Christo and Jeanne-Claude, preserves in photographs.

Also preserved only in photographs are the Dada performances held during World War I at the Cabaret Voltaire in Zurich. Performance art, often created in protest against the Vietnam War, became popular in the United States during the 1960s. Subsequent performance art has expanded its content to include other forms of political, social, and racial protest.

It is largely because of the expansion of style, material, and art categories in the twentieth century that Arthur Danto pronounced art dead after Warhol. In his view, art is now infinite and cannot be considered art until it can be fitted into a theory. His views essentially deny the reasons why art is made in the first place, and he ignores the multifaceted sources of artistic inspiration. He also ignores the fact that the origins of art are found not only in ancient history, but also, as Denis Dutton points out, in the very fact of being human.

4

Form and meaning

In order to describe works of art, one must be able to match words to visual images. To do this, it is helpful to become familiar with certain terminology, which has been called the *language* of art. In this chapter we discuss two main categories of this language: formal terminology, describing the structure and composition of a work of art; and ways of interpreting meaning by reading the subject matter and themes of a work.

Structure and composition refer to the way artists approach a surface or a space and how they organize it. A painter, draftsman, printmaker, or photographer traditionally creates an image on a flat surface. A sculptor shapes material to form a three-dimensional image. Soft materials such as clay can be *modeled* with one's hands, whereas hard materials such as stone are carved with a sharp instrument. And an architect organizes existing space into a building that typically has one or more specific functions.

Line and plane

Line is a basic element of the artist's formal vocabulary; lines on a flat surface can enclose space, create an illusion of movement, of mass and volume, and of light and dark. They can also convey emotions. Think, for example, of facial expressions: upwardly curving lines can indicate cheerfulness, whereas downward curves can suggest sadness. Horizontal lines depicting features – eyes, nose, and mouth – suggest an impassive, unknowable expression, which could be referred to as inscrutable.

Plane refers to a flat surface that lies in a direction of space, which can result from the arrangement of a single line or of a group of lines. Floors of buildings usually form horizontal planes; walls are usually vertical planes; and a pitched roof is composed of diagonal planes. Rolling hills and ocean waves form curved planes. If we consider the lines and planes of space in Leonardo's anatomical drawing in **Figure 27**, we note that lines enclose the shapes of the top figure and define bone and muscle; the planes define broader directions of space. The figure seems to be bowing his head slightly, producing a diagonal plane of space in contrast to the horizontal direction of the shoulders. The diagonal creates an illusion of movement in the bowed head, while the diagonal muscles crisscross each other as they do in reality. The area left blank by the lines, such as the top of the head, appears light, but the heavy lines, at the neck and in between the muscles, appear dark. Where the changes from light to dark are gradual (or *shaded*), there is an appearance of mass and volume, as in the left shoulder. In Rembrandt's self-portrait etching (see **Figure 22**), the lines of the collar and the curl of the hat are formed into upwardly curving planes that convey the impression of an upbeat, optimistic mood even though the expression is somewhat pensive.

Since sculpture is three-dimensional, it does not contain lines in the same way that a picture does. What one might refer to as the outline of a sculpture is more properly a contour. Within the contour, individual elements, such as folds of clothing, facial features, and other surface details, may have a linear quality, depending on the artist's style. In the Mesopotamian statue of Gudea in **Figure 8,** for example, the designs on the robe, the flowing water of the vase, and the cuneiform inscriptions are made by *incising* lines into the surface of the stone with a sharp instrument. Similarly, the wing feathers, leg muscles, and body hair of the Assyrian lamassu (see **Figure 9**) are linear. We recognize what the shapes incised in the legs, wings, and body

Figure 27 Leonardo da Vinci, *Anatomical Studies of the Shoulder*, 1510–11, black chalk, pen, and ink on paper, 11 3/8 in. x 7 5/6 in. (289 x 199 mm). Royal Library, Windsor, England.

represent because of where they are located on the sculpture. But if we were to see those same shapes out of context, we would have no way of identifying them. Such surface details that do not conform to nature or appear organic are called *stylizations*, which are characteristic features of ancient Near Eastern art.

The plane of a sculpture leads our eye in a certain direction, depending on what the artist intends to convey. The *Gudea with a Vase*, like the *Beau Dieu* at Amiens (see **Figure 19**), occupies a vertical plane that emphasizes the regal composure of the figure. Myron's *Discus Thrower* (see **Figure 14**), on the other hand, creates a circular plane composed of two arcs that intersect at the neck. The plane is consistent with the round disk and base of the statue, as well as with the pivoting movement made by the athlete. As such, Myron's figure satisfies the Classical Greek ideal of unity in both form and character. The outstretched arms of Bernini's *St Longinus* (see **Figure 21**), as we have seen, create an expansive diagonal plane that echoes the pose of the crucified Jesus and seems to invite viewers into Longinus's experience of conversion to Christianity.

Line and plane in architecture resemble those in sculpture, though usually on a larger scale. In the Parthenon (see **Plate 4**), the overall plane is horizontal (although the columns are vertical), conveying a sense of stability and steadfastness. As a result, many later institutional structures, such as government buildings and banks (especially those of the American Federal style and of the French Neoclassical style), are designed to resemble Greek temple fronts in order to create the impression that the buildings, and by extension the ruling body and the depositors' money, respectively, are stable and safe. Conversely, the soaring vertical plane of the towers on the façade of Amiens Cathedral that carries our eye upward expresses the Christian desire to rise to heaven after death.

Space: real and illusory

In sculpture and architecture, three-dimensional space is real. The four buildings illustrated in this volume – Stonehenge, Khafre's pyramid at Giza, the Parthenon, and Amiens Cathedral – all contain actual interior space. The Mesopotamian ziggurat does not have enclosed interior space, but its stepped exterior creates open spaces visible from the outside.

In pictures, which exist on a flat surface, the impression of three-dimensional space is an illusion created by the artist. Several techniques can be used to create spatial illusions in pictures, the simplest of which is overlapping form. We can see the use of overlapping in the Byzantine *Court of Justinian* (see **Plate 5**), especially in the group of soldiers at the left. This technique creates the impression of a solid army supporting the emperor, who, with the archbishop Maximian, overlaps the figures on either side of him. By placing the emperor and the archbishop in front of the churchmen and the soldiers, the artist makes it clear that the former are the most important personages. They literally 'step on the toes' of the adjacent figures. Also contributing to the impression that Justinian and Maximian are in the front is the fact that they are larger than everyone else.

Bruegel's *The Harvesters* (see **Plate 8**) conveys a greater sense of natural three-dimensional space than the *Court of Justinian*, and this three-dimensionality is characteristic of Renaissance pictures. Around 1400 in Florence, Italy, a system of *linear perspective* was invented that expanded spatial illusion in pictures and made it possible for artists to determine mathematically the size of a figure or object in relation to its notional distance from the picture's surface. As a result, when we view a Renaissance picture, we have the impression that we are looking through a window onto the natural world. In Bruegel's painting, the peasants in the foreground at the right are the largest figures in the painting and they become progressively smaller as they approach the horizon.

Likewise, in the rows of harvested wheat, as well, the artist has made a conscious effort to depict spatial recession. And there is an abrupt shift in space from the elevated wheat field to the village and seascape below.

In Botticelli's Renaissance *Birth of Venus* (see **Plate 7**), the transition from foreground to background is more gradual than in *The Harvesters*, although we still have the impression that we are viewing the scene through a window. In addition to linear perspective, Botticelli makes use of another technique for showing three-dimensional space that is known as *atmospheric perspective* and is more often seen in Far Eastern than in Western art; as forms move into the distance, they begin to lose clarity. This is evident in the waves, which are clearly defined in the foreground, but begin to fade and disappear toward the horizon.

The Renaissance idea that a painting is a window began to change in the nineteenth century. With Impressionism, artists gradually shifted their painted spaces by slanting floors and other surfaces upward, so that the box-like, receding space of Renaissance pictures became progressively flattened. By the 1880s, Cézanne had revolutionized the depiction of space in painting, using his rectangular brushstrokes to transform air space into a solid geometric space that seems to be composed of shifting crystals. This led to the development of Cubism in the early twentieth century in Europe and the United States.

Open and closed space in sculpture

If we compare three sculptures – the *Gudea with a Vase*, Michelangelo's *David*, and Bernini's *St Longinus* – we can see the effect of actual open and closed space in a sculpture. Outside the contours of the *Gudea*, because of its frontality and rigid pose, there is virtually no open space aside from small areas on either side of the head. In other words, the *Gudea* would fit inside a

notional rectangle, leaving open only those two small spaces. The *David* would also fit inside such a notional rectangle, but it contains more open space. There is a closed triangle of space between David's legs and an open triangle under his bent left arm. There is open space above the shoulders and a long, irregular rectangular closed space between the right arm and the body. In contrast to the *Gudea*, the *David* turns his head and engages the viewer in the question of what he is looking at. In the *Longinus*, the diagonal planes of the arms and raised head expand the space and create a sense of energetic movement that is absent in the *Gudea* and the *David*. From these different uses of space, we have the impression of a steadfast, forceful ruler in Gudea, a watchful David, and a dynamic, expansive St Longinus.

Color and texture

Color is one of the most striking formal elements at an artist's disposal and it is an integral part of the natural world. Although very few traces of color remain on ancient Greek marble sculptures, they were painted – typically with encaustic – to enhance their lifelike quality. Duane Hanson's sculpture of the policeman illustrated in chapter 1 (see **Figure 3**) is shown wearing a uniform exactly like that of an actual policeman, and this contributes to the figure's convincingly real effect – and in contrast the absence of color on a sculpture usually gives it a more abstract appearance. Since we are so accustomed to seeing marble sculptures devoid of color, we mistakenly think of white marble as an ancient tradition. Even though a work such as Michelangelo's *David* was carved from a block of white marble and not painted, it is not likely to strike us as abstract. However, the abstract quality of Brancusi's marble *Mlle. Pogany* (see **Figure 2**) is readily apparent because, in addition to being white, its forms are geometric and have been simplified.

Color can also be a mood-creating element in a work of art. In everyday language, we sometimes speak of color as if it is equivalent to a mood – for example, blue Monday when we have to go back to work; a white night when we are unable to sleep; the green-eyed monster denotes envy; one who is yellow is a coward; a person who is furious might be called purple with rage; a red-hot mama is a woman who exudes sexuality; and so forth. In works of art, we tend to experience yellows, oranges, and reds as warm colors and blues and greens as cool colors. Black and white, technically speaking, are not colors; black is the absence of color and white is the combination of all colors. Thus when white light is passed through a prism it is broken up into the visible spectrum of seven colors – red, orange, yellow, green, blue, indigo (blue-violet) and violet – as happens when light passing through raindrops creates a rainbow.

Bruegel's *The Harvesters* is suffused with a warm yellow that corresponds to the color of the wheat, to the heat of midday, and to summer. The cool colors – especially the pale blues and greens – of Botticelli's *Birth of Venus* give the goddess a languid character; and the contrasting energetic quality of the cloak carried by the woman on shore is reinforced by its rich, reddish-pink color. Manet's *Olympia* contains harsher colors that create stark, light-dark contrasts, consistent with the aggressive character of the nude as the painting challenges the viewer to look at a segment of French society that most people would rather not have seen. Botticelli's figure of Venus, unlike Olympia, is removed from everyday reality and exists only in the distant realm of myth. In *Impression: Sunrise*, Monet creates a mood of passing, transitional time by blending his colors so that they literally seem to move with nature. The rich blues, greens, yellows, and browns of Cézanne's *Mont Sainte-Victoire* reinforce the sense of solid geometric form and space.

Color and light are often combined to create certain visual and emotional effects. For example, the light that enters Gothic cathedrals through the stained glass windows is transformed from

natural light to colored light. This transformation symbolizes the change from the material world to a spiritual world that is the aspiration of Christian worshippers. When the gold tesserae of mosaics reflect the interior light of Byzantine churches, the impression of a divine presence is created. In Nam June Paik's *Piano Piece*, light and color are electronically generated and are secular in nature. The animation created on the monitors focuses our attention and moves in sync with the digitally generated music.

In paintings, light and its effect on color can create an impression of flattened or three-dimensional form, depending on the artist's technique. The absence of shading in the Minoan *Bull-Leaping Fresco* (see **Figure 12**) creates the sense that light is evenly distributed across the surface of the picture. Aside from minimal overlapping, there is no illusion of depth, no use of chiaroscuro – and no visual distraction from the narrative flow – since the bull and the figures co-exist in a flat blue space. In Leonardo's *Belle Ferronière* (see **Figure 4**), however, there *is* shading – for example, on the woman's left cheek and left arm (our right). As a result, we have the impression that the figure exists in three-dimensional space and that the light enters the picture from our left.

Texture can be real or simulated. The paint texture of Leonardo's *Belle Ferronière* is actually smooth, but the color and shading create the illusion of real texture in the woman herself and in her dress. In van Gogh's *Starry Night* (see **Plate 12**), the paint is actually thick, and the brushstrokes stand out from the surface of the canvas. The physical texture of the painting reinforces its dynamism because it adds a third dimension that appeals to our sense of touch. Jackson Pollock's *Convergence* (see **Plate 1**) is another instance where the artist applies the paint so thickly that it stands out from the surface of the canvas. But rather than define and animate forms such as the sky, landscape, and village of *Starry Night*, Pollock eliminates recognizable objects, weaving

the paint in and out of itself so that texture becomes a primary feature of the picture's content.

Texture can also be an aspect of our experience of architecture and sculpture. In either case, texture may be determined by the culture that produces it, by the preference of an artist or patron, and by the nature of the materials used by the builder or sculptor. At Stonehenge (see **Figure 7**), the texture of the monoliths is rough, and the stones are unpolished, though they may have been shaped in order to insure that the uprights were equal in height. The roughness of the stone surfaces is characteristic of Neolithic architecture. Compare, for example, the precisely cut limestone blocks of the Giza pyramids, which were made possible by the more advanced engineering skill of Egyptian architects; and the gold caps reflect the fact that Old Kingdom Egypt had achieved skill in metal-working long before Western Europe. Similar differences can be seen in a comparison of the relatively rough surface of the *Venus of Willendorf* (see **Figure 6**) with the polished surface of the *Gudea with a Vase* (see **Figure 8**).

The composition of a work of art

The *composition* of a work of art refers to the way in which the formal elements are arranged. Among the principles of organization that comprise a work's composition are balance, pattern and rhythm, scale and proportion, and time and motion.

Pictures need balance in order to appear well-organized (formal balance). Sculptures and buildings have to be structurally balanced in order to stand up and formally balanced in order to be aesthetically pleasing. There are two main categories of balance: symmetry, in which the two sides of a work are mirror images (or near mirror images) of each other, and *asymmetry*, which is more complicated. Asymmetrical works are balanced by non-equivalent forms. The difference between these two types of

balance is apparent if we compare the statue of Gudea with Bernini's *St Longinus*. If we were to draw a vertical line through the center of the *Gudea*, we would find equivalent forms on either side of the line. But the same line drawn through the center of the *St Longinus* would leave us with greater weight on one side than on the other. The saint leans to his right (our left) and gazes upwards. He raises his right hand on an upward diagonal and holds the lance with which he pierced the side of Jesus. The resulting asymmetry of the pose is stabilized by the lance, which creates a closed triangle of space animated by curling drapery folds between it and Longinus's body. Leading our eye back to the saint's left (our right) is the downward diagonal of his left arm, which takes our gaze towards the Roman armor at his feet. By this shifting of form and space, in which one planar thrust compensates for another, Bernini achieves structural as well as formal balance, while also creating a sense of dynamic energy that is absent in the rigid tension of the relatively symmetrical *Gudea*.

Pattern and rhythm in a work of art reinforce each other and are often imbued with meaning. In the *Court of Justinian* (see **Plate 5**), the repetition of vertical figures in similarly attired groups creates a pattern that carries our gaze across the mosaic in a horizontal direction. At the same time, however, the larger central figure of Justinian arrests our gaze, emphasizing his literal centrality and power as emperor. At Amiens (see **Figure 18**), the upward planar movement of the façade that directs our gaze toward the heavens is reinforced by the verticality of the pointed arches and the patterns of carved surface details. The rose window at Chartres (see **Plate 6**) is filled with geometric shapes arranged in circular rhythmic patterns that carry our gaze around the inner central circle. This movement reinforces the Christian notion of Jesus as the center of the Church and the circle as representing the never-ending, universal character of the Church.

Plate 1 Jackson Pollock, *Convergence*, 1952, oil on canvas, framed: 95¼ x 157 1/8 x 2 7/8 in. (2.42 m x 3.99 m x 7.30 cm); support: 93½ x 155 in. (2.37 x 3.94 m). Albright-Knox Art Gallery, Buffalo, New York. (© Albright-Knox Gallery/Corbis)

Plate 2 Andy Warhol, *Brillo Soap Pads Boxes*, 1964, plywood boxes with serigraph and acrylic. Boxes 43.2 x 43.2 x 35.6 cm each. National Gallery of Canada, Toronto. (© Jaxpix/Alamy)

Plate 3 James Abbott McNeill Whistler, *Nocturne in Black and Gold: The Falling Rocket*, 1875, oil on panel, 23¾ x 18 3/8 in. (60.2 x 46.7 cm). Detroit Institute of Arts, Detroit, Michigan. (Source: Wikimedia Commons)

Plate 4 View of the east façade and a south wall of the Parthenon, 447–438 BC, marble. Architects: Iktinos and Kallikrates. Sculptor: Phidias. Athens, Greece. (© Sborisov/iStockphoto)

Plate 5 *Court of Justinian*, apse mosaic, Church of San Vitale, c.547. Ravenna, Italy. (Source: The Yorck Project/Wikimedia Commons)

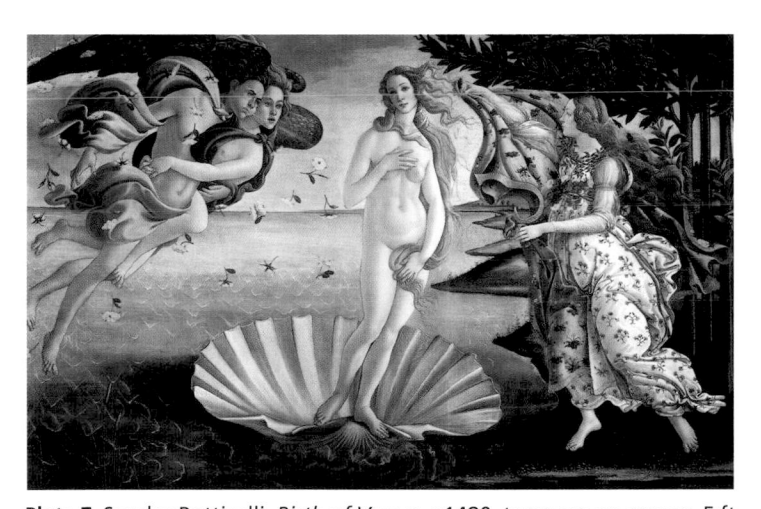

Plate 7 Sandro Botticelli, *Birth of Venus*, c.1480, tempera on canvas, 5 ft 8 in. x 9 ft 1 in. (1.73 x 2.77 m). Galleria degli Uffizi, Florence, Italy. (Source: Wikimedia Commons)

Plate 6 Rose window, north transept, Chartres Cathedral, thirteenth century. Chartres, France. (© St. Nick/Shutterstock.com)

Plate 8 Pieter Bruegel the Elder, *The Harvesters*, 1565, oil on panel, 46½ x 63¼ in. (1.18 x 1.61 m). Metropolitan Museum of Art, New York. (Source: Szilas/Wikimedia Commons).

Plate 9 Eugène Delacroix, *Liberty Leading the People*, 1830, oil on canvas, 8 ft 6 in. x 10 ft 7 in. (2.59 x 3.23 m). Musée du Louvre, Paris, France. (Source: Wikimedia Commons)

Plate 10 Édouard Manet, *Olympia*, 1865, oil on canvas, 4 ft 3 in. x 6 ft 3 in. (1.3 x 1.9 m). Musée d'Orsay, Paris, France. (Source: Wikimedia Commons)

Plate 11 Claude Monet, *Impression: Sunrise*, 1872, oil on canvas, 1 ft 7½ in. x 2 ft ½ in. (49.5 x 64.8 cm). Musée Marmottan, Paris, France. (Source: Wikimedia Commons).

Plate 12 Vincent van Gogh, *Starry Night*, 1889, oil on canvas, 28¾ x 36 ¼ in. (73 x 93 cm). Museum of Modern Art, New York. (Source: Google Art Project/Wikimedia Commons)

Plate 13 Paul Cézanne, *Mont Sainte-Victoire*, c.1900, oil on canvas, 30¼ x 39 in. (78 x 99 cm). Hermitage Museum, Saint Petersburg, Russia. (Source: The Yorck Project/Wikimedia Commons)

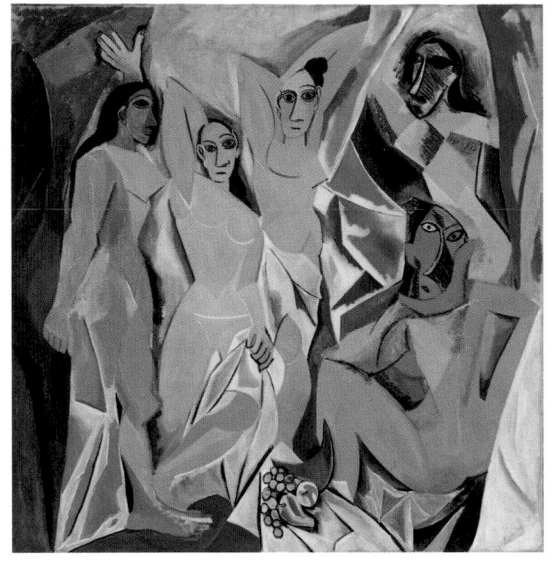

Plate 14 Pablo Picasso, *The Women of Avignon*, 1907, oil on canvas, 8 ft x 7 ft 8 in. (2.44 x 2.34 m). Museum of Modern Art, New York. (© Corbis)

Plate 15 Nam June Paik, *Piano Piece*, 1993, closed-circuit video sculpture, 120 x 84 x 48 in. Albright-Knox Gallery, Buffalo, New York. (© Albright-Knox Gallery/Corbis)

Scale and proportion can also have meaning in works of art. Compare, for example, the Roman sculptures of Augustus (see **Figure 16**) and Constantine (see **Figure 17**). Neither is small in scale, but the proportions of Constantine are many times those of Augustus. Although Augustus appears imposing and in command, he pales in comparison to the over-eight-foot-high head of Constantine. As viewers, we have a sense that we could communicate and identify with Augustus, but that Constantine is beyond our reach. In addition, whereas Augustus looks straight ahead toward his troops, Constantine seems to gaze upward. The difference reflects their relative grasp on political power. As the first emperor who took power during a period of political insecurity and widespread corruption and brought stability to Rome, Augustus wisely projected an image of himself as ruling in accordance with the wishes of his subjects and not as the tyrant that many Roman emperors became. Constantine was no tyrant, but in light of growing problems in Rome as Christianity encroached on the Western world and as the empire began to decline, he felt the need to represent himself on a super-human scale, as a figure of divine power.

There are several ways in which time and motion can be represented in works of art. With architecture, the viewer literally requires time to experience the spaces and solids of a building from the inside as well as from the outside. The same is true of many installations. A sculpture-in-the-round has to be viewed from all sides in order to be fully experienced. But pictures on a flat surface present themselves to viewers 'at a glance', even though a consideration of the work takes time.

A picture can represent a sequence of time in several frames as in a comic strip, in a series, or, if the image is within a single frame, time can be implied or condensed. In the Minoan *Bull-Leaping Fresco* (see **Figure 12**), time is implied in the forward motion of the bull as well as in the arrangement of human figures that suggests a sequence of movement. The white-skinned girl at

the left grabs the horns of the bull before beginning her somer-
sault; the dark-skinned boy at the center has already leapt over
the horns and is preparing to land in the arms of the girl waiting
behind the bull at the right. The energy (and danger) of their
action is reinforced by the diagonals of the bull's legs, his lowered
horns, and the curvilinear style of all the figures. In Botticelli's
Birth of Venus (see **Plate 7**), the goddess moves slowly forward,
toward the foreground shore, whereas the woman waiting with
the cloak rushes diagonally toward the sea and the arriving god-
dess. Unlike the Minoan figures moving *across* the surface of the
picture, Botticelli's figures seem to move back and forth, closer to
or farther from the picture's surface. To achieve this effect,
Botticelli had to create an illusion of three-dimensional space,
which, as we have seen, is characteristic of Renaissance style. In
Picasso's *Women of Avignon* (see **Plate 14**), and even more so as
Cubism developed, the illusion of space is altered by filling what
in nature is air space with solid geometric forms. This technique
allows the artist to depict the front, back, and side of a shape
simultaneously. We can see this in the squatting figure at the right;
Picasso shows us her back and face at the same time – an example
of what is called a simultaneous viewpoint.

In Christian art, a kind of symbolic time was created by using
the system of historical parallelism known as *typology*. For exam-
ple, in the *Court of Justinian* (see **Plate 5**), the Chi Rho on the
shield refers back in time to the reign of Constantine and earlier
still to Christ himself. The Chi Rho, in alluding to Christ's
monogram, reminds viewers of Justinian's divine right to rule
and shows him as continuing the line of Roman emperors. The
result is a kind of genealogical connection beginning with Jesus
and persisting beyond AD 313 when Constantine legalized
Christianity in Rome to the time of Justinian and the Byzantine
Empire. Genealogy is, of course, a significant feature of the Bible
and is especially prominent in the series of 'begats' in the opening
chapters of the Gospel of Matthew. When typology is used visu-
ally, it serves to condense time.

TYPOLOGY

Typology, literally a science of types, is essentially a form of Christian revisionist history designed to show that all of time is incorporated in the events preceding, following, and including the life of Jesus. In the typological system of history, figures and events of the Old Testament are paired with (or are types for) those of the New Testament and both are sometimes paired with later historical events. For example, Jesus is referred to in the New Testament as the New Adam and the New Solomon. Mary is the New Eve. The Old Testament story of Jonah who was swallowed by a whale and emerged after three days was seen as a prefiguration of the death and resurrection of Jesus three days after his entombment, as recounted in the New Testament. In Christian art, therefore, a scene in which Jonah emerges from the whale could be an allusion to the resurrection of Jesus, thus condensing the time span between the two events.

In the typological system, historical events could be paired with biblical events and were often connected with the development of the Church. Thus, in the fifteenth century, when the Byzantine patriarch John VIII Paleologus traveled to Italy to repair the East–West schism in the Church, his visit was compared with the Queen of Sheba's visit to King Solomon as well as with the visit of the Magi to Bethlehem. In all three instances, dignitaries from the East traveled westward. By making such parallels, Christian authors were attempting to unite all of time under the umbrella of a universal Church.

Another way of condensing genealogical time in Christian art occurs in the arrangement of the stained glass rose window on the north transept wall of Chartres Cathedral (see **Plate 6**). Here it is the genealogy of Jesus that is represented. The small circle at the center of the rose window depicts Mary with the infant Jesus. Directly below in the central vertical lancet window, St Anne, Mary's mother, is shown holding the infant Mary.

On either side of the central lancet are images of two Old Testament kings, David and Solomon (who are Old Testament types for Jesus), and next to these are two Old Testament priests, Aaron (the brother of Moses, who could be paired with Jesus) and Melchizedek (who brought bread and wine to Abraham and thus was paired with Jesus at the Last Supper when he told his apostles that the bread is his body and the wine his blood). Time is thus aligned both vertically and horizontally in the windows. The vertical aligns direct biological descent: St Anne, Mary, and Jesus. The horizontal aligns symbolic, typological connections: Anne and the infant Mary, flanked by Old Testament precursors of Jesus. Since the vertical lancets are below the rose window, which represents the never-ending universal Church, they are symbolically the foundation of the rose window. This arrangement is a formal parallel to the notion that the Old Testament was the foundation of both the New Testament and the New Dispensation – i.e. the Christian era. Below the standing kings in the rose window are small figures representing villainous kings; they include Saul, who tried to destroy David, and the pharaoh who held the Jews captive until Moses led them out of Egypt. By standing over the villainous kings, the good kings are portrayed as triumphant over evil. Depicted between the villainous kings is the emblem of the French royal family, which is vertically aligned with Sts Anne and Mary and the infant Jesus. This placement achieves two ends at the same time: on the hand it shows a certain humility on the part of the royal family by virtue of its visual connection with evil rulers and, on the other, it situates them in the line of the heavenly king, Jesus, and thus accentuates their rule by divine right.

With the inventions of film, video, and electronic music, literal time can be incorporated into a work. In *Piano Piece* (see **Plate 15**), Nam June Paik creates both visual and musical time. Music like poetry, Leonardo wrote, is experienced through time, because it is sequential. But pictures are experienced

more immediately. That is, one can see and apprehend an image more quickly than one can hear a piece of music or read a poem. But Paik, like many video artists, challenges this assumption by presenting images *through* time. In *Piano Piece*, he combines the time sequence of music with video, and thus extends viewing time as we watch images changing on the monitor screens while we listen to the music unfold temporally.

Interpreting meaning

Armed with some of the terms and concepts that are used to describe works of art, we can survey interpretive terms and approaches to reading meaning in works of art – known as the *methodologies* of art historical analysis. *Formalism*, in which form is taken as content, has in fact already been briefly considered in our exploration of formal terminology. For example, the relatively stable form of Michelangelo's *David* is consistent with his role as a reliable, watchful guardian of the Florentine Republic. The greater rigidity of the *Gudea* conveys his regal, steadfast power. And the unstable pose of the *St Longinus* reflects his inner emotional turmoil as he makes the transition from a Roman executioner of Jesus to a Christian. The other major methods we consider in this section are the *Marxist* and *feminist* methods, *iconography*, *biography* and *autobiography*, *psychoanalysis*, and *semiotics*. Each method provides a different approach to analysing a work of art, although in a thorough analysis several methods can be combined to enrich our understanding of an image.

Marxism and feminism

Marxist and feminist methodologies are contextual in that they take into account economics, class, and gender in approaching

works of art. Both approaches take issue with formalism as ignoring political, economic, and social reality. Marxism, which is based on the writings of Karl Marx in the context of the nineteenth-century industrial revolution, divides society into the working class (the proletariat) and the owners of production (the bourgeoisie). Artists, in Marx's view, belong to the working class, are alienated from their products, and are exploited by wealthy patrons. A Marxist approach might consider, for example, the social, economic, and political distance between the artists who made Justinian's mosaics and the emperor himself. Those artists, who were considered artisans rather than artists in the modern sense, were workers who did not benefit from the wealth and power of the ruling class – except, of course, in so far as they were employed by the rulers. In addition, the abundance of jewels in the frame of Justinian's mosaic and the cost of the gold tesserae emphasize the wealth of the patron in contrast to those who produced the work. Similarly, a Marxist approach might note the effect of the guild system, a solid establishment (which included some of the same rules and benefits as modern trade unions) during the expansion of the Gothic style when Gothic cathedrals were being constructed throughout Western Europe. Although still considered artisans, builders, sculptors, and makers of stained glass – and their families – were protected by guilds, which recognized, and tried to compensate for, some of the social and economic inequities between the working class and their wealthy patrons.

Iconography

A comparison of the *Court of Justinian* (see **Plate 5**) with Bruegel's *The Harvesters* (see **Plate 8**) provides us with an iconographic juxtaposition that can be read from a Marxist point of view. The iconographic method of analysis deals with how an image is

'written' by the artist. It reveals the multivalent, complex nature of images. If the Marxist approach is combined with the iconographic method of reading works of art, then we consider how the artist 'writes' economics, politics, and social class into an image. Not only does the mosaic representing Justinian's court have a jeweled frame, but it shows the figures frontally dominating the picture space. From their location on the apse wall of San Vitale, they are literally elevated and thus look down on viewers. In so doing, they reinforce their positions of authority in the Byzantine Empire. The harvesters, in contrast, are shown either working, eating, or resting; they are smaller than the Byzantine figures in relation to the picture space and they do not dominate the image as do Justinian and the members of his court. As viewers, we can identify with the daily activities of Bruegel's peasants who move naturally in three-dimensional space, whereas we directly confront the figures in the mosaic who occupy a flatter space. This direct confrontation creates a sense of awe on the part of the viewer when face to face with regal power. The contrasting style and iconography of these two images embodies the Marxist dichotomy between those who rule and those who *are* ruled, and implicitly between those who own the means of production (the bourgeoisie) and the working class (the proletariat).

Aspects of the Marxist discussion could be extended to the contemporary period, in which the art market is driven by economic factors. It happens, for example, that young artists often sell work for a modest amount because they are starting out and need money. Later on, if their work is appreciated by the market – i.e. deemed to be a good investment – prices may rise considerably. Very few artists realize the benefits of their reputation on works that have already been sold. They do not receive 'royalties' on the resale of a work, even though their subsequent work may be highly priced. This can produce a sense of alienation in the artist, who knows that his or her talents have not

changed and feels that the intrinsic value of the work, early or late, is the same.

Economic factors have also played out to some degree in works by women artists, who have traditionally been considered not as 'great' as male artists, and whose work has rarely commanded equivalent prices. The feminist method of reading works of art expanded as a result of the twentieth-century feminist movement, although the role of women in the arts is not a new subject. In antiquity, women artists were praised for their talent, but none of their work has survived. Until the Renaissance, women artists, like male artists, are rarely known by name. However, feminist art historians have researched the role of women in the arts and have discussed medieval patronage by women of high social status such as Jeanne d'Évreux, a wealthy French patron who contributed to church renovation, and Blanche, the French queen mother who financed the rose window on the north transept of Chartres Cathedral (see **Plate 6**). Some historians believe that many of the medieval tapestries were woven by women, and that nuns living in convents produced illuminated manuscripts. By the end of the Renaissance, largely as a result of the humanist movement, prominent women artists began to emerge, although they continued to receive training at home and generally were less prominent than male artists. In *Lives of the Artists*, Vasari praises women painters and sculptors, asserting that they are as talented as men. Nevertheless, women continued to encounter obstacles to studying the male nude. As a result, until the twentieth century women artists largely restricted their subject matter to still life and portraiture, and the market for their work was thus more limited than for male artists.

As recently as the nineteenth century, prominent women artists such as Mary Cassatt, the American Impressionist, could study from nude models only in a very few Paris art schools. In the early twentieth century, the United States produced

two important women abstractionists – Georgia O'Keeffe and the Transcendental painter Agnes Pelton. But with the rise of the feminist movement and feminist art in the 1960s and 1970s, many more major women artists have emerged around the world.

Feminist art historians also consider the iconographic approach to the representation of women. They have argued that viewers are traditionally considered to be male and thus that images of women become the object of the male gaze. The fourth-century-BC *Aphrodite of Knidos* by Praxiteles, discussed in chapter 6 (see **Figure 28**), is an idealized depiction of the female nude. Aphrodite modestly covers herself after she has been seen bathing. But Manet's figure of Olympia (see **Plate 10**), whose pose is similar to that of the *Aphrodite* – as well as to Botticelli's figure of Venus – does not strike viewers as modest. She is not as languid as the Aphrodite of Praxiteles nor as modest as Botticelli's Venus; her nakedness is used as a challenge to the viewer.

A feminist approach to the depiction of women in art is exemplified by Linda Nochlin's interpretation of the figure leading the rebellious mob in Delacroix's *Liberty Leading the People* (see **Plate 9**). Liberty, Nochlin points out, is not an actual real woman; she is an allegorical woman based on ancient victory goddesses. As such, she reflects male notions denying women real power and relegating such figures to the realm of myth.[1] Nochlin also addressed the depiction of women in David's *Oath of the Horatii* (see **Figure 23**). She points out that there is a clear dichotomy in the painting between active male power and female passivity. The women, she notes, are collapsed in on themselves and relegated to a corner, whereas the men take center stage. Reinforcing this opposition is the formal arrangement of the figures: the men create sturdy triangular forms, raising their arms and their swords under the center arch in a show of patriotic fervor, while the women give way to curvilinear forms and become limp with personal anguish.[2] Nochlin thus reads both

the iconography and the formal arrangement of Delacroix's *Liberty Leading the People* and David's *Oath of the Horatii* from a feminist viewpoint.

Biography, autobiography, and psychoanalysis: Michelangelo, Picasso, and Van Gogh

We have seen that the Marxists and feminists consider the way an image is written from the point of view of economics and gender. But additional levels of meaning are discernible if we pursue the iconography of an image in further depth. The more we know about an artist's biography, and the more he or she makes that visible in art, the more readily we can delve into the psychology of the artist. Such is the case with Michelangelo, Picasso, and van Gogh; in addition to available documentation on these artists, they themselves have provided us with information about their lives. Michelangelo wrote poetry and some of his original statements survive; Picasso's biography and art have been particularly well documented during his lifetime and afterwards; and van Gogh wrote numerous letters to his brother recording his life and his ideas about art.

Michelangelo's *David* is a good example of a work with autobiographical content that can be analysed psychologically as well as iconographically. Taking the *David* at face value, we see a young man holding a stone in one hand and a sling in the other. He stands upright in a traditional relaxed pose, but the carving of the neck and torso indicates that he is, in fact, tense. The literary source for the statue is the biblical story of David and Goliath; the sling and a stone indicate that the statue refers to David's slaying and decapitation of the giant Goliath. As in the biblical account, David wears no armor and has only his sling and stone to use against the Philistine giant. Using David as a typological

precursor of Jesus, the statue was originally intended to be placed on the exterior of Florence Cathedral; but why was it finally placed in front of the Palazzo Vecchio (town hall) of the city? The answer to that question resides in the statue's meaning within its cultural context.

In the fifteenth century, Florence was a republic and constantly under threat of invasion from the more tyrannical duchy of Milan. Since David was a youthful biblical hero who defended his people against a powerful enemy, he came to embody the heroic resistance of Florence against Milan and other dangers to its political freedom. Further, David was one of several young heroes who were honored in the Renaissance as exemplars of having achieved everlasting fame through courageous actions. This notion, which became a popular cultural theme, reflected a new interest in the individual and his or her accomplishments. It reinforced the revival of the ancient Greek focus on humanity and the sense that man, rather than gods, are central in the universe. Finally, with David as a typological precursor of Jesus, his victory over Goliath was paired with the triumph of Jesus over Satan, good over evil.

In addition to the political, religious, and philosophical levels of meaning in Michelangelo's *David*, the statue's relationship to the artist himself can yield further interpretations: the biographical and autobiographical approaches to reading meaning in a work of art. Taking biography and autobiography into account in considering a work assumes that artists put something of themselves into their works, even though there may not be enough data to ferret out what that might be. In the case of Michelangelo, however, quite a lot is known about his life, thanks in large part to Vasari, whose *Lives of the Artists* spans the period from the end of the Byzantine era in the late thirteenth century to early Mannerism in the later sixteenth century. For Michelangelo, as for Florence, the figure of David had special significance. On a preparatory drawing of David's arm, the artist wrote 'David with

the sling, and I with the bow'. In this case, the bow was part of the tool used by Michelangelo for drilling into marble, and the connection he made between the bow and the sling reflects his identification with David. In addition, the block of marble from which the David was carved was nicknamed *The Giant* for its large size and the difficulty in handling it. Symbolically, therefore, Michelangelo overcame his own 'giant' and its psychological implications when he transformed the marble into David.

On a deeper autobiographical level, involving the psychoanalytic method of interpretation by taking into account the artist's unconscious, the relationship of David to Goliath approximates the relationship between Michelangelo and his father as described by Vasari. In his biography of the artist, Vasari depicts Michelangelo's father as abusive, asserting that he physically beat his son to discourage him from becoming a sculptor. On the grounds that he considered sculpture to be a low-class, manual profession, the artist's father agreed to apprentice Michelangelo only to a painter, because he considered painting a higher-class activity than sculpture. But by the time Michelangelo was sixteen, according to Vasari, his genius had been recognized by the reigning Medici family, who took him into their household, gave him access to their collection of ancient art, and commissioned him to create sculpture. In this manifestly oedipal story, Michelangelo triumphs over his father by finding his way to a more enlightened symbolic 'father' in the person of Lorenzo de' Medici, known to history as Lorenzo the Magnificent. He, unlike the artist's biological father, understood genius when he saw it and his patronage set Michelangelo on the path to an enormously successful career as a painter, sculptor, and architect, and to worldwide fame.

Picasso's *Women of Avignon* (see **Plate 14**) was in part inspired by the artist's youthful visits to a brothel on the Carrer d'Avinyo in the red-light quarter of Barcelona. Preliminary drawings show a young medical student (who represents the artist) entering

a room with five distorted prostitutes. In the final painting, Picasso eliminated the student so that, instead of reading the image as a narrative, the viewer confronts the women directly. We as viewers are thus placed in the same position as the young artist who 'walks in on' a sexually charged space. The jumbled character of the women's features and geometric forms is both frightening and intriguing, which may well reflect the artist's impression of his first sexual encounter in a Barcelona brothel.

It is also likely that Picasso's first sexual encounter as an adult would have evoked – consciously or unconsciously – his childhood experience or fantasy of the primal scene. This is the child's view, real or imagined, of sexual encounters between parents or other adults. Childbirth, a natural result of primal scene activity, was, in Picasso's biography, associated with an earthquake in Spain that coincided with the birth of his sister when he was three years old. This, in turn, has been related to the jumbled violence of his monumental anti-war painting, *Guernica*,[3] and it may well have informed the disjointed figures in *The Women of Avignon*.

Picasso's father, in contrast to Michelangelo's, supported his son's artistic ambitions. An artist himself, but a lesser talent, Picasso's father allegedly gave up painting and entrusted his brushes to his son. Recognizing Picasso's genius, his father encouraged him. In so doing, he freed Picasso from the sense that he had to struggle oedipally against his father in order to succeed as an artist. Interesting in the light of their fathers' differing approaches to their sons' genius is the fact that Picasso was enormously prolific and rarely, if ever, suffered from creative blocks or inhibitions. Michelangelo, on the other hand, quarreled constantly with his major patron, Pope Julius II – a symbolic father figure (il Papa) – and more than once left important works unfinished.

Throughout his entire life van Gogh struggled with poverty, difficult personal relationships, and the failure to find a wife. Born in Holland, at first he wanted to follow in his father's footsteps and enter the ministry. He worked with miners in Belgium and

identified with peasants – both of whom became subjects of his paintings. But his father understood little of his genius, and van Gogh's odd behavior prevented his ever being ordained. Eventually he decided on a career in art and went to work for his uncle's art dealership in Belgium. He studied art briefly, and taught at school for a while in England, before moving in with his brother, Theo, in Paris.

In *Starry Night* (see **Plate 12**), van Gogh painted a dream-like recollection of a Dutch village. He made the picture during a hospital stay following a nervous breakdown. The painting, which reflects his emotional state, is an expression both of exuberant freedom and of internal agitation. The artist illuminated a dark night sky with bright stars exploding with haloesque auras and a vivid yellow-orange moon. Two forces of nature seem to be thrust against each other – the clouds spiraling from left to right across the sky and the hills cascading downward from right to left. As if to stabilize the animation of nature (and possibly his own emotional state), van Gogh depicted a vertical church spire in the valley and two dark green cypress trees at the left. The centrality of the church building may refer to his father's profession as a minister and to van Gogh's failed attempts to become ordained himself – a mirror of his failure to identify with his father. The double trees have been related to his sense of twinship with Theo. The presence of the trees is thus not only a formal anchor, but also a psychological one. Reading the imagery in the light of the artist's state of mind, we recognize the extraordinary control of color and form that reflects his genius, as well as the pulsating anxiety that sent him to the hospital.

Semiotics and deconstruction

Semiotics, like psychoanalysis, approaches art in a way that looks for hidden meanings, but it deals with signification rather than

with the dynamics of the unconscious mind. A sign is the union of a signifier (physical marks or sounds) and a signified (the idea that is the meaning of the marks or sounds). Signs signify, and signification is the act of signifying. Semiotics was originally a linguistic system, but it has also been applied to the visual arts. Consider, for example, Magritte's *Betrayal of Images* (see **Figure 1**). The word *pipe* is a sign that consists of the word or sound component *p-i-p-e* and the mental image or idea we have of a thing with a stem and a bowl that one smokes. A semiotician would note that the connection between the word or sign *pipe* and the thing we use to smoke is purely arbitrary. It is nothing more than a convention. The semiotic sign is thus unlike the psychoanalytic symbol, which is not arbitrary. If we take Magritte's pipe as a psychoanalytic symbol, we could read the bowl as female because of its rounded form and that fact that it is a receptacle. Although this may at first seem far-fetched, such a reading is confirmed by a humorous drawing Magritte produced in which a man is shown smoking the same pipe, but his nose has become a phallus that extends into the bowl of the pipe. The same image appears in his painting of 1935 entitled *The Philosopher's Lamp*.

A category of semiotics which was most successfully pursued by the French philosopher Jacques Derrida deals with deconstruction. In Derrida's analytic system, meaning is always deferred because there are no fixed meanings and signs refer to other signs and so on, apparently without end. He continually asks questions that challenge traditional assumptions and opens up new avenues of investigation. A simple example given by Derrida himself is whether the preface to a book is or is not part of the book. In so far as it precedes or introduces the book, it is not part of it; but in so far as it a book's preface, it is part of the book.

Whereas there is only a conventional relation between signifier and signified, there *is* a natural relation between a symbol and what it symbolizes. For instance, returning to *David*, the large size

of Goliath in comparison to David relates to the relative size and power of a father and young son, which informs the oedipal fantasy. The typical oedipal boy loves his father but wishes to eliminate him in order to have an exclusive relationship with his mother. Fearing the father's retaliation for his forbidden wish, the boy imagines that his punishment will take the form of castration. In the heterosexual outcome of the oepidal fantasy, the boy gives up his mother, identifies with his father, and succeeds in his own right. Such was the outcome of the story of David, who defeated not only Goliath but also King Saul when he turned against him. David won a kingdom for his real father, became a king himself, and married Bathsheba. Read on an oedipal level, the manifest physical tension of Michelangelo's *David* reflects his emotional tension prior to his oedipal battle against Goliath.

In contrast to the biographical, autobiographical, and psychoanalytic approaches to a work of art, Derrida does not believe that the author confers definitive meaning. Of the works illustrated in this volume, Derrida might ask whether the *Aphrodite of Knidos* (see **Figure 28**) really represents the Greek goddess of love and beauty even though that is its title. This is a question that might arise with any work based on a model but named something different. The same could be said of Manet's figure of Olympia, who is named for a mythic woman but is actually the artist's model Victorine Meurend. Since she posed for a number of paintings by Manet, Victorine reappears in various iconographic guises in his work. Is she Victorine, Derrida might ask, or is she Olympia? Or is she the nude for which she posed in Manet's *Le Déjeuner sur l'Herbe* (*The Luncheon on the Grass*), and which, like *Olympia*, shocked viewers when it was first exhibited? As Derrida would put it, Victorine Meurend both is and is not Olympia. His point is that there is no way to decide which she is. The works by Praxiteles and Manet, he would say, are undecidable. The woman in one is both Praxiteles'

mistress and a goddess and in the other is both Victorine and Olympia.

But what if the artist, like Rembrandt (see **Figure 22**), creates a self-portrait? There the subject is himself, more explicitly than van Gogh's *Starry Night* is van Gogh or than Michelangelo's *David* is Michelangelo. All three reflect aspects of the artist's biography, although the Rembrandt may be less open to question. A Derridean analysis might also query Hanson's *Policeman* (see **Figure 3**) and Warhol's *Brillo Boxes* (see **Plate 2**). Clearly the *Policeman* is not a policeman and the *Brillo Boxes* are not Brillo Boxes; they are the creations of an artist and they are not what they seem. And what about the question of Pollock's frame in *Convergence* (see **Plate 1**)? In that case, the artist produced a frame composed of the same paint as the final picture. But the frame did not travel with the picture; it remains today on the floor of Pollock's studio protected by a plastic cover. What, we might ask, is the truth of the frame of *Convergence*?

Derrida makes much of Cézanne's statement that he owes 'the truth in painting', but what, Derrida asks, does that mean?[4] Images lie, as Magritte stated in *The Betrayal of Images* (see **Figure 1**) and yet, in order to qualify as a work of art, an image has to convey a sense of truth. The American artist and New Yorker cartoonist Saul Steinberg once said that to make a good drawing one has to tell the truth. On the other hand, however, Brancusi said that making a work of art is like committing the perfect crime – which implies untruth, or at least breaking the law. In his 1963 discussion of Pop Art cited above (see p. 13), Leo Steinberg alluded to the artist's sense of trickery and play when he declared that 'artists always play peekaboo'.[5] This ambivalence between telling the truth and lying, and between working and playing, is an aspect of image-making that is also part of Magritte's message in *The Betrayal of Images*. His pipe literally deconstructs itself, for it is presented to the viewer in a realistic form, but its untruth is

confessed at once by the written statement below it. The endless fascination of Magritte's painting results at least in part from the fact that it speaks clearly to the viewer about the complexity of the artistic process and its product – and also that it plays with the viewer's sense of what is and what is not.

5

Purposes of art

People make art for many reasons, a fact that contributes to the complexity of imagery. Reasons for making art range from personal adornment to decorating the environment, to illustrating historical, religious, and personal narratives, projecting images of power, and attempting to prolong life and defy death. People commission and buy art for a similar array of reasons, but they also do so for investment and status. Art, in fact, is all around us, although we do not always recognize it for what it is, just as we do not always understand its many layers of meaning. Often the purposes and meanings of art are multifaceted, so that a work can have both religious and political meaning, personal and public meaning, financial and aesthetic meaning, and so forth. In 1937, the Dutch painter Piet Mondrian wrote:

'Art is not made for anybody and is, at the same time, for everybody. It is a mistake to try to go too fast. The complexity of art is due to the fact that different degrees of its evolution are present at one and the same time. The present carries with it the past and the future.'[1]

Decorating the body and the environment

Since the beginnings of human civilization people have adorned themselves. They paint their faces in a variety of ways, tattoo and

scar their skin, wear jewelry, arrange their hair, and dress according to the impression they want to make. War paint, intended to intimidate the enemy, can be found in ancient and modern cultures throughout the world – as in Early Britain, where the natives painted patterns on themselves with woad, a blue dye, before fighting the invading Julius Caesar and his Roman legions. The elaborate make-up and jewelry worn by the women of ancient Egypt was a form of body adornment intended to attract rather than to repel viewers. Fashion has been an element of personal decoration for millennia. Personal decoration can also carry signs of status – such as the headpieces worn by rulers, hence Justinian's crown in the Ravenna apse mosaic in the church of San Vitale (see **Plate 5**).

A great deal of art is created for interior spaces – living space, working space, and leisure space – and it too has been used for a variety of purposes. The *Bull-Leaping Fresco* in **Figure 12** once decorated a wall in the Minoan palace at Knossos. Illustrating the sacrificial bull ritual, known from Greek myth, that reflected the Minoan demand for tribute from Athens, it declared Minoan power in the Mediterranean. Similarly, the Assyrian lamassu (see **Figure 9**) was both a work of art decorating the palace entrance and a reminder to visitors of the king's supremacy. In ancient Rome, wall paintings and mosaics decorated the interiors of private homes. Frescoes, stained glass windows, and sculptures were incorporated into Western churches, where a major purpose of the images was to impart Christian teachings to the largely illiterate public in the Middle Ages. We can see this in the numerous sculptures on the façade of Amiens Cathedral (see **Figure 18**), including the figure of the Teaching Christ on the trumeau (see **Figure 19**), and in the large rose window at Chartres (see **Plate 6**). Because Islam forbids figurative religious imagery, Islamic artists decorate mosques with elaborate, curvilinear abstract designs derived from nature. Islamic manuscripts emphasize the beauty of the Word of God with exquisite *calligraphy*,

which was also a technique used to create illuminated Christian manuscripts – although with figurative as well as abstract forms.

Exterior spaces are decorated with works of art ranging from urban sculptures and fountains to garden design. Andy Goldsworthy's *Striding Arch* (see **Figure 26**), for example, is a traditional architectural form placed in landscape. But in contrast to its traditional usage, this arch stands alone, independent of a particular building or wall. Goldsworthy's *Arch* alters the environment by placing a man-made structure in a natural setting and is related to the so-called Earth Art – or Land Art – movement that includes Robert Smithson's famous *Spiral Jetty* in the Great Salt Lake of Utah and Walter de Maria's *Lightning Field* in New Mexico.

In 1970 Robert Smithson created *Spiral Jetty* by moving tons of earth and black basalt rocks to create a huge spiral 1500 feet in length and fifteen feet wide projecting from the edge of the lake into the water. The water turned a reddish color from algae trapped inside the spiral and created a gradually shifting color contrast with the bluer water outside the spiral. The shifting dynamic of nature that is part of the thematic content of Smithson's work reflects his view that nature is 'never finished'. In 1999, twenty-six years after the artist's death in 1973, the Dia Art Foundation received *Spiral Jetty* as a gift from Smithson's estate. Since then, the foundation has been working with the United States Army Corps of Engineers to preserve the site and the natural ecology of the area around it. To do so, the foundation has had to fend off applications to extract potassium sulfate from solar evaporation ponds that could threaten the site with droughts and dust storms, as well as efforts to obtain permission for oil drilling within five miles of the site. Co-operation from the State of Utah and others has so far proven effective both in preserving the aesthetic quality of *Spiral Jetty* and in insuring its long-term existence in an unspoiled environment.

Spiral Jetty, with its large scale and its location on public land, is not the only work of art that has required cooperation from political and financial authorities to prolong its existence. In 1977, Walter de Maria created *The Lightning Field*, another example of Earth Art that impacts the environment. Located in the New Mexico desert, the work comprises a one-mile by one-kilometer grid made of 400 stainless steel poles placed 220 feet from each other. The poles are two inches in diameter and on average around twenty feet seven inches high. Each pole ends in a metal pointed tip creating a horizontal line of sight and attracting lightning. In contrast to *Spiral Jetty*, which is best seen from the shore or from an airplane, *The Lightning Field* should be seen from a distance during a thunderstorm when lightning strikes the metal rods. Commissioned and owned by the Dia Foundation, which encourages viewing at sunrise and sunset, *The Lightning Field* is open at night from May through October. In addition to support from Dia, the work receives support from a number of foundations, individuals, and the State of New Mexico.

A good example of decorating the urban travel environment with works of art can be seen in public art commissioned by the MTA Arts for Transit in New York. For the thousands of riders on New York City subways, decorating dark, sometimes dingy stations with works of art has significantly enhanced the aesthetic pleasure of subway travel. Some stations have been decorated by well-known, established artists and others by young, emerging artists. Their materials range from steel and bronze to glass, tile, ceramic, and mosaic and the works vary according to the style of a particular artist.

In 2009, the 59th Street Subway Station at Columbus Circle in Manhattan was decorated according to the instructions of the Conceptual artist Sol LeWitt who had died two years earlier. Entitled *Whirls and Twirls (MTA)*, LeWitt's work is composed of 250 bright porcelain tiles in six colors (red, yellow, orange, blue, green, and purple). In contrast to many of LeWitt's so-called

Wall Drawings, this was planned to be site-specific and it occupies a large wall fifty-three by eleven feet opposite a wide stairway. The vivid color and dynamic curves, which seem to flow across vertical and horizontal planes of tile, animate the interior. Ironically, this and other subway stations that have become installation spaces for works of art grew out of the graffiti art movement of the 1970s and 1980s, when some artists – such as Keith Haring – painted directly on subway walls and others – such as Jean-Michel Basquiat – painted in a style that resembled graffiti. Originally, the graffiti artists raised the hackles of those who considered it a form of vandalism to paint city walls, sidewalks, and lamp posts, whereas other people considered their work to have improved some of the urban spaces they decorated.

Religious purposes of art

For millennia, people have created art for religious purposes, usually to achieve a sense of connection with their gods. To the degree that art inspires feelings of wonder and removes us from our mundane lives, it might be said that all art has a religious, or spiritual, quality. But a great deal of art is made specifically in relation to a belief system and, as such, is often commissioned by established religious authorities.

In the case of the Neolithic cromlech of Stonehenge and other Neolithic structures in Western Europe, we do not know who commissioned them. But there are marks on the stones that suggest religious ideas about man's relationship with the movements of the stars, the sun, and the moon. Although it is not known precisely what these markings mean, they indicate that Neolithic cultures had an awareness of a larger universe and wished to create links beyond their own time and space. When the ancient Mesopotamians constructed ziggurats, they did so as

a way of attracting the gods to protect their cities. In Classical Athens, the Parthenon provided a link between the city and its patron goddess, Athena. Decorated with sculptures celebrating her birth on the east pediment and illustrating the Panathenaic Procession on the inside wall, the sculptures reflected the admiration in which the goddess was held by the citizens. The colossal gold and ivory cult statue in the *naos* of the temple celebrated Athena as a powerful armed warrior who stood for, and defended, Athenian values.

In the medieval world, each Gothic cathedral was thought of as a New Jerusalem and a microcosm of the Christian universe. The aesthetic and awe-inspiring effect of the soaring vaults and stained glass was believed to provide a glimpse of Paradise and was intended to evoke contemplation of one's faith and eternal future. At the same time, however, the Christian stories illustrated in the windows and sculptures created an avenue of identification with the humanity of the personages around which the Christian Church had been formed. Cathedral buildings, along with their narrative sculptures and window scenes, thus appealed to worshippers on a spiritual as well as a human level. Bernini's *St Longinus* in St Peter's Basilica (see **Figure 21**) exemplified the Counter-Reformation requirement that Christian imagery evoke not only narrative identification with saints and martyrs but also a mystical identification – in this case with the ecstasy of conversion, spiritual insight, and faith.

The religious motivations for creating art are often related to ideas about death and the wish to prolong life. This was perhaps most literally expressed in the colossal Old Kingdom Egyptian pyramids at Giza (see **Figure 10**), which housed the mummified bodies of the pharaohs. Their physical preservation, like the many statues of the pharaoh and his or her household possessions, was designed to insure a rich material afterlife. The Egyptian practice of making multiple statues of the deceased pharaoh in the event that the mummy was destroyed reflects the sense that an image

contains the essence of the real person. Egyptians believed that the *ka* (soul) could enter the statue, which therefore served as a substitute for the real body.

THE TERRACOTTA ARMY

The wish to preserve one's life after death is not confined to the Western tradition. One of the most extensive and impressive examples of a ruler wishing to preserve his existence in the next life occurred in third-century-BC China under Shihuangdi, known as the Emperor of Qin. Wishing to insure that his power would outlast his lifetime, he commissioned an army of life-size terracotta warriors of every rank, together with horses, to protect him in the afterlife. Each figure was originally painted and represented with distinctive features, creating the impression that this was a real army composed of actual individuals. There are over 8000 such sculptures which are presently being excavated in Xi'an, in central China. Today, the rows of figures comprising the Terracotta Army have become a huge archaeological site and a major tourist attraction.

In ancient Greece, funeral rites were required so that one's shade could find rest in the Underworld and avoid the fate of eternal wandering. But in Greece there was no need for the elaborate Egyptian mummification practices or the replicas commissioned by the Emperor of Qin. During the Etruscan civilization, which flourished on the Italian peninsula from around 1000 BC until it was absorbed by Rome in the first century BC, the dead were cremated and their remains placed in sarcophagi or ash-urns, which were small or large depending on the wealth of the deceased. The lids of these containers were often decorated with likenesses of the deceased showing them as if they were still alive, and Etruscan tomb walls depicted the dead engaged in banqueting, with music and dancing. Some of the small urns were in the

form of a small house, but early Etruscans also built entire *necropo-leis* (cities of the dead) consisting of large-scale houses equipped with furnishings to provide living quarters in the next life.

In Christianity, the destiny of one's soul mattered more than the physical preservation of the body. This is reflected not only in the upward movement of the cathedral spires and vaults, but also in the defiance of gravity shown in traditional scenes of the Last Judgment, in which the saved souls emerge from their tombs and rise upwards, toward heaven. The damned, on the other hand, typically descend to Hell.

Art as a route to life after death

Religious art often mirrors specific beliefs about death; but there are also more universal ideas about art as a means of prolonging life. As we have seen, the very creation of art has been related to having children, which is a way of extending one's existence into future generations. Imagery has the power to keep the memory of someone alive and thus can be a metaphorical denial of death. When artists make self-portraits, they multiply their own image, which makes them recognizable beyond their lifetime. Anyone who has spent time in museums or looked at books on art is likely to recognize an image of Rembrandt or van Gogh, both of whom produced many self-portraits. And who, today, does not know the face and smile of the woman known as Mona Lisa? Although we know very little about her life, she is one of the most recognizable images in the world.

Echoing the notion that portraiture substitutes for the real person are statements made by the Italian Renaissance architect and theorist Leon Battista Alberti and by the northern Renaissance painter Albrecht Dürer. The former asked his contemporaries to paint *his* likeness in their historical and Christian scenes so that he would live a long time in the cultural memory. The latter said

that he painted to preserve the image of a person after his or her death. Today, the proliferation of digital cameras, the ease of sending images over the internet, and the thousands of pictures we take of children, grandchildren, pets, and friends, as well as of newsworthy events, are testament to the universal impulse for image-making and the sense that such images are, in themselves, substantive.

Who would deny that we have a stronger sense of the woman in Leonardo's *Belle Ferronière* (see **Figure 4**) and of Brancusi's *Mlle. Pogany* (see **Figure 2**) from their images than we would have from verbal descriptions of them? Leonardo's woman is upright; she appears aristocratic, elegantly dressed, well groomed, and self-assured. Brancusi's figure seems modest and even somewhat introverted as she inclines her head and covers part of her face with her graceful, detached hands. Her large eyes, which contrast sharply with her delicate nose, convey a quality of wonder as if she is discreetly trying to take in the world around her. Similarly, in Rembrandt's self-portrait in **Figure 22**, we have the sense that he is telling us something quite directly about himself; he looks jauntily out of the picture and engages us with his self-confident optimism.

It is not only our present and future that we attempt to preserve through imagery, but also our past. An example of our impulse to preserve the memory of important people can be seen in our relationship to ancestors. In Neolithic Jordan, people rebuilt skulls with plaster and inlaid eyes made of shells so that they would appear lifelike. These have been found under the floors of houses, which suggests that they were part of an ancestor cult and may have been a way of keeping alive the memory of the deceased. Similar reconstituted heads have been discovered as far away as New Guinea, indicating that such ideas are universal rather than culture-specific. Cultures as diverse as ancient Mycenae, Rome, and early America made death masks of important people, which could be used by artists creating

posthumous portraits. Institutions such as the National Portrait Gallery in London are evidence of the value placed on keeping alive the memory of historically significant personages. American presidents traditionally commission their portraits for the White House, schools display portraits of past principals, law firms of past partners and founders, banks and clubs of past presidents, and so forth. All such images exemplify the sense that history can be embodied in an image. This quality, which is a characteristic of imagery, leads us to some of the political purposes of art.

Political purposes of art

Works of art have been used throughout the world's civilizations for numerous political purposes. We have already considered some of these in other contexts. The mosaic of Justinian's court (see **Plate 5**), for example, was a kind of visual ambassador to Ravenna, for Justinian himself had never visited there. During the Renaissance in Italy, princes minted medals with their portrait on one side (the *obverse*) and a symbolic political image on the other (the *reverse*). Since medals were less expensive than paintings and sculptures, lighter in weight, and capable of being cast in multiples, they were easily disseminated and carried the ruler's image and political message from place to place. For example, in 1438 the Byzantine emperor John VIII Paleologus traveled to Italy to attend a Council of Churches in the hope of uniting the Eastern (Byzantine) and Western (Roman) branches of the Catholic Church. His effort – although it failed – was commemorated in a large medal showing the emperor's profile on the obverse and an inscription identifying him as 'emperor and autocrat' of the Romans. On the reverse he is shown on horseback in a rocky landscape with a crucifix in front of him; a double inscription, in Latin (the language of the Western Church) and in

Greek (the language of the Eastern Church), identifies the artist who designed the medal. The presence of both languages in the inscriptions alludes to the emperor's political effort to unite the Church, which had been split for centuries.

In the early sixteenth century, when Pope Julius II decided to rebuild the fourth-century Early Christian church of Old St Peter's into the colossal basilica in the Vatican today, he commissioned a medal with his own portrait on the obverse and the façade of the new St Peter's designed by Donato Bramante (the first of several architects hired for the project) on the reverse. In so doing, the pope memorialized the fact that he had conceived the new building and created a lasting record of the building's original design.

Historical documentation through imagery often serves a political purpose. We have seen that the reliefs on the armor of the *Augustus of Prima Porta* (see **Figure 16**) were designed to show his power over his enemies and the benefits that Mother Earth conferred on his empire. The Cupid by his right leg also had a political purpose, namely to show that, as a Roman and as a descendant of Aeneas, Augustus could trace his lineage to the gods.

In addition to imperial portraits, Roman emperors commissioned colossal single columns decorated with spiral friezes that documented their military victories. Trajan's second-century-AD column located in his forum in Rome chronicles the history of his campaign against the Dacians, in modern Romania, and his plunder of their gold and silver. Without any written text, the reliefs on the column record the appearance of fortifications and armor, military strategy, the use of boats to cross the Danube, and the treatment of prisoners. Trajan used the booty from the Dacian campaign to great political advantage, for it financed a retirement colony in modern-day Algeria for his retired troops. Trajan's column thus projected a combined political image of himself both as a great general and conqueror and as a benevolent ruler concerned for the welfare of his subjects.

THE PILLARS OF ASHOKA

The universal appeal and the potential political advantages of the tall vertical as a sign of achievement and authority are apparent in its use beyond the West. The third-century-BC Indian emperor Ashoka, for example, commissioned huge stone pillars inscribed with decrees detailing his moral and social philosophy, as well as communicating the message of Buddhism, then a new religion. Many of the pillars were crowned with a lion capital showing four lions facing outward on a round abacus. The lion stood for Siddhartha (who was called the 'lion' of his clan and who later became the Buddha), and carved on the abacus was the Buddhist Wheel of the Law. In this iconography, Ashoka proclaimed the spiritual power of Buddhism as well as his own political power as emperor on the Indian subcontinent.

Centuries later, in 1804 in France, Napoleon, who had originally come to power supporting the overthrow of the monarchy, crowned himself emperor. Inspired by the free-standing columns of ancient Rome and impressed with the power of their form, the newly minted French emperor, as we saw in chapter 2, commissioned the colossal column in the Place Vendôme, in Paris. Instead of marble, however, he used melted-down artillery captured from his Prussian enemies. Like Ashoka and the Roman emperors, Napoleon recognized the power of the imposing, single vertical structure and he used it to narrate his military victories.

In seventeenth-century Europe, three absolute monarchs – Charles I of England, Philip IV of Spain, and Louis XIV of France – used political iconography specifically to further their images as rulers by divine right. Charles I commissioned portraits of himself on horseback in the tradition of imperial Roman equestrian statues. He also performed in court masques designed

to persuade his audience that he was a powerful but peaceful ruler. That these efforts were more show than substance is evidenced by the fact that his subjects were dissatisfied with his reign, and that he lost both his crown and his head. Philip IV called himself the Planet King because, at the time, the sun was fourth in the hierarchy of stars and he wanted to shine more brightly than Louis XIV, who called himself the Sun King to reflect his identification with Jesus and the Greek sun god Apollo. The iconography of Louis's palace and its gardens at Versailles is a vast expression of the king's determination to be seen as one with the sun gods of ancient Greece and Rome. In one pool in the palace grounds, for example, a gilded bronze sculpture of Apollo – the *Apollo Fountain* – shows the sun god at dawn rising from the water with his unruly horses. He is surrounded by sea gods trumpeting the new day. The same king famously declared '*L'État, c'est moi*', and in his portrait of 1701 by the Rococo painter Hyacinthe Rigaud, Louis XIV stands by a huge column signifying both the French state and the Classical tradition. Some two centuries later, in 1860, Mathew Brady's Cooper Union photograph portrait of Abraham Lincoln would show the president standing by a column – in that case an allusion to both his role as the United States president and his resolve to preserve the 'union' of North and South. In both portraits, the column is an architectural metaphor: for Louis XIV it was a sign of monumental power, but for Lincoln it was a reference to the metaphor in his Cooper Union speech in which he declared that 'a house divided against itself cannot stand'.

By the late eighteenth and nineteenth century in France, works of art began to reflect revolutionary sentiments that had been building up as kings became more and more aloof from their subjects and unresponsive to their needs. Louis XVI commissioned David's *Oath of the Horatii* of 1785 (see **Figure 23**), and he viewed its patriotic message as consistent with the program of moral reform he had instituted in France. But revolutionary

sympathizers saw the work differently; for them it embodied the ideals of the Roman Republic. The presence of Doric columns and of the triple arch in the background was an implicit reminder of the ancient Athenian democracy and the republic of Rome.

Over forty years after the French Revolution in 1789, a new rebellion broke out. That struggle was memorialized in Delacroix's *Liberty Leading the People* of July 1830 (see **Plate 9**). The allegorical character of Liberty, like the Greek and Roman architecture in the *Oath of the Horatii*, was a reminder of an ancient past viewed with a democratic gloss. Both pictures convey a sense of patriotic fervor and a conviction that French citizens are willing to die for freedom. The red, white, and blue, which were the revolutionary colors that became the source for the *tricolor*, the French flag held aloft by the figure of Liberty, are repeated in the revolutionary mob propelled forward by the ideal of freedom. Delacroix thus used color as symbolic content, for the reds, whites, and blues, which are scattered among the living and dead in the painting, are literally united in the flag and symbolically united in a political cause.

In the twentieth century, politics continued to influence the arts, which often provided a venue for protest. This had been the case during World War I, when artists and writers gathered in Zurich, in neutral Switzerland, at the Cabaret Voltaire, where they gave anti-war performances to protest against war and the destruction it caused. The reigning artistic, literary, and philosophical movement in which the performers were engaged is known as Dada, which we considered earlier. The meaning of the term 'Dada' has been the subject of a great deal of discussion; it combines the artistic notion of creation and destruction – that an artist has to supersede the past in order to create something new – but it is given wider political meaning when used as a means of protest. Since *da-da* are the first syllables spoken by infants, the term contains the idea of starting over, leaving behind the destructive character of the past and creating a more peaceful and

productive future. The failed political aspirations of Dada are readily evident, however, for World War I was soon followed by World War II, the Spanish Civil War, the Korean War, the Vietnam War, the Cold War, and so on.

One of the most powerful protests against war was painted in 1937 during the Spanish Civil War as the seeds of World War II were being sown. Picasso's huge painting entitled *Guernica* was inspired by the German bombing of unarmed civilians in the town of Guernica, in Spain. With the collaboration of the Spanish dictator, Generalissimo Francisco Franco, German planes attacked Guernica. The atrocity was widely reported in the press, which inspired not only the iconography and fragmented style of the painting, but also its depiction in black and white. As with the *Women of Avignon*, Picasso transformed a specific event into a universal image of mythic power – in the case of the *Guernica*, a manifestly political image.

In the United States during the early decades of the twentieth century, new sources of controversial political protest arose that were expressed in the arts. During the 1920s, the Harlem Renaissance encouraged black artists to seek inspiration in their African-American heritage, while later black artists, such as Faith Ringgold, Betye Saar, and Robert Colescott, developed new forms of politically motivated racial iconography. In her 1969 painting entitled *Flag for the Moon: Die Nigger*, Ringgold used the American flag as part of her protest iconography, incorporating the words 'Die Nigger' into the stars and stripes. She objected to the United States spending money on space exploration rather than addressing issues of racial discrimination at home. Saar protested against the stereotype of the black 'mammy', which relegated African-Americans to bandana-wearing house-cleaners and caretakers of white children. In her mixed-media work entitled *The Liberation of Aunt Jemima* of 1972, Saar depicted an Aunt Jemima holding a broom and a pistol in one hand and a rifle in the other. Cut into the body of the large Aunt Jemima is a smaller

image of a leering Aunt Jemima standing behind a raised black fist and carrying a bawling white infant. Here, as in *Flag for the Moon: Die Nigger*, the artist used well-known iconic American imagery to convey the history of black rage and white discrimination. Colescott portrays similar themes of racial protest by appropriating famous Western paintings, such as Emanuel Leutze's *George Washington Crossing the Delaware* and Picasso's *Women of Avignon*, and substituting African-American stereotypes for the original figures.

In the early 1960s, with the entry of the United States into the Vietnam War, performance art became a regular form of protest; in the 1970s feminist art addressed issues involving women artists. In the multimedia performance art of the American Laurie Anderson, for example, the artist protested against social and political injustice of various kinds, including the war in Vietnam. The Action Sculptures – called 'art actions' – of the German performance artist Joseph Beuys were intended to create world peace. He thought himself a kind of shaman, which he expressed in his *Coyote, I Like America and America Likes Me* of 1974. In that performance, Beuys moved with a live coyote for over a week in a New York art gallery. The artist was covered in a felt blanket from which projected a shepherd's crook, alluding to Jesus the Good Shepherd. Like a shaman, who crosses between the human and animal worlds, Beuys wanted to encourage harmony between nations.

From 1974 to 1979, the American feminist artist Judy Chicago created *The Dinner Party*, a mixed media monument to the role of women throughout history. The work consists of a huge, triangular dinner table laid with thirty-nine place settings, each one for a famous woman; the floor contains the names of an additional 999 women. Among the thirty-nine are the Egyptian queen Hatshepshut, the British author Virginia Woolf, and the American painter Georgia O'Keeffe. Their historical significance contrasts with the traditional notion that a woman's place is in the home.

In addition, to elevate the importance of so-called 'women's work', Chicago uses traditional women's crafts – appliqué, needlepoint, and embroidery – in the details of *The Dinner Party*.

More recently, concerns about the environment have given rise to new political artistic statements that fall under the category of Environmental Art. A good example of Environmental Art with a political agenda of protest – in contrast to the Earth Art projects of Smithson, De Maria, and Goldsworthy – is the work of the Danish-born Icelandic artist Olafur Eliasson. From 1998 to 2000, Eliasson produced *Green River*, a project designed to provoke discussion about the future of our planet. He chose a river in each of four cities – Bremen in Germany, Moss in Norway, Los Angeles in California, and Stockholm in Sweden – and turned them bright green with a non-toxic dye. His intention was to disrupt people's assumptions about landscape and to provoke serious thought about the future of the environment.

Plunder, theft, investment, and status

Ever since the beginning of recorded history, people have wanted to acquire art for personal and national status, as well as for financial investment. In times of war, stealing art from the enemy as a symbol of victory is an age-old practice. In the ancient Near East, for example, in about 1170 BC, conquering Elamites (inhabitants of modern-day Iran) stole the Akkadian Victory Stele of Naramsin and the Babylonian law code of King Hammurabi. Both objects were greatly esteemed by the cultures that produced them. A six-and-a-half-foot-high sandstone marker, Naramsin's stele was carved with a relief that celebrates an Akkadian victory over a mountain people and depicts the ruler as being under the protection of the gods. Hammurabi's law code, occupying a

seven-foot-high stele of black basalt, was carved at the top with a scene of the sun god presenting the king with symbols of rule. Inscribed in cuneiform below are around 300 statutes that comprised the legal fabric of ancient Babylon. The theft of these two works was more symbolic than financial, for their monetary value meant far less to the Elamites than the value of having conquered the civilizations that produced them.

In contrast to the symbolic value of what the Elamites took from Akkad and Babylon, the Romans, under the emperor Titus, stole objects of actual value, and destroyed and plundered the Temple of Jerusalem in AD 71. Their theft signified the power of the Roman legions and included objects of gold, silver, and other precious materials, which required a full two days to parade through Rome. Similarly, when Napoleon brought back works of art from his conquered territories, when the Nazis stole works from important European collections, and when the Russians seized art from Germany during World War II, real money, as well as symbolic value, was a motivating factor.

One of the most convoluted examples of the legal complications in such thefts involves the so-called Schliemann Treasure. In the nineteenth century, the successful German businessman Heinrich Schliemann decided to use his fortune to pursue his conviction that the Trojan War had been a reality and he set out for the west coast of Turkey. There, at the site of the ancient city, but probably not at the level of Priam's Troy (that is, the level that corresponds with the period of the Trojan War), he excavated valuable gold objects and brought them, via his Greek wife, through Greece to Germany. When the Russians defeated Germany in World War II, they took the treasure, though they did not admit to having it until 1993. Today, there is still discussion over the fate of the objects – the Germans claim that Schliemann had permission to remove the objects from Turkey; the Turks want them back; and the Russians claim that, as victors in a war Germany started, they have a right to keep them.

Today, such plunder is frowned upon internationally, and there are protocols that attempt to protect against it. In 1972, the UNESCO World Heritage Convention and subsequent Geneva Convention riders (1977 and 1997) were designed to prevent the destruction of cultural property. Nevertheless, the looting of archaeological sites remains an ongoing problem that is difficult to control. With the 2011 uprisings in North Africa and the Middle East, the problem of archaeological looting became exacerbated. The Egyptian Museum in Cairo was broken into, as were the sites of Abydos and Saqqara. In such cases, the looters hoped either to sell the objects to unscrupulous collectors, or to melt them down for their gold. Once an object has been plundered from a site, a practice that will continue as long as there is a market for stolen art, its history and context are lost.

Plain old-fashioned art theft from homes, museums, and other institutions is also an ongoing problem – inhibited only by the difficulty of fencing well-known works. Among the many examples of such theft is *The Scream* by the late nineteenth-century Norwegian painter Edvard Munch, which has been stolen several times from (and later returned to) the Munch Museum in Oslo.

Museums have also been robbed for other motives – for example, in 1911, when the *Mona Lisa* disappeared from the Louvre, in Paris. Clearly that was a work that could never be openly sold except by the museum itself. But in this case, the thief apparently had no plans to sell the picture; he was an Italian housepainter who believed that, since the *Mona Lisa* had been painted by Leonardo da Vinci, it belonged in Italy rather than in France. Even though the Louvre had acquired the picture legitimately, because Leonardo died while living in France and in the employ of the French king, Francis I, the thief asserted that his motives were purely patriotic. Eventually the *Mona Lisa* was recovered; it was found in Florence, hidden under the housepainter's bed.

Sometimes important works are held for ransom and often there is no official explanation given for how works are recovered. When the United States invaded Iraq under President George W. Bush, the Iraqi museum in Baghdad was not sufficiently protected and thousands of famous works were stolen by local looters. Eventually a portion of the best-known works was recovered, largely because, as with both *The Scream* and the *Mona Lisa*, it would not have been possible to sell them openly. But as of this writing, many more are still missing. There have been other thefts of works that cannot be fenced or sold on the open market, which have not so far surfaced; the fate of these works – for example, Rembrandt's *The Storm on the Sea of Galilee*, stolen from the Gardner Museum in Boston – remains unknown.

Although some would argue that art belongs to all of human culture, ownership of specific works continues to have significance. This fact is exemplified by the political tug-of-war that arose around Michelangelo's *David* in 2010. The statue (see **Figure 20**) was commissioned by the Republic of Florence in 1501 for the exterior of its cathedral. But it ended up outside the entrance to the Palazzo Vecchio, where, as we have seen, it stood for freedom from tyranny. At the time, Italy was not yet a nation, but rather a patchwork of city-states, duchies, kingdoms, and republics. In 2010 the Italian Ministry of Culture commissioned a study to determine the legal ownership of the statue. The lawyers concluded that the *David* belongs to Italy, not to Florence, on the grounds that the nation is the rightful successor of the Florentine Republic. The Accademia, in Florence, where the statue is presently housed, originally belonged to the Kingdom of Italy, which was the predecessor of modern Italy. The mayor of Florence countered that the *David* had been given to the city by the Kingdom of Italy as part of a larger agreement in 1871 when Rome became the capital of present-day Italy.

The real issues motivating this debate are control, revenue, and civic pride. If Italy owns the *David*, it could theoretically

remove it from Florence to another location. In 2009 over a million people visited the Accademia to see the sculpture, and ticket sales exceeded $7,000,000, which went to the national Ministry of Culture – not to Florence. Nevertheless, the *David* is a source of enormous civic pride and is partly responsible for attracting large number of tourists to the city, which benefits its economy. The mayor of Florence, unimpressed by the legal arguments of the Italian government, was quoted in the *New York Times* (1 September 2010, p. A9) as having declared that 'the *David* is not an umbrella to be haggled over. It is a monument in which the city of Florence still sees its identity'. And furthermore, the mayor added, the issue was 'a new instance of David versus Goliath. Our battle is for a different way of managing the cultural patrimony of a city that lives off culture'.

THE CASE OF THE ELGIN MARBLES

Art theft of the Gardner Museum variety is a straightforward crime. But there are some gray areas in the world of art – such as the issue of who owns Michelangelo's *David* – that continue to be a matter of controversy. Perhaps the most persistently newsworthy instance involves the fate of the Elgin Marbles – also called the Parthenon Marbles. Early on in the nineteenth century, when Greece was under Turkish rule, Thomas Bruce, the seventh earl of Elgin and the British ambassador in Constantinople, obtained permission from the Turkish authorities to remove works of ancient sculpture from the Acropolis in Athens and ship them to England. Among these works were free-standing statues from the Parthenon's pediments and its relief sculptures. Technically, Lord Elgin did not break the law, and the removal of the sculptures did not damage the historical record as does plundering from archaeological sites. Nevertheless, some would argue that Turkey was not morally in a position to grant permission to take Greek national treasures out of the country. On the other hand, the Parthenon was in poor condition when Lord Elgin removed the sculptures and no one was caring for either

the building or its sculptural decoration. The Parthenon had been converted first to a church and then to a mosque, and in the seventeenth century it was used by the Turks to store gunpowder and exploded. By taking the sculptures Elgin saved them from further damage – even though one of the shipments sank and those sculptures were lost. He sold the remainder to the British Museum in London, where they remain as of this writing.

For years, the Greeks have been trying to persuade Britain and the world that the sculptures should be returned to Athens. But one argument against this view is that modern air pollution in Athens would have worsened the damage to the marble, just as it has seriously damaged the Parthenon itself. In Athens, meanwhile, a huge, temperature-controlled museum was officially opened to the public in 2009. It was built, in large part, to persuade the world that the sculptures should be returned and that they would be well cared for. Another debatable issue is whether the works should be returned on the grounds that they are cultural property and would be better understood if viewed in close proximity to the Parthenon, their original site. But in the British Museum they can be seen in the context of the ancient Mediterranean world, along with works from the Near East, the Aegean, and Egypt. Given the determination of the British to keep the Parthenon sculptures and the ongoing Greek demands that they be returned to Athens, it is probable that this essentially political debate will continue for some time.

Private patronage and investment

In addition to the value of art as booty in war and as a symbol of cultural heritage, art has been valued as a route to achieving personal status through collections, and bequests. In antiquity as today, museums were valued institutions. The very term *museum* comes from the Greek word *mouseion*, meaning 'home of the Muses', the nine daughters of Zeus, who were arts goddesses.

In the fifth century BC, the entrance to the Athenian Acropolis, for example, was originally flanked by a sculpture gallery and a

painting gallery. In the fourth century BC, Ptolemy Soter (367–283 BC), the Greek ruler of Egypt, founded a museum of antiquities in Alexandria. Later, travel and conquest also led to the establishment of museums, from the Crusaders whose accumulated objects were publicly displayed, to 'curiosities' collected by explorers of the New World. In the nineteenth century under Napoleon, the Louvre housed the French Museum of the Republic; in the United States philanthropists began funding museums to benefit Americans. Today there are some 8000 museums in the United States and around 25,000 worldwide. Public displays of works of art thus have a long history, their primary mission being to exhibit the creative products of civilization. In addition, individuals sometimes achieve personal and social status by donating to museums, a practice that has been particularly prevalent in twentieth-century America.

THE MEDICI FAMILY

One of the greatest periods of private patronage, the Renaissance in Italy, was also a period of immense papal and political patronage and sometimes these motivations for commissioning art overlapped. This was especially true of the Medici family, which vied with other wealthy and powerful families in donating art and which emerged as both the political and artistic 'first family' of fifteenth-century Florence. The Medici philosophy of *magnificenzia* entailed financing public and private works of art and architecture both for personal status and to beautify the city, its churches, and its civic institutions. This attitude to art and politics was responsible for, among others, Brunelleschi's Hospital of the Innocents; the Convent of San Marco and its frescoes by Fra Angelico; the Medici-Riccardi Palace, which housed the *Battle of San Romano* series by Uccello, the *Procession of the Magi* by Benozzo Gozzoli, sculptures by Donatello, Verrocchio, and Michelangelo; and paintings by Botticelli such as the *Birth of Venus* (see **Plate 7**), all of which were financed by the Medici fortune.

Patronage, which can be political, religious, for personal investment and status or for private aesthetic pleasure, is an issue that has affected both the display and the marketing of works of art. For centuries, as we have seen, rulers commissioned works of art to project their political images and they continue to do so today. Papal patronage in the West has produced some of the greatest Christian art, whereas in Protestant Europe patronage has become progressively secular, Protestant churches and cathedrals notwithstanding. In seventeenth-century Holland, civic institutions and individuals commissioned many portraits that were purely secular. During the eighteenth century, in France, the center of artistic activity shifted from the Versailles court to the Salon, usually a gathering in an elegant private house. By the nineteenth century, the art dealer had become an established figure in the world of art. Private galleries were established for the purpose of buying and selling works of art, while museums, in principle, were planned for their permanent display. In fact, however, most museums de-accession (sell) works even if that was not the original intention of a donor – the only major museum in the United States that has never de-accessioned a work is the National Gallery of Art in Washington, DC.

With the proliferation of dealers and a thriving art market, art auctions have also become a fixture of the art world. Although auctioning art and other objects is known from ancient Rome, the modern-style art auction began in seventeenth-century England. By the nineteenth century, auctions had become an established business model. Although nineteenth-century Paris was the center of the Western art world, its new styles, beginning with Realism, were not generally accepted. Manet, for example, put a value of today's equivalent of $72,000 on the *Olympia*, which he kept until his death. When the painting was auctioned

in a studio sale, it failed to make its reserve of half that amount (even though works by contemporary artists who are far less esteemed today were being sold for multiples of Manet's valuation of the *Olympia*). The Louvre denied the picture entry into its collection until 1907.

Like the Realists, the Impressionists and Post-Impressionists had a great deal of difficulty finding buyers for their work. Only a few French dealers recognized their value and, as a result, many examples of those styles were purchased by foreigners – both privately and at auction. Eventually the market value of these styles skyrocketed.

In the twentieth century, as the focus of modern art activity shifted to New York, each new generation of artists – Dadaists, Abstract Expressionists, Pop artists (see box, p. 156), Graffiti artists, Body artists, Feminists, Minimalists, Conceptualists, Photo-Realists, Super-Realists, Earth artists, Environmental artists, Video artists, and so forth – has had to struggle for recognition and buyers. By the 1980s, as a result of inflation in the art market and increasing media hype, the investment value of art became apparent and began to be thought of in financial circles as an asset class. In 1987, a still life of sunflowers by van Gogh sold for nearly $40 million and a still life of irises by him was bought by a Japanese collector for about $54 million; in 1990 a portrait of van Gogh's friend and physician, Dr Gachet, sold for over $82 million. In 2000, a Blue Period Picasso was auctioned for $5.5 million, and ten years later, in 2010, his *Nude, Green Leaves and Bust* of 1932, was sold for $106.5 million, setting a world record for a painting sold at auction. The media, as well as auction frenzy, and the perception of art as a good investment, fueled these sales and, like cities that boast 'the world's tallest building' or medieval towns that boasted 'the world's tallest cathedral', each new record sale made international news.

THE RISE OF POP ART

Pop Art exemplifies the pattern of early rejection followed by a meteoric increase in market value that characterizes a number of twentieth-century art styles. Pop made its debut in England in the late 1950s, and flourished in New York during the 1960s. Its figurative iconography of commodity was both a rebellion against non-figurative abstraction and a reflection of consumer culture in the United States. The most visible of the Pop Art collectors in New York were Robert and Ethel Scull, owners of the taxi company popularly known as 'Scull's Angels'. The Sculls' tastes and lifestyle mirrored their collection. They combined a high-profile social life with a real sense of aesthetic value and, although they had collected some Abstract Expressionism, were the first to buy art later identified as Pop – notably works by Andy Warhol, Jasper Johns, Robert Rauschenberg, Roy Lichtenstein, James Rosenquist, and George Segal.

Among others, the Sculls commissioned a ninety-eight-inch-high painting of a double American flag by Jasper Johns, one of twenty-two works they owned by the artist. Today, the American flag has become an iconic Pop Art image. In 1954, Johns began painting flags, using the encaustic medium that had been popular in ancient Greece and Hellenistic Egypt on strips of canvas. In 1958, the avant-garde New York art dealer Leo Castelli offered the artist a one-man show, which brought him to the attention of Alfred Barr, Director of the Museum of Modern Art. Thirty years later, in 1988, a white American flag by Johns sold for $7 million, which at the time was the highest price ever paid for a work by a living artist. The following year, Johns's *Two Flags* sold for over $12 million. Then, in 1998, the Metropolitan Museum bought a white flag for an undisclosed sum, confirming Johns's reputation as an established American artist. In a May 2010 auction in New York, another of Johns's flags sold for $28.6 million.

In 1973, the Sculls scandalized the art world by selling off part of their collection at auction. They made over $2 million on the sale, much of which was profit since they had had the foresight to

recognize the value of Pop Art before it became fashionable. Nevertheless, the Sculls were accused of shameless greed by several critics and artists, and protestors gathered outside the auction house. Following a drawn-out divorce and Robert Scull's death in 1986, a second auction disposed of the remainder of the collection for another $10 million.

Sales such as these have raised again the issue of whether or not artists should realize royalties on the resale of their art. On the one hand, one might argue that buyers of unknown art are helping to support young, emerging artists, and thus it is fair for them to profit if the work increases in value. On the other hand, one might argue that the artist should also benefit from the increase in value – although, as some of the artists bought by the Sculls pointed out, they benefit in any case because they can now sell their new works for higher prices.

6

The power of images: why art creates controversy

In the art trials discussed in chapter 1, and in the reaction to the auction of the Scull Collection, we have encountered many examples of controversy engendered by the visual arts. Regardless of the explicit arguments in such cases, the most significant causes of artistic controversy lie in the psychological power that images can exert over viewers.[1] Throughout history, this power has assumed many forms and has inspired aesthetic quarrels, political protest, religious fervor, claims of indecency, and even vandalism. Recently, there has been controversy over the issue of restoration – when should a work of art be restored, and to what degree does any restoration amount to an unnecessary and often inaccurate revision of history?

Restoration: renovation, revision, or destruction?

When a work of art must undergo restoration to survive, most experts would agree, the effort to save it should be undertaken. But the history of art is filled with examples of major works being altered through over-painting and zealous refinishing, as well of important buildings being torn down to make space for new ones. One's view of such activity is, in large part, dependent

on one's view of how art should be treated and what it means for civilization. It also depends on what one considers to be art in the first place.

One could argue that, given the changing assessment of art, as seen in the critical history of van Gogh and others, it is a mistake to alter or destroy any work by an artist. Unfortunately a great deal of art has been destroyed by wars, natural disasters, accidents, indifference, and outright vandalism. In ancient Egypt, pharaohs needing stone for their buildings and sculptures were not above removing it from works created under previous pharaohs. In Italy, frescoes by one generation of artists were sometimes white-washed to make clean surfaces available for subsequent artists. In Spain, during the sixteenth century, partly for political and partly for religious reasons, an aesthetically undistinguished Christian church was added to the magnificent mosque at Cordoba, disrupting the spectacular effect of the original building. The Parthenon, used as an arsenal by the Turks, was damaged by a Turkish cannonball and Leonardo's monumental fresco of the *Last Supper* in Milan suffered when Napoleon's soldiers used it for target practice. And so on.

THE RESTORATION OF THE SISTINE CHAPEL

In the 1990s, when the Vatican began to restore Michelangelo's Sistine Chapel frescoes – financed by the Japanese and giving reproduction rights to Nippon Television for a number of years – there was a groundswell of controversy over the restoration. Members of the art establishment were divided over the pros and cons of cleaning the frescoes. Those in favor championed the removal of centuries of smoke and grime from the surface of the paintings and, when the restoration had been concluded, they applauded the revelation of Michelangelo's rich, bright color. The opposition, led by James Beck, Professor of Art History at Columbia

University, argued that there was no need for the restoration, that the frescoes were in no danger, and, worse, that the restorers had unwittingly removed the artist's *ultimo mano* – the final protective layer of *size* (a mixture of glue and resin) that Michelangelo had applied to the surface of the ceiling. In so doing, according to Beck, the restorers not only used toxic materials, but they also removed sections of *chiaroscuro* that were crucial to the appearance of three-dimensional power typical of Michelangelo's style.

One question that must be asked about recent restorations, which have been particularly frequent in Italy, is the degree to which they are motivated by money rather than by necessity. Cleaning paintings and sculptures makes them brighter and more appealing to modern taste, and thus attracts viewers. It also creates employment for restorers and publicity for the art, which means more visitors to churches and museums which benefits local economies. And although when first produced, works are undoubtedly brighter than they are centuries later, a restoration can have unintended consequences. Would we, James Beck asked rhetorically during an unpublished lecture in New York, feel as free to 'touch up' an original manuscript by Shakespeare or Lincoln as we do to repaint a picture or polish a sculpture? Appalled by what he considered a spate of unnecessary restoration in chapels, museums, and elsewhere, Beck founded the organization ArtWatch to monitor such activity. Since his death in 2007, ArtWatch has continued its oversight of restoration.

Sometimes an artist's own technique causes his or her work to deteriorate over time – a factor in the fate of Leonardo's *Last Supper*. The most recent restorer wanted to return the painting to its original state – that is, to the way it had been before previous restorations and the assault by Napoleon's soldiers. One problem with this plan originated with Leonardo himself, who

departed from the tried and true fresco technique when he painted the mural. Always experimental and a slow worker, Leonardo hoped to delay the quick-drying fresco process by adding tempera and oil to the plaster wall. This prevented the bonding that takes place when water paint is applied to damp plaster and, as a result, the paint began peeling soon after Leonardo had completed the work. Subsequently, a number of restorations were undertaken so that it is difficult to determine exactly how the original appeared. After the most recent restoration, which lasted from 1979 to 1999, very little of the picture remained and the restorers had to repaint sections of the work. The restored *Last Supper* now appears washed out, pale, and flattened when compared with reproductions of its previous condition.

In any case, the issue of restoration continues to raise controversy, although most of the arguments are the result of honest disagreement. When it comes to the outright intentional destruction of a work, however, we find many possible motivations ranging from delusional thinking to political, religious, and aesthetic justifications for destroying or attempting to destroy a work of art. In some cases, there is a fine line distinguishing these various motives from each other.

Vandalism

Vandalism, a term derived from the Germanic tribe that sacked Rome in the fifth century, has had many motives, among which is political iconoclasm. During the French Revolution rebellious mobs, incensed at the abuses of the monarchy, mistook the kings and queens of the Old Testament represented on the door jambs of Chartres Cathedral for French royalty, in their rage smashing several of the statues. In China, during the Cultural Revolution under Mao Zedong, an enormous amount of important art of the past was demolished on the grounds of creating a new,

egalitarian society. As a result, China has forever lost a great deal of its cultural heritage.

Individuals have vandalized art because of personal grievances. In 1911, a ship's cook attacked Rembrandt's famous monumental painting *The Night Watch* with a knife while visiting the Rijksmuseum in Amsterdam. He had recently been fired from the Dutch navy, and had displaced his rage onto a Dutch national treasure which, because it was housed in a national museum, he associated with the government. Three years later, in 1914, at the height of the suffragette movement in England, Velázquez's painting entitled *Venus with Cupid and a Mirror* (also known as the *Rokeby Venus* after the family that had owned it) in the National Gallery in London was the victim of a knife attack. One Mary Richardson (who earned the nickname 'Slasher Mary') wanted to protest against the imprisonment of the suffragette leader, Emmeline Pankhurst, and some of her followers. Richardson later claimed that she was offended by the representation of the nude and its implicit invitation of the male gaze.

In 1972, Michelangelo's marble statue of the *Pietà* in St Peter's was attacked by a hammer-wielding Hungarian who claimed that he, not Jesus, was the Messiah. Originally commissioned by a French cardinal, who was ambassador to the Vatican, for his tomb in St Peter's, the statue depicts Jesus after being taken down from the Cross. He lies across Mary's lap, while she mourns his death. This was not the first time that the *Pietà* had inspired an angry response. In 1549, when a copy of the work was displayed in Florence, the Inquisition became incensed at the youthful character of Jesus' mother. She was too young in the eyes of the Inquisitors, and this, they alleged, made the sculpture incestuous – possibly by reference to the belief in a mystical marriage between Jesus and Mary when they are crowned King and Queen of Heaven. In any event, the Inquisition pronounced Michelangelo an 'inventor of filth'. To protect the statue, it was removed from

the chapel and hidden away until the religious climate in Italy changed.

The fate of two colossal statues of the Buddha at Bamiyan, in Afghanistan, was not so fortunate as that of Michelangelo's *Pietà*. In 2001, the Islamic fundamentalist Taliban exploded the Buddhas and other statues dating to between the second and fifth centuries, which had been carved into existing rock and attracted many visitors to the site. The Taliban justified their vandalism on the grounds that the works represented figures in human form, as is forbidden by the Qur'an, and that they were not Muslim. This act was carried out in defiance of international protocols against the destruction of cultural property. Recently, archaeologists have recovered fragments of the smaller Buddha and have proposed trying to restore it. Nevertheless, as in Mao Zedong's Cultural Revolution in China, important works of art from Afghanistan were permanently destroyed.

Religious controversy

As in the Inquisition's condemnation of Michelangelo's *Pietà* and the ancient Greek objections to the *Aphrodite of Knidos*, artworks can cause controversy because of implicit or explicit accusations of obscenity. But just as there are multiple layers in the meaning of a work of art, so there are multiple levels in their interpretation, and thus in the responses they provoke.

The Iconoclastic Controversy, a religious dispute over the very nature of imagery, raged during the eighth and ninth centuries under the Byzantine Empire between Iconophiles (literally, 'lovers of imagery') and Iconoclasts ('breakers of imagery'). The former considered images of saints and other Christian figures to be a positive contribution to their faith and cited the tradition that St Luke himself had painted a portrait of the Virgin Mary. The Iconoclasts believed that imagery was dangerous and would

THE *APHRODITE OF KNIDOS*

An ancient Greek controversy explicitly reacting to erotic content occurred in the response to the fourth-century-BC *Aphrodite of Knidos* (**Figure 28**), which was carved by the Late Classical sculptor Praxiteles for the Ionian Greek city of Kos. The first known artist to use his mistress as a model for statues of nude females, including of goddesses, Praxiteles depicted Aphrodite after her bath, covering her nudity as if suddenly realizing that she has been observed. But Kos objected to the work on the grounds that the goddess was represented in a way that was too sexually explicit; the statue was acquired instead by Knidos, a Greek city on the west coast of Anatolia (modern-day Turkey), for a sanctuary of Aphrodite. There it attracted much admiration and one anecdote tells of a young man who hid in the sanctuary one evening so that he could spend the night with the statue. So aroused was he by the image of the goddess that he was reputed to have left a stain on the marble. According to another ancient Greek account, when Aphrodite rose from the sea to view her likeness, she exclaimed 'Where did Praxiteles see me nude?'

lead to idolatry, that is, to the worship of the image (the idol) rather than of what the image represents – a somewhat different view of the dangers of imagery than the one espoused by Plato. The passions fueling the Iconoclastic Controversy created a split in the Church, and, in the year 730, Emperor Leo III issued a decree forbidding religious imagery. The result was a decline in the production of art, especially sculpture, until the edict was revoked in 843, which led to a new surge in artistic activity. Nevertheless, sculpture remains less approved by the Eastern (Orthodox) branch of the Catholic Church than by the Western branch.

Fear of the power of images to corrupt worshippers revived in the Catholic Church in Florence during a period of political and economic tension at the end of the fifteenth century. For several

Figure 28 Praxiteles, *Aphrodite of Knidos*, c.350 BC, marble, 6 ft 8¾ in. (2.05 m) high. Museii Vaticani, Rome, Italy. (Source: Marie-Lan Nguyen/ Wikimedia Commons)

generations, from the rise of the Medici family until the death of
Lorenzo the Magnificent in 1492, Florence had been a center of
humanism. But a growing conservative backlash, mainly advo-
cated by the Dominican Order, began to develop as the Medici
lost their grip on power and the fortunes of their banks declined.
Antoninus (later St Antoninus), the Dominican archbishop of
Florence from 1446 and the founder of the Convent of San
Marco, which had been financed by the Medici, preached against
the evil influence of humanism. Supporting his cause was
Girolamo Savonarola, the Dominican abbot of San Marco, who
decried all forms of luxury, as well as pictures of nudes and myth-
ological scenes. Savonarola took control of Florence and, in 1498,
gathered up all the art of which he disapproved, along with ele-
gant articles of clothing and other luxury goods, and burned
them in what has come to be called 'the Bonfire of the Vanities'.
Although Savonarola did not remain in favor with the Florentine
citizens for long and was publicly hanged, he succeeded in
destroying a great deal of important Renaissance art.

During the period following the High Renaissance, amid the
turbulence caused by the Reformation and the Counter-
Reformation, the Church revived the fear that humanism was a
moral threat to the fabric of society. At this time, works by
Michelangelo again came under attack. After completing the
David, Michelangelo was commissioned by the humanist pope
Julius II to paint a series of frescoes on the ceiling of the Sistine
Chapel – the pope's private chapel and the traditional site of the
pope's election by the College of Cardinals. A little over three
decades later, in 1534, another humanist pope, Paul III, commis-
sioned the artist's huge *Last Judgment* for the chapel's altar wall.
But later popes, notably Hadrian VI and Clement VIII, following
the edicts of the Council of Trent, wanted both works destroyed
on the grounds that the nude figures were indecent. After con-
siderable controversy, however, the Church settled for having
draperies painted over the nudes, and these remained in place
until the controversial restoration undertaken in the 1990s.

THE INQUISITION AND VERONESE'S *LAST SUPPER*

In 1573, ten years after the final meeting of the Council of Trent, the Inquisition used its new powers to attack an enormous painting by Paolo Veronese in Venice. It measured more than forty-two feet in length and represented the Last Supper. The Inquisitors summoned the artist and questioned him about what they considered unsuitable features of the painting. In particular, they wanted to know why a servant was depicted with a nose-bleed, why an apostle was using a toothpick, and why jesters and Germans (reminders of Martin Luther) were present at the Lord's supper. Veronese's defense, citing artistic license, did not sway the Inquisitors, who gave him three months to fix his Last Supper. Instead he changed the name of the painting to *The Feast in the House of Levi*, and the issue was closed.

Political controversy

Political controversies have had religious foundations, but arguments can have more secular sources. In the case of the satirical artist Honoré Daumier, the content of his work enraged the government and created controversy in nineteenth-century France, during which there were several political upheavals. The July Revolution of 1830 against the Bourbon king, reflected in Delacroix's *Liberty Leading the People* (see **Plate 9**), had resulted in the restoration of Louis-Philippe, known as the citizen-king. But France suffered a period of economic downturn and social unrest, and the government of Louis-Philippe enacted unpopular laws restricting the right of assembly and of free expression.

Known for his satirical iconography, Daumier soon made his opinion of the king public by publishing lithographs defending freedom of the press. Most of his satires appeared in two publications – the weekly *La Caricature*, launched by Charles

Philipon in 1830, and the daily *Le Charivari*, founded in 1832. *La Caricature* continued to publish until it was censored by the government in 1835, when France restricted freedom of the press. In 1831, Daumier published a lithograph showing Louis-Philippe as Gargantua, a friendly giant in French folklore. But in Daumier's rendering, Louis-Philippe is an obese king enthroned before the Chamber of Deputies, whose members are depicted as pigs dressed up as senators. In front of the king, a group of impoverished citizens is forced to deposit coins into a basket, from which they ascend a ramp leading into the king's mouth. For this image, Daumier and his editor were jailed in 1832.

On 9 January 1834, Daumier published the lithograph in **Figure 29**, which depicts the king's head in the shape of a pear (*poire* being a derogatory term in French that connotes a fool) in *La Caricature*. The iconography of Daumier's pear-headed Louis-Philippe was derived from the *Allegory of Prudence* by the Venetian Renaissance painter Titian, in which three heads symbolize the past, present, and future. In Titian's *Allegory*, the oldest head (which is his self-portrait) stands for old age and faces left, the middle-aged head is the present and faces front, and the future is a young man facing right. Daumier reframed Titian's allegory as a political satire, in which three states of Louis-Philippe's mind are shown. At the left, in the past, he smiles and his expression is one of self-confidence. At the center, he frowns, showing his displeasure with the present state of affairs, and at the right he is decrepit and in a fearful frame of mind, which does not bode well for his future.

Politics becomes a factor when works make an impact on public areas. We can see this particularly in the art of Christo and Jeanne-Claude, who have to obtain local permission for their major environmental projects. The artists have to deal with the political mood – and the civic authorities – at a particular site and convince local residents of the advantages of their work. In addition, their projects, which have become

Figure 29 Honoré Daumier, *Past-Present-Future*, 9 January 1834, lithograph, sheet 10¼ x 8 in. (26 x 20.3 cm). Metropolitan Museum of Art, New York, USA.

international events, often contain implicit political elements in their iconography. In contrast to Smithson's *Spiral Jetty* and De Maria's *The Lightning Field*, the large-scale projects of the Christos are temporary, the sites are returned to their original condition, and the materials are recycled. The artists have typically spent years obtaining permission from local authorities for

their projects, which require hundreds of workers to make into a reality. Among the Christos' most spectacular works was *Pont Neuf Wrapped*, which was executed in Paris in 1985 after ten years of discussion with city officials. The bridge, built during the reign of King Henri IV, connects the Ile de la Cité with the Left and Right banks of the River Seine. Three hundred workers, using more than 440,000 square feet of silky yellow fabric, some one million feet of rope, and over twelve tons of steel chains wrapped the bridge, bringing new life to an old form. The project lasted two weeks, during which time the Pont Neuf glowed when illuminated by the sun, reflecting a golden yellow in the river's slowly moving waters, and changed color according to the time of day.

In February 2005, after more than twenty years of negotiation with local officials, Christo and Jeanne-Claude realized the *Gates Project for Central Park* in New York City. Central Park had been designed by Frederick Law Olmsted in the nineteenth century and the several openings in the surrounding wall were called 'gates'. Some were named for groups such as engineers, soldiers, mariners, artists, and so on, and these inspired the title of the Christos' project. The final work consisted of over 7500 'gates' made of saffron-colored fabric panels suspended from poles on either side of the park's walkways. The artists wanted the project to happen in winter so that the gates would sway in the wind and contrast with the snow. They got their wish, for it did snow, and for the duration of the project thousands of people strolled along the walkways, enjoying the color and animation that the gates provided. Further enlivening the environment were the patterns of bare tree branches and the surrounding skyline of the city. As with the *Pont Neuf* project, the appearance of the *Gates* changed with the times of day; they were nuanced at sunrise, and crisp in the clear cold afternoon, and, as dusk fell, backlighting from the sky and from lamps illuminated the translucent quality of the fabric.

Aesthetic quarrels

As we saw in chapter 1, aesthetic differences have resulted in controversy and even litigation. A long-standing debate on the relative merits of painting and sculpture took on a quality of sibling rivalry between sister arts in sixteenth-century Italy. Those who considered sculpture superior to painting argued that God's first man had been a sculpture – i.e. Adam fashioned out of clay. They also noted that sculptures last longer than paintings, because they are made from stronger materials, such as bronze, wood, and stone. The advocates of painting countered that creating a picture was a more intellectual, and thus a more gentlemanly, pursuit than producing a sculpture – a notion echoed by Michelangelo's father when he refused his son training as a sculptor and apprenticed him to a painter. Leonardo himself weighed in on this argument, when he wrote that sculptors not only make a lot of noise with their hammers and chisels, but they are also covered with marble and plaster dust and cannot dress as elegantly while working as a painter can.

An aspect of the painting-versus-sculpture controversy involved the issue of two- versus three-dimensionality in a work and how that affected a viewer's response. Advocates of painting, such as Leonardo, preferred painting because one could see and comprehend a flat image more quickly than a sculpture, which had to be looked at from more than one angle. Advocates of sculpture countered that, precisely because a sculpture was three-dimensional, more than one view of an image was visible and thus showed more than a painting did. This argument, according to Vasari, was addressed by the young Venetian painter Giorgione da Castelfranco, who painted a figure that could be seen from all four sides simultaneously. He depicted the figure in back view, but the front was reflected in a pool of water, the right side was reflected in a mirror at the right, and the left side was reflected in a shiny metal cuirass at the left. Unfortunately,

this tour de force no longer exists; it is known only from Vasari's description.

The debate over the relative merits of two- and three-dimensional works of art was paralleled in the Renaissance by another on the same lines between *colorito* (color) and *disegno* (drawing). This argument was taken up by the sixteenth-century Italian critic Pietro Aretino, who preferred the loose brushwork and use of oil paint (*colorito*) characteristic of Titian to Michelangelo's more linear fresco painting (*disegno*). On another level, this controversy paralleled the artistic rivalry between Titian and Michelangelo and the political rivalry between Florence and Rome, where Michelangelo worked, and Venice, where Titian worked.

For Aretino, the painterly textures and soft, fleshy figures characteristic of Titian were superior to the clear edges and more linear style of Michelangelo. Furthermore, although Titian produced some very sensual nudes, Aretino objected to Michelangelo's nudes in the Sistine Chapel on the grounds that they were unsuitably muscular. He argued that it was difficult to distinguish the men from the women, or the children from the adults – pronouncing the frescoes fit for a bath-house, but not for the pope's private chapel.

The debate over line versus color was revived in 1648, during the Baroque period, when Jean-Baptiste Colbert, the brilliant minister to Louis XIV of France, founded the French Academy (the Royal Academy of Painting and Sculpture). Line now became associated with the classicizing style of Nicolas Poussin, the French painter who lived in Rome and was attracted to Greek and Roman subject matter. Color was associated with the Flemish painter Peter Paul Rubens, who, like Titian, produced sensuous, fleshy nudes. Rubens's brushwork was typically more painterly than that of Poussin and his colors were generally richer and brighter. Seventeenth-century proponents of line were thus referred to as 'Poussinistes', whereas proponents of color were called 'Rubenistes'.

The Poussinistes were called Ancients and the Rubenistes, Moderns. Characteristic of the Ancients (descendants of the proponents of *disegno*) was the adherence to Classical tradition. Their style was considered controlled, rational, and, because the Greek sun god Apollo was believed to embody reason, Apollonian in nature. Dionysos, the Greek god of wine, theater, and orgiastic rites, on the other hand, was associated with the Moderns (descendants of the proponents of *colorito*), whose style struck viewers as more emotional and expansive compared to the perceived restraint of the Ancients. In the nineteenth century, James McNeill Whistler turned the argument between *colorito* and *disegno* into a personal reflection on line versus color. For Whistler, the differences were eroticized and became a matter of masculine control versus the dangers of feminine seductiveness. In a letter of 1867, he defined the issue as follows:

> 'Drawing, by God! Color is vice, although it can be one of the finest virtues. When controlled by a firm hand, well-guided by her master, Drawing, Color is then like a splendid woman with a mate worthy of her – her lover but also her master – the most magnificent mistress possible. But when united with uncertainty, with a weak drawing, timid, deficient, easily satisfied, Color becomes a bold whore … '[2]

Government funding of the arts in the United States

When art receives public funding controversy is almost inevitable. And although the United States government spends relatively little money on the visual arts compared with many Western European countries, when it does, the results have often provoked vigorous controversy. One of the most heated involved the American Minimalist sculptor Richard Serra, whose *Tilted Arc* (**Figure 30**) was commissioned in 1979 by the General Services

Figure 30 Richard Serra, *Tilted Arc*, 1981–9, unfinished plate of solid steel, 120 ft (36.6 m) long, 12 ft (3.66 m) high, and 2.5 in. (0.064 m) thick. Originally installed at Federal Plaza, New York, USA. (© ART on FILE/ Corbis)

Administration (GSA) for Foley Square in Lower Manhattan; it was installed in 1981. Constructed of Cor-ten steel at a cost of $175,000, the work was a slim, broad arc, slightly tilted, measuring ten feet in height, 120 feet in length, and two-and-a-half inches in depth. The resulting long, thin curved sculpture cut a large swath in the space outside the entrance to the Federal Building where hundreds of federal employees worked. The surface of the sculpture was slightly rough, as are most of Serra's large-scale steel works, and it was made so that it would rust over time. Characteristic of Serra's work, the *Arc* was a monumental, imposing presence that could feel overwhelming, even menacing, to viewers unaccustomed to his style.

Although Serra was an established American artist, his *Arc* created heated controversy for a number of reasons. First, it was

abstract, which alienated a large segment of the public and, nick-named 'the Berlin Wall of Foley Square', it was vandalized with graffiti. Hearings were held, and it became clear that federal workers objected to having to walk around such a large structure on the way to their offices. The *Arc* was seen as a restriction to freedom of movement and as an imposition of someone else's taste on people who had to encounter the work every day. Further, there was a conflict between the so-called elitism of the art world and that of the ordinary worker and taxpayer, which revived the issue of whether the government should fund the arts at all. On an even larger scale the controversy became symbolic of an opposition between the public and art.[3]

Serra defended his sculpture on the grounds that it was pre-cisely the position of the work that made viewers aware of their environment and of their own movements through the space of the Square. In other words, it altered their perception, which is what unfamiliar works of art generally do – compare Victor Hugo's declaration that innovative works of art and literature 'create a shudder'. This, it seems, is precisely what *Tilted Arc* did. In March 1985, a public hearing was held to determine the fate of the *Arc*. Artists, critics, and curators supported the work as a masterpiece of Minimalism, whereas federal workers claimed that it blocked their free use of Foley Square, interrupted the view, attracted vandalism and rats, and might even become a target for terrorist bombs. The jury decided by a vote of four to one to remove *Tilted Arc*.

Suggestions that the piece be relocated were vetoed by the artist. He insisted that it was site-specific and that he would disown *Tilted Arc* if it were removed from Foley Square. Furthermore, he observed that it is not the function of art to be democratic. But his appeals failed and, in 1989, at considerable expense, the work was cut into three sections and removed under cover of night to a scrap-metal yard. Today, Richard Serra is a highly esteemed artist, with sculptures in the style of *Tilted Arc* in

public spaces throughout the world – including the plaza in front of the Berlin concert hall, near the entrance to Liverpool Street Station in London, and in the Guggenheim Museum in Bilbao, Spain. At the time of the *Tilted Arc* controversy, Serra asserted that the function of art is not to please viewers or to be democratic. Like all such controversies, if the art is destroyed as this was, the public, which originally opposed the art, loses in the end. Imagine if Michelangelo's Sistine Chapel frescoes had been erased by conservative popes or his *Pietà* had been destroyed by the Inquisition. Today, that seems absurd, but at the time, in the heat of controversy, the importance of the art is lost in political, religious, and aesthetic fervor so that people miss the proverbial woods for the trees. That is what happened with *Tilted Arc*, and will no doubt continue to happen.

Fervent controversy over issues of decency and the First Amendment guarantee of free speech was raised during the late 1980s by government National Endowment for the Arts (NEA) grants awarded to two photographers, Andres Serrano and Robert Mapplethorpe. In 1987, Andres Serrano created a large Cibachrome photograph entitled *Piss Christ*. It was part of a 1989 group exhibition of prize-winning artists organized by the Southeastern Center for Contemporary Art (SECCA) and held in Winston-Salem, North Carolina. As a result of being one of ten artists chosen for the exhibition, Serrano had been awarded an NEA grant of $15,000. Several museums exhibited the work without incident, but when it was shown at the Museum of Fine Arts in Richmond, Virginia, it aroused the ire of viewers, including the clergyman who had founded the American Family Association. He objected to the fact that the artist had placed a crucifix in a four-gallon Plexiglas container of his own urine, which he photographed so that a streak of soft yellow light appeared to shoot through a red background and illuminate the image of Jesus on the Cross. The museum was accused of promoting hatred and intolerance. Serrano was accused of blasphemy,

bigotry, anti-Christian sentiments, and indecency in thousands of letters of protest sent to Congress. He also received threats from Christian fundamentalists.

In fact, Serrano's photograph does have aesthetic value and, like much of his work, evokes a powerful response on the part of the viewer. In the case of *Piss Christ*, the image is soft, reflective, even restful, despite the content. It would probably not have bothered anyone had they not been told (by virtue of the title) the identity of the media used by the artist. Serrano himself said that at the time he was interested in the theme of body fluids, as were other artists, particularly in the context of the AIDS crisis. As with Veronese's defense of artistic license when the Inquisition objected to his *Last Supper*, the opposition prevailed. The United States Congress voted to halt funding to SECCA in the amount of $15,000, and passed a one-year prohibition on grants to artists depicting indecent subjects in a way that has no artistic value. By cutting SECCA funds to match Serrano's grant, Congress essentially agreed that *Piss Christ* had no serious artistic value, which in fact it did have – as had Veronese's *Last Supper* and Michelangelo's *Pietà* and Sistine Chapel frescoes.

Robert Mapplethorpe's imagery is often unabashedly disturbing, with sexually explicit, sadistic, masochistic, and homosexual content. The NEA awarded a $30,000 grant to the Institute of Contemporary Art for a Mapplethorpe exhibition entitled *Robert Mapplethorpe: The Perfect Image*, which, like *Piss Christ*, was shown in several major museums without incident. But the Corcoran Gallery of Art in Washington DC, where the exhibition was scheduled to open in July, 1989, caved in to pressure from conservative groups and canceled it. In the following year, 1990, the Mapplethorpe show was scheduled to open in Cincinnati, Ohio, at the Contemporary Arts Center. The director placed the most explicit photographs – the X-Portfolio – in a separate space that was off limits to viewers under the age of eighteen. But even though the first President Bush defended the

NEA, as well as First Amendment protection of free speech, there was a flood of protest in Cincinnati. The views of those who opposed the show on the grounds that the pictures were obscene, uncivilized, and morally offensive were publicized in the local press; they argued that the Arts Center should be held criminally liable for exhibiting such works. The director of the Arts Center was indicted for obscenity in April 1990, and the case went to a jury trial in September. Five days later the jurors – noting that the function of art is not necessarily to be 'pretty' – found the Arts Center and its director innocent of the charges. Although they were disturbing, Mapplethorpe's photographs did not meet the legal criteria for obscenity. Since they are beautifully printed, generally in black and white, the pictures do have aesthetic quality. In fact, one might argue that a characteristic of Mapplethorpe's sexually explicit photographs is the very contrast between the disturbing subject matter and the elegant, aesthetic quality with which they are printed. But as a result of additional lobbying, Congress cut NEA funding by another $30,000, equivalent to the grant awarded to the Institute of Contemporary Art. As of this writing, certain political factions are attempting to eliminate all public support for the NEA.

CHRIS OFILI: ELEPHANT DUNG AND *THE HOLY VIRGIN MARY*

In 1999, the Brooklyn Museum in New York mounted an exhibition of contemporary British art entitled *Sensation*, with works from the collection of the English advertising tycoon Charles Saatchi. The one work in the show that aroused the most heated controversy was a colorful painting by Chris Ofili, winner of the previous year's Turner Prize. The work showed a black Virgin Mary dressed in a blue cloak and set against a yellow background enlivened with

patterns created by little details of the female genitalia. What most irritated the critics, however, was the small lump of resin-coated elephant dung on the Virgin's breast.

The artist, who is of Nigerian descent, grew up in Manchester, in northern England, and received a Masters degree from London's Royal College of Art. In 1992 he visited Zimbabwe on a grant and became interested in African culture, which he combines with Western tradition in his paintings. At first he used dung he brought back from Zimbabwe, and, when that ran out, he obtained dung from the London Zoo. In Africa, elephant dung has positive associations and was endowed with fertilizing power. Similarly, in ancient Egypt the scarab dung beetle was associated with Khepri, the god who pushed the sun across the sky – just as the beetle rolled balls of dung along the ground. As with elephant dung, the dung beetle was a sign of rebirth, and its dung was believed to be reborn each day like the sun.

Oblivious to the cultural significance of elephant dung, one person smeared paint on the Brooklyn Museum to protest the show and another attacked the painting itself. Without having seen the painting, or indeed any part of the exhibition, New York's Mayor Rudy Giuliani tried to close the museum, cancel its funding from the city, and fire its board of directors. This, of course, led to outcries from academics and artists, and to protesting crowds gathering outside the museum. An art historian at the University of Chicago, W.J.T. Mitchell, aptly described the controversy as instructive 'high entertainment'. The issue was closed when a legal agreement required the city to restore the museum's funding and drop the lawsuit.

The Turner Prize in the UK

Destined to become a perennial source of controversy by its very nature, the UK's prestigious Turner Prize, established in 1984, buys promising work by contemporary artists for London's Tate Museum. The original award paid ten thousand pounds sterling

to the winner, a sum that has increased substantially since 1984. The prize was named for Joseph Mallord William Turner, who, in his own day, had been controversial because of his expression-istic colors and dynamic forms that often blended with one another. Not every decision made by the judges of the Turner Prize has been fraught with controversy – but by virtue of choosing contemporary avant-garde artists, their decisions dem-onstrate time and again the power of visual art to provoke intense reactions.

Included in some of the less passionate controversy – appar-ently for nationalistic reasons – were Malcolm Morley (who won the first prize in 1984), because, although British, he had been living in the United States for twenty-five years, and Wolfgang Tillmans (the winner in 2000), because he was German rather than British. In 1996, there was opposition because the shortlist of contestants consisted only of men and because for the first time the prize went to a video artist, Douglas Gordon. The fol-lowing year, objections were raised to the fact that the shortlist contained only women, allegedly pandering to political correct-ness. There were additional objections raised by those who thought the prize was too often awarded to Conceptual artists. In 2001, for example, the Scottish artist Martin Creed won with his *Work No. 227: The lights going on and off*. Installed in an otherwise bare room, lights were timed to go on and off every five seconds, and the artist was quoted in the *Daily Telegraph* (10 December 2001) as describing his work as being about 'the quality of nothing'. This notion, along with the Conceptual style of the nominees, irritated Britain's Culture Minister, who declared the works by the artists on the shortlist to be 'cold, mechanical, Conceptual bullshit'.

In 1999, it was an artist on the short list, rather than the winner, Steve McQueen (a film and video artist), who sparked the most intense controversy. Tracey Emin's installation entitled *My Bed* consisted of her own unmade bed, rumpled sheets and all.

On a blue rug next to the bed were scattered cigarette butts, unwashed underwear, and empty liquor bottles – all allusions to the artist's presence even though she is not there. As such, the work was a kind of autobiographical statement of Emin's intimate self, publicly exposed, and of a section of her personal space. This time, Britain's Secretary of Culture aired his concern that the 'shock' (Hugo's 'shudder') created by such work would be bad for the country's international image.

The controversy over arts versus crafts became an issue again in 2005, when Simon Starling won the Turner Prize for his *Shedboatshed*. He made a wooden shed into a boat, sailed it down the Rhine, and then turned it back into a shed. Is it art? was asked repeatedly. Is craft art? Is an idea art? Is a boat trip art? people wondered. Questions about low versus high art were again raised three years later, when Mark Leckey, who incorporated comic book characters such as Felix the Cat and Homer Simpson into his work, won the prize.

In 1993, the winner, Rachel Whitread, raised controversy with her work entitled *House* and came into conflict with the taste of local authorities. She chose a condemned Victorian house at 193 Grove Road in the East End of London and made a concrete cast of the interior. She then stripped away the exterior, leaving the cast of the interior devoid of such architectural features as windows, doors, and a roof. The result was a spectral, block-like structure, reminiscent of her 1990 work entitled *Ghost*, in which she had made a plaster cast of one room, rather than of a whole house. In both works, Whitread essentially made sculptures of spaces and voids, which produced an other-worldly, unexpected effect. *House* caused an uproar and many outraged viewers wanted it torn down. Protests in support of the work notwithstanding, *House* was demolished on the grounds that the artist had not secured planning permission for the structure. As had been the case with Serra's *Tilted Arc*, another modernist work of art was permanently lost and now exists only in photographs.

Ghost, however, was acquired by the National Gallery in Washington, DC.

Perhaps the most 'difficult' of the works so far awarded the Turner Prize, and one that has raised an enormous amount of controversy, is Damien Hirst's *Mother and Child, Divided*, which won in 1995. This consisted of a cow and calf cut in half and immersed lengthwise in a light blue formaldehyde solution in a glass tank. Creating shock *and* 'shudder', Hirst made visible the insides of the animals as well as their outsides, reflecting a duality that pervades the work. Life and death are also opposed, as is the notion of preservation implied by the formaldehyde versus the reality of rotting flesh. These themes are also present in traditional Madonna and Child iconography, which evokes Christian beliefs in life after death, resurrection of the flesh, and the universal mother–child relationship. The original work is now in the Modern Museum in Oslo, but replicas have been made for various temporary exhibitions. When a version of the sculpture traveled to Japan, it ran into the ban on imported beef, and special arrangements for its entry into the country had to be made.

An ongoing controversy

Arguments have erupted in Elk Grove, California, over a work of architecture. In 2006, Elk Grove decided to hold a competition for a civic center consisting of seventy-eight acres. The city council chose Zaha Hadid, a native of Baghdad whose internationally known architectural firm is located in London. This, the mayor thought, would put Elk Grove on the map. However, by 2011, the 2008 recession had intervened, a new council had been elected, and the new mayor disliked the project. The design that Hadid submitted was an elegant chrome structure with curvilinear projections that reminded some viewers of a giant squid

or starfish. The project met with vociferous objections during a council meeting. One person compared the plan to something one might see in Dubai, another to a science fiction image, and another found it incompatible with the character of Elk Grove. Positive comments applauded the space left available for soccer and softball fields. The upshot, as of this writing, is that a new competition is in the offing – the present mayor is against the present design, but the city's planning director, quoted as saying 'I'll be disappointed if this ends up as Anytown, USA', hopes that Hadid's firm will propose a new project.

Most instances of controversy in the arts, however, tend to lose force with time, and Elk Grove's turmoil will probably be no exception. Viewers gradually become used to what had originally been shocking, or shudder-producing, and eventually wonder what all the fuss was about. The power of imagery is such, however, that it will almost certainly continue to produce controversy as artists continue to pursue new styles, use new materials, and create new ways of changing how the world looks at, sees, and reads works of art. This brings us to our last chapter – what is the future that art has in store for us?

Conclusion:
the future of art

The future is a time that never comes; it is always ahead of us. The past has come and gone, and thus is history; the present is what we experience directly, but it doesn't last long, since, as they say, time marches on. The future of art, therefore, like all futures, is a construct; in financial circles, futures are a bet. Collectors who bet successfully on the future value of a work of art or on the significance of a style of art can, like the Sculls, reap enormous financial rewards as well as personal satisfaction. So far, one thing seems certain: art has always had a future, although notions of such a future have ranged from optimistic to despairing, and the art of choosing which art will have a profitable future seems to be a matter of talent – 'an eye' – on the part of a particular viewer.

On occasion, artists have weighed in on the future of art. In 1912 the Greek-born Italian Surrealist artist Giorgio de Chirico wrote that the 'aim of future painting' will be 'the same as that of poetry, music, and philosophy; to create previously unknown sensations; to strip art of everything routine and accepted, and of all subject matter, in favor of an aesthetic synthesis; completely to suppress man as a guide ... to free itself from the anthropomorphism that always shackles sculpture; to see everything, even man, in its quality of *thing*'.[1] De Chirico made this statement at a time when avant-garde artists were trying to free themselves from the Classical tradition and were looking to non-Western art, especially geometric African sculpture, for inspiration. The year 1912 was five years after Picasso painted his *Women of Avignon*, and one year after the two Cubist exhibitions in Paris.

De Chirico's prediction suggested a non-figurative future for art styles, which was fulfilled first in Kandinsky's Expressionism and then more widely in American Abstract Expressionism. De Chirico's notion was also consistent with Brancusi's 'essence of things'.

In 1966, the Earth Artist Robert Smithson declared that 'painting, sculpture and architecture are finished, but the art habit continues'.[2] He was not referring to figurative versus non-figurative art, but rather to the idea that traditional art categories have been superseded by newer art categories. In 1969, the Conceptual artist Joseph Kosuth said, 'I really think the future of art has to do with a certain way of filling the gap which philosophy left'.[3] By this he meant that philosophy, like religion, has declined in the cultural consciousness and that art will take the place of both. In 1984, Danto announced the death of art. Since then, however, he has published a number of qualifications of his notion that art died after Warhol, notably by saying that he really meant 'the end of the master narratives of art' and that 'radical pluralism' defined 'the objective structure of the art world'.[4] There is, of course, no indication that the narratives of art have come to an end or that the 'structure', if there is one, of the art world will be tomorrow what is today.

'ART IS DEAD'

This claim has a long history. The ancient Roman author Pliny the Elder announced the end of art after the first Olympiad. In 1550 Vasari wrote that, since art had achieved perfection in the work of Michelangelo, it had nowhere else to go and had thus come to an end. In the seventeenth century, the French Baroque painter Nicolas Poussin accused the Italian Baroque painter Caravaggio of having destroyed the art of painting. In contrast to the restrained classicism of Poussin, Caravaggio's style was famous for its expressive and emotive drama. For Clement Greenberg, modernism emerged as naturalism declined, and for Danto art died from within its own historical imperative.

Despite the insights of some artists, critics, and collectors into ways in which art might develop, its future is by and large unknowable. Who, before the twentieth century, could have known or even imagined what directions art styles would follow? Who would have thought that urinals, Brillo boxes, and fluorescent light bulbs would become either media or subjects of art – especially since none of those objects existed before the twentieth century? 'Found objects' and graffiti, in contrast, have existed for thousands of years, but they did not become a category of art before 1900.

In the early twentieth century, Futurists imagined a future based on technology and machinery, as well as the total destruction of the past and of things that recorded the past such as libraries and museums. In 1911, the two Cubist exhibitions in Paris shocked the art community with their radical depictions of space, and in 1913 the Armory Show shocked New Yorkers with what the avant-garde had been doing in Europe. The Dada movement, and especially the Readymades of Duchamp, seemed outrageous. Abstract Expressionism came as a shock to viewers in the 1940s and 1950s, and Pop Art in the 1960s caused a Hugo-esque 'shudder', according to Steinberg, in a public that had become accustomed to Abstract Expressionism. In fact, the very notion that art has the power to shock inspired the title of a popular book and television series on modern art entitled *The Shock of the New* (1980) by the critic Robert Hughes. After Pop Art had become an accepted style, it was the prices of Pop Art that produced shock – notably at the auctions of the Scull collection. Then along came the Minimalists and Conceptualists; and who could have imagined a future in which an artist – Sol LeWitt – would sell instructions for making a work of art rather than the work itself? When Christo and Jeanne-Claude first wanted to wrap a building, they were told that a building could not be wrapped (personal communication from the artists). Nevertheless, in 1967 and 1968, Christo wrapped the Kunsthalle in Berne, Switzerland

to celebrate the fiftieth anniversary of the museum, and at the same time Jeanne-Claude wrapped a medieval tower in Spoleto, Italy, during the Festival of the Two Worlds. Neither artist saw the 'wrapping' of the other since the two projects overlapped. Together Christo and Jeanne-Claude wrapped two major architectural monuments – the Reichstag in Berlin and the Pont Neuf in Paris. Artists, it appears, fulfill the popular wisdom contained in the assertion: 'Never say never'.

Developments in technology, such as cameras, airplanes, automobiles, and space ships, had been imagined long before the twentieth century, though their actualization remained in the future. But it is not likely that members of a prehistoric civilization would have imagined a future that included computers, light bulbs, or steam engines. Ancient Greeks could not have imagined Christian art; the medieval Catholic Church could not have imagined the Protestant Reformation, which brought about changes in both patronage and subject matter. As recently as a hundred years ago, digital imagery, which is so prevalent today, was still to come.

Another expression of the unknowable future of art can be seen in the role played by media as content of art. In 1948, Hans Hofmann recognized the importance of artistic media when he asserted that 'The medium becomes the work of art'. But, he added, the artist has to understand both the nature and the 'governing principles' of the medium.[5] The enormous impact of media – whether in art or in society-at-large – is reflected in the famous statement of Marshall McLuhan in 1964: 'The medium is the message'.[6] McLuhan foresaw the importance of technology and the increasing general awareness of the meaning of material, which is as true in art as it is in other fields. The media of art have intrinsic aesthetic potential, as well as physical, psychological, and symbolic significance for artists and cultures. Today, modern technology has given us the computer, digital imagery, and the Internet, all of which have made globalization possible.

But who would have foreseen, before the invention of the computer, that pixels could replace brushstrokes as picture elements? Although digital elements can be manipulated on a computer and printed out to become a material presence, they lack the tactile qualities inherent in drawing, painting, mosaic, stained glass, wood, bronze, marble, and other traditional art media.

Subjects and themes of Western art have been remarkably constant for thousands of years, but they have also changed. Some of the most persistent subjects include rulers, gods and goddesses, nudes, portraits and self-portraits, animals of various types, landscapes and still lifes, warfare, and genre. All of these subjects continue to be represented by artists today, contradicting Danto's assertion that the 'narratives' of art have come to an end. It is unlikely that prior to the twentieth century one could have predicted future subjects of sculptures such as Emin's installation of an unmade bed. Although animals have been depicted by artists since the Paleolithic period, who could have predicted that Damien Hirst would create a sculpture of a cow and calf cut in half and preserved in formaldehyde? Themes in art have also persisted throughout the ages, one of the most prevalent being the mother–child relationship, for example, in Leonardo's *Madonna and Child with St Anne* (see **Figure 25**). Hirst's sculpture is well within the mother–child tradition, but its style, medium, and presentation are unprecedented.

Difficult as it is to predict the future, artists seem to have a heightened sense of what will happen in both society and in art styles. One example of foresight as regards the subjects and themes of art can be seen in an exhibition held from 19 November 2008 to 22 February 2009 at the German Historical Museum in Berlin. Entitled *Kassandra: Visions of Disaster*, the show featured pictures by Kandinsky and a number of German artists between 1900 and 1939 that were apocalyptic in nature. The exhibit reflected the Greek Classical notion that artists are like prophets; both have foresight, because they are able to 'read' the *zeitgeist*

(the mood of a period) more intensely than most people. Some of the German artists at the time represented themselves literally as prophets. The name of the show, *Kassandra*, was inspired by the legendary Greek Kassandra, whom the gods had blessed with the gift of prophecy but cursed with the fate that no one would believe her. When she warned that the Greeks would destroy Troy and that Agamemnon would be murdered by his wife and her lover, no one listened. When artists painted images of war, first under Kaiser Wilhelm II who led Europe into World War I and then as Hitler began taking power, few viewers appeared to connect the images with the *zeitgeist* or with the future.

Artists are typically less shocked by newness, notably their own, than is the general public. Since artists, especially the more significant artists such as Cézanne and Picasso, are the ones who create newness, they are in a position of aesthetic and stylistic leadership; they are the avant-garde. Their work illustrates the fact that art need not conform to accepted standards of beauty or to tradition, and that great art rarely does so. With his drip paintings, Pollock created a new technique of applying paint. With his Readymades, Duchamp created new definitions and boundaries of art.

The future is always more predictable in retrospect. Just as looking back on the *Kassandra* exhibition makes us realize that artists had a sense of the forthcoming disasters that would lead to World War I and World War II, so certain changes in style seem to have predicted what might come next. For example, in the late Gothic period, there was an increase in the intimacy of the mother–child relationship that intensified during the Renaissance. As Renaissance philosophers and artists learned more about ancient Greece and Rome, art became more naturalistic and reflected the Greek notion that man was the center of the universe. In retrospect, new geographical exploration and discoveries of hitherto unknown worlds, beginning in the Renaissance,

can be seen as a precursor to late nineteenth-century artists who began to collect, and be influenced by, non-Western art.

As the formal space of paintings began to flatten during the nineteenth century, and Cézanne depicted a geometric vision of nature, someone with foresight might have predicted Picasso or recognized that his *Women of Avignon* signaled the development of a revolutionary new style, namely Cubism. Similarly, someone might have understood that the mood-creating colors of Post-Impressionism and its dynamic brushstrokes would lead to Expressionism and Abstract Expressionism. The fragmentation that swept Western Europe during and after World War I was reflected in Dada and in collage. Surely, one ought to have known that, with digital technology and the internet, globalization in the arts was inevitable. But this is all hindsight.

What we can safely say about the future of art is that as long as the human race exists, art has a future. Arguments about whether a particular artist, style, or work of art is good, bad, ugly, beautiful, indecent, or indifferent will continue. The boundaries of art will continue to expand as will the accepted categories of art, because it is in the nature of art, as it is in the nature of all creative endeavors, to explore uncharted territory. In matters of art, artists tend to lead and art theory, art criticism, philosophies of art, and the art market follow in their wake.

In the *Poetics*, Aristotle differentiates between historians and poets: historians, he says, tell us what has happened and poets tell us what might happen. From this he concludes that poetry is more scientific than history because it produces general truths rather than specific facts. The same could be said of art and artists – and the greater the artist, the more he or she is likely to sense what will be. To quote Denis Dutton once again: 'As art forms and techniques change and develop, as artistic fashions blossom or fade, so art theory too tags along, altering its focus, shifting its values'.[7]

Instead of being shocked, shuddering at newness, and declaring the death of art, the viewing public would do well to take a deep breath, recognize that artists have something to say, study their work and, before denouncing what is unfamiliar and seemingly outrageous, consider the lessons of history.

Glossary

acrylic a fast-drying, water-based paint

aesthetics the philosophy and science of art

altarpiece a work consisting of painting and/or sculpture placed behind or on an altar

apadana a royal audience hall in an Achaemenid palace

apse a projecting part of a building (especially a church), which is usually semi-circular and surmounted by a half-dome

architecture the art and science of building for human use

assemblage a work of art made by grouping together three-dimensional objects

atmospheric perspective a technique for showing distance by making colors less distinct and reducing their intensity

attribute an identifying characteristic

avant-garde literally 'the advanced guard'; innovators in a field, especially art

basilica in ancient Rome a rectangular building with an apse at each end, used for trials, shops, and meeting places; in Christian architecture, the form of the church building based on the Roman prototype

buon* (true) *fresco see *fresco*

calligraphy literally 'beautiful writing'; the art of fine writing

cartoon a preparatory drawing, which can be transferred to a surface to be painted

carve to create a three-dimensional image by removing material with a sharp instrument

chiaroscuro the gradual change in light and dark to create the illusion of three-dimensionality

chryselephantine made of gold and ivory

citadel an elevated, fortified area

collage a work of art made by attaching fragments of material, such as paper or cloth, to a flat surface

column a vertical support, which may consist of a *base*, a (vertical) *shaft* and (decorative) *capital*; in the *Doric Order* (see below), there is no base and the shafts are decorated with *flutes* (concave indentations that run the length of the shaft)

composition the arrangement of formal elements

contour the edge of a figure or object

corbel arch an arch formed by the meeting of two corbels (masonry courses, each of which projects beyond the one below it)

cromlech a prehistoric monument consisting of a ring of stone monoliths

cuneiform the earliest known writing system invented in ancient Mesopotamia and consisting of wedge-shaped characters

cyclopean masonry stone construction using large, unfinished blocks of stone without mortar

Doric Order a system of elevation invented on the ancient Greek mainland; from the bottom up, parts include the three steps, columns (shaft with flutes and capital consisting of the *echinus* and *abacus*), the entablature (consisting of the *architrave*, frieze with *triglyphs* and *metopes*, and the *cornice*)

dynasty a family of rulers

embroidery the process of creating designs on cloth, leather, or other material; an object created by such a process

encaustic a painting medium using pigment mixed with hot wax, which is fixed by heat

engraving a process of incising an image on a hard surface such as wood, metal, or stone; a print made by such a process

etching a process in which a print or impression is taken from a metal plate on which an image has been eaten away by acid; a print made by such a process

figurative art art that represents figures and objects in a recognizable way

flying buttress a buttress shaped like half an arch

fresco a painting technique in which paint is applied to a plaster surface; in *fresco secco*, the paint is applied to a dry plaster surface; in *buon* (true) *fresco*, the paint is applied to a damp plaster surface with which it bonds

frieze a horizontal band that is decorated with pictures or relief sculpture

frontal facing front

genre a category of art representing scenes of everyday life

hatching parallel lines used to create an impression of shading or shadow in drawings and prints; *cross-hatching*: a second set of parallel lines set at an angle to the hatching lines

hieroglyphs ancient Egyptian picture writing

illuminated manuscript a handwritten page decorated with painted illustrations, especially in the Middle Ages and Renaissance

impasto thickly applied paint

incise to carve into a surface

linear perspective a mathematical system of creating the illusion of depth on a flat surface, invented around 1400 in Italy

linocut a print made by cutting forms into linoleum

lithograph a print made by making an image with a greasy substance on a stone plate

medium (pl. **media**) the material of a work of art

megalithic made of large, unfinished stones, usually in prehistoric architecture

Mesolithic referring to the Middle Stone Age

methodologies of art approaches to interpreting art: *formalism* (in which form is content); *iconography* (the study of how an image is 'written', the meaning of the subject matter); *Marxism* (reading works of art in terms of economic and social context); *feminism* (reading works in so far as they pertain to women); *biography and autobiography* (reading works from the point of view of the artist's life); *psychoanalysis* (reading works from the point of view of the artist's unconscious, or the unconscious meaning of cultural conventions); *semiotics* (reading works using a system of signs and deconstruction)

modeling in pictures, using shading to suggest light and dark; in sculpture, creating form by manipulating a pliable material with one's hands

monolith a single large stone block

monumental being or appearing big

mosaic an image made by arranging colored tiles or pebbles

mummy an embalmed body, especially in ancient Egypt

naos the main room for a cult statue in a Greek or Roman temple

nave the long central aisle of a church or basilica

necropolis ancient burial ground; literally 'city of the dead'

Neolithic referring to the New Stone Age

non-figurative abstraction a style of art that does not represent recognizable forms

obverse the front side of a coin or medal

Paleolithic referring to the Old Stone Age

patron a person or group that commissions a work of art

pediment the triangle at the top of the cornice on the short ends of a Greek temple. Also a triangular element over a door or window

pharaoh an ancient Egyptian ruler

picture a two-dimensional image

pigment a powdered substance that gives color to paints, inks, etc.

plane a flat surface having a direction of space

polytheism the belief in many gods

portrait a likeness

post-and-lintel an architectural system of elevation in which a vertical (post) supports either end of a horizontal (lintel)

pyramid a solid geometric shape having a square base and four triangular sides that meet over the center of the square; in ancient Egypt, a place of burial

relief sculpture a sculpture in which one side has not been cut away from the original material

reverse the back side of a coin or medal

rose window in Gothic architecture, a large, round, stained glass window

scriptorium (pl. **scriptoria**) a room in a convent or monastery where manuscripts are produced

sculpture a three-dimensional image

sculpture-in-the-round a free-standing, three-dimensional work of sculpture

sfumato a technique to create softened form by gradual changes of light and dark

shading a gradual change from light to dark

silhouette the outline of a figure, usually filled in with a uniform, unshaded color

size a mixture of glue or resin to make the surface of a painting less porous

stained glass pieces of colored glass held in place by lead strips, especially in windows

stele an upright stone slab, often decorated with relief sculpture or an inscription

stylization a surface detail which has been distorted according to a convention of representation

symmetry an aesthetic balance in which two sides of an image are mirrors of each other; *asymmetry* the absence of symmetry

tapestry a heavy woven textile, often with designs

tempera paint made by mixing pigments with egg yolk and water

tessera (pl. **tesserae**) a small piece of stone or glass tile used in mosaic

transept a cross arm perpendicular to the nave in a church

trilithon a single post-and-lintel, in which an upright (the post) supports either end of a horizontal (the lintel)

trumeau a stone slab between two doors in Romanesque and Gothic architecture

typology a system of reading history in which past events or personages are types (prefigurations) for later events or personages

woodcut a print made by carving an image on a wooden block

ziggurat in ancient Mesopotamia, a stepped structure symbolizing a mountain

Notes

Chapter 1

1. Baudelaire cited in Rose, *Oldenberg*, p. 19.
2. Kokoschka cited in Ashton, ed., *Twentieth-Century Artists*, p. 17.
3. Hofmann cited in Chipp, *Theories of Modern Art*, p. 539.
4. Henri Matisse, 'Looking at Life with the Eyes of a Child, 1953', in Flam, ed., *Matisse on Art*, p. 148.
5. Kosuth cited in Mazona, *Conceptual Art*, p. 72.
6. Giménez and Gale, eds., *Constantin Brancusi*, frontispiece.
7. Hegel, *Aesthetics*.
8. Greenberg cited in Chipp, *Theories of Modern Art*, p. 580.
9. See Danto, *Philosophical Disenfranchisement*.
10. All quotations from Steinberg in the next two paragraphs are from 'A Symposium on Pop Art' (1963) in Fabozzi, ed., *Artists, Critics, Context*, pp. 127–30.
11. See Dutton, *Art Instinct*.
12. Ibid., p. 33.
13. Ibid., pp. 50–1.
14. Ibid., p. 51.
15. Cited in Brown, *Story of the Armory Show*, pp. 112–13.
16. Marien, *Photography*, p. 26.

Chapter 3

1. Newman, 1947, cited in Chipp, *Theories of Modern Art*, p. 551.
2. Newman, cited in ibid., p. 552.
3. Newman, cited in ibid., p. 552.
4. Hans Hofmann, 1948, cited in ibid., p. 539.

Chapter 4

1. Nochlin, *Women, Art, and Power*, p. 23.
2. Ibid., p. 4.
3. See Gedo, *Picasso*.
4. Derrida, *Truth in Painting*.
5. Steinberg cited in Fabozzi, ed., *Artists, Critics, Context*, p. 129.

Chapter 5

1. Piet Mondrian, 'Plastic art and pure plastic art (figurative art and non-figurative art)', 1937, cited in Chipp, *Theories of Modern Art*, p. 352.

Chapter 6

1. See Freedberg, *Power of Images*.
2. James McNeill Whistler in a letter to Fantin-Latour, cited in Weintraub, *Whistler*, p. 124.
3. For further discussion of Serra's *Tilted Arc*, see Senie, *Tilted Arc Controversy*.

Conclusion

1. De Chirico cited in Chipp, *Theories of Modern Art*, p. 397.
2. Smithson cited in Graziani, *Robert Smithson*, p. 1.
3. Kosuth cited in Gale, *Artists Talk*.
4. Danto, *After the End of Art*, p. xv.
5. Hofmann, cited in Chipp, *Theories of Modern Art*, p. 539.
6. McLuhan, *Understanding Media*.
7. Dutton, *Art Instinct*, p. 48.

Bibliography

Ashton, Dore, ed., *Twentieth-Century Artists on Art* (New York: Pantheon, 1985).

Brown, Milton W., *The Story of the Armory Show* (New York: Abbeville, 1963).

Chipp, Herschel B., *Theories of Modern Art* (Berkeley and Los Angeles: University of California Press, 1968).

Danto, Arthur C., 'Appreciation and Interpretation', in *The Philosophical Disenfranchisement of Art* (New York: Columbia University Press, 1986).

—— *After the End of Art* (Princeton: Princeton University Press, 1997).

Derrida, Jacques, *The Truth in Painting*, trans. Geoff Bennington and Ian McLeod (Chicago and London: University of Chicago Press, 1987).

Dutton, Denis, *The Art Instinct* (New York: Bloomsbury Press, 2009).

Fabozzi, Paul F., ed., *Artists, Critics, Context* (Upper Saddle River NJ: Prentice-Hall, 2002).

Flam, Jack D., ed., *Matisse on Art* (New York: E.P. Dutton, 1978).

Freedberg, David, *The Power of Images* (Chicago and London: University of Chicago Press, 1989).

Gale, Peggy, *Artists Talk, 1969–1977* (Nova Scotia: The Press of the Nova Scotia College of Art and Design, 2004).

Gedo, Mary, *Picasso: Art as Autobiography* (Chicago: University of Chicago Press, 1980).

Giménez, Carmen and Matthew Gale, eds., *Constantin Brancusi, the Essence of Things* (New York and London: Guggenheim Museum, 2004).

Graziani, Ron, *Robert Smithson and the American Landscape* (Cambridge: Cambridge University Press, 2004).

Hegel, G.F.W., *Aesthetics: Lectures on Fine Art* (2 vols.), trans. T.M. Knox (Oxford: Oxford University Press, 1975).

Hughes, Robert, *The Shock of the New* (New York: McGraw-Hill, 1991).

Marien, Mary Warner, *Photography. A Cultural History* (London: Laurence King, 2002).

Mazona, Daniel, *Conceptual Art* (Cologne and London: Taschen, no date).

McLuhan, Marshall, *Understanding Media: The Extension of Man*, first edition (New York: McGraw-Hill, 1964).

Nochlin, Linda, *Women, Art, and Power and Other Essays* (New York: Harper and Row, 1988).

Rose, Barbara, *Claes Oldenberg* (New York: Museum of Modern Art, 1970).

Senie, Harriet F., *The Tilted Arc Controversy* (Minneapolis and London: University of Minnesota Press, 2002).

Weintraub, Stanley, *Whistler* (New York: Weybright and Talley, 1974).

Further reading

Adams, Laurie, *Art on Trial: from Whistler to Rothko* (New York: Walker, 1976).

—— *Looking at Art* (Englewood Cliffs NJ and London: *Exploring Art*, Laurence King, 2002).

Adams, Laurie Schneider, *Art and Psychoanalysis* (New York: HarperCollins, 1993).

—— *Italian Renaissance Art* (Boulder CO: Westview, 2001).

—— *The Methodologies of Art*, 2nd edition (Boulder CO: Westview, 2010).

—— *A History of Western Art*, 5th edition (New York: McGraw-Hill, 2011).

Alexander, Jonathan J.G., *Medieval Illuminators and their Methods of Work* (New Haven: Yale University Press, 1992).

Alpers, Svetlana, *Rembrandt's Enterprise. The Studio and the Market* (Chicago and London: University of Chicago Press, 1990).

—— *The Vexations of Art: Velázquez and Others* (New Haven and London: Yale University Press, 2005).

Andrews, Francis B., *The Medieval Builder and His Methods* (Mineola NY: Dover, 1999).

Aristotle, *The Poetics* (Cambridge MA and London: Loeb Library, 1991).

Ashton, Dore, *American Art since 1945* (New York: Oxford University Press, 1982).

Avery, Charles, *Bernini, Genius of the Baroque* (London: Thames and Hudson, 1997).

Barolsky, Paul, *Infinite Jest: Wit and Humor in Italian Renaissance Art* (Columbia SC: University of South Carolina Press, 1978).

Baxandall, Michael, *Giotto and the Orators: Humanist Observers of Painting in Italy and the Discovery of Pictorial Composition, 1350–1450* (Oxford: Oxford University Press, 1971).

—— *Painting and Experience in Fifteenth-Century Italy* (Oxford: Oxford University Press, 1988).

Bearden, Romare and Harry Henderson, *A History of African-American Artists: From 1792 to the Present* (New York: Pantheon, 1993).

Beardsley, John, *Earthworks and Beyond: Conceptual Contemporary Art in Landscape* (New York: Abbeville, 1998).

Beck, James (with Michael Daley), *Art Restoration: The Culture, the Business, the Scandal* (London: John Murray, 1993 and New York: Norton, 1994).

Bell, Clive, *Art* (New York: Capricorn Books, 1958).

Bell, Quentin, *Ruskin* (New York: George Braziller, 1978).

Berger, Robert W., *The Palace of the Sun: The Louvre of Louis XIV* (University Park PA: Penn State University Press, 1993).

Blier, Suzanne, *The Royal Arts of Africa: The Majesty of Form* (New York: Abrams, 1998).

Blunt, Anthony, *Artistic Theory in Italy, 1450–1600* (New York: Oxford University Press, 1994).

—— et al., *Baroque and Rococo: Architecture and Decoration* (New York: Harper and Row, 1982).

Bonfante, Larissa, ed., *Etruscan Life and Afterlife: A Handbook of Etruscan Studies* (Detroit: Wayne State University Press, 1986).

—— *Etruscan: Reading the Past* (Berkeley: University of California Press/ British Museum, 1990).

Brendel, Otto J., *Prolegomena to the Study of Roman Art* (New Haven: Yale University Press, 1979).

Brilliant, Richard, *Roman Art from the Republic to Constantine* (London: Phaidon, 1974).

Bryson, Norman, *Word and Image: French Painting of the Ancien Régime* (Cambridge: Cambridge University Press, 1981).

—— *Tradition and Desire: From David to Delacroix* (New York: Cambridge University Press, 1984).

Carrier, David, *The Aesthete in the City: The Philosophy and Practice of American Abstract Painting in the 1980s* (University Park PA: Penn State University Press, 1994).

—— *High Art: Charles Baudelaire and the Origins of Modernist Painting* (University Park PA: Penn State University Press, 1996).

Cartledge, Paul A., *Alexander the Great* (Woodstock and New York: Overlook Press, 2004).

Castleden, Rodney, *The Making of Stonehenge* (London: Routledge, 1993).

Clark, Kenneth, *The Romantic Rebellion: Romantic versus Classic Art* (New York: Harper and Row, 1973).

Clark, T.J., *The Painting of Modern Life: Paris in the Art of Manet and His Followers* (Princeton: Princeton University Press, 1984).

—— *The Absolute Bourgeois: Artists and Politics in France, 1848–1851* (Berkeley: University of California Press, 1999).

Clunas, Craig, *Art in China* (New York: Oxford University Press, 2009).

Cole, Alison, *Virtue and Magnificence: Art of the Italian Renaissance Courts* (New York: Abrams, 1995).

Cole, Bruce, *The Renaissance Artist at Work: From Pisano to Titian* (New York: HarperCollins, 1983).

Collins, Bradford R., ed., *12 Views of Manet's Bar* (Princeton: Princeton University Press, 1996).

Collins, Bradley I., *Leonardo: Psychoanalysis and Art History: A Critical Study of Psychobiographical Approaches to Leonardo da Vinci* (Evanston IL: Northwestern University Press, 1997).

—— *Van Gogh and Gauguin: Electric Arguments and Utopian Dreams* (Boulder CO: Westview, 2001).

Crane, Diana, *The Transformations of the Avant-Garde* (Chicago and London: University of Chicago Press, 1987).

Crow, Thomas E., *Painters and Public Life in Eighteenth-Century Paris* (New Haven: Yale University Press, 1985).

—— *The Rise of the Sixties: American and European Art in the Era of Dissent, 1955–69* (London: Abrams, 2005).

Cuttler, Charles D., *Northern Painting from Pucelle to Bruegel, Fourteenth, Fifteenth, and Sixteenth Centuries* (Fort Worth TX: Holt, Rinehart & Winston, 1991).

Dachy, Marc, *The Dada Movement, 1915–1923*, trans. Michael Taylor (New York: Skira/Rizzoli, 1990).

Denvir, Bernard, *Post-Impressionism* (New York: Thames and Hudson, 1992).

Diebold, William J., *Word and Image: An Introduction to Early Medieval Art* (Boulder CO: Westview, 2000).

Eitner, Lorenz, *19th-Century European Painting: From David through Cézanne* (Boulder CO: Westview, 2002).

Elderfield, John, *The Cut-Outs of Henri Matisse* (New York: George Braziller, 1978).

Eldredge, Charles C., *Georgia O'Keeffe* (New York: Abrams, 1991).

Farrington, Lisa E., *Creating Their Own Image: The History of African-American Women Artists* (New York: Oxford University Press, 2005).

Flam, Jack D., ed., *Robert Smithson: The Collected Writings* (Berkeley: University of California Press, 1996).

—— *Matisse and Picasso: The Story of Their Rivalry and Friendship* (Boulder CO: Westview, 2003).

Foucault, Michel, *This Is Not a Pipe*, trans. J. Harkness (Berkeley: University of California Press, 1983).

Fry, Roger F., *Vision and Design* (London: Chatto and Windus, 1920).

Geist, Sidney, *Brancusi: The Sculpture and Drawings* (New York: Abrams, 1975).

Geldzahler, Henry, *New York Painting and Sculpture: 1940–1970* (New York: E.P. Dutton, 1969).

—— and Robert Rosenblum, *Andy Warhol: Portraits of the Seventies and Eighties* (London: Thames and Hudson, 1993).

Gombrich, Ernst, *Symbolic Images*, 3rd edition (Chicago: University of Chicago Press, 1985).

—— *Art and Illusion: A Study in the Psychology of Representation* (Princeton NJ: Princeton University Press, 2000).

Green, Christopher, ed., *Picasso's Les Demoiselles d'Avignon* (Cambridge: Cambridge University Press, 2001).

Greenberg, Clement, *Art and Culture* (Boston: Beacon Press, 1961).

Guth, Christine, *Art of Edo Japan* (New York: Abrams, 1996).

Hamilton, George H., *Manet and His Critics* (New Haven: Yale University Press, 1986).

Hauser, Arnold, *Mannerism: The Crisis of the Renaissance and the Origin of Modern Art* (Cambridge MA: Belknap, 1986).

Henri, Adrian, *Total Art: Environments, Happenings, and Performances* (New York: Praeger, 1974).

Herbert, Robert L., *Impressionism: Art, Leisure and Parisian Society* (New Haven: Yale University Press, 1988).

Honour, Hugh, *Romanticism* (New York: Harper and Row, 1979).

—— *Neo-Classicism* (Harmondsworth: Penguin Books, 1987).

Hopkins, David, *Modern Art 1945–2000* (Oxford and New York: Oxford University Press, 2000).

Hultén, Pontus, *Futurism and Futurisms* (New York: Abbeville, 1985).

Irwin, Robert, *Islamic Art in Context: Art, Architecture, and the Literary World* (New York: Abrams, 1997).

Kant, Immanuel, *Critique of Judgment* (1790), trans. Werner S. Pluhar (Indianapolis: Hackett, 1996).

Kramer, Samuel Noah, *History Begins at Sumer: Thirty-nine Firsts in Man's Recorded History*, 3rd revised edition (Philadelphia: University of Pennsylvania Press, 1981).

Lane, Barbara G., *The Altar and the Altarpiece: Sacramental Themes in Early Netherlandish Painting* (New York: Harper and Row, 1984).

Levey, Michael, *Rococo to Revolution: Major Trends in Eighteenth-Century Painting* (New York: Oxford University Press, 1977).

Lippard, Lucy, *Pop Art* (New York: Thames and Hudson, 1985).

Lloyd, Jill, *German Expressionism: Primitivism and Modernity* (New Haven: Yale University Press, 1991).

Locke, Nancy, *Manet and the Family Romance* (Princeton: Princeton University Press, 2001).

Mainardi, Patricia, *The End of the Salon: Art and the State in the Early Third Republic* (Cambridge: Cambridge University Press, 1993).

Marshall, Richard, et al., *Robert Mapplethorpe* (New York: Whitney Museum of American Art, 1988).

—— *Jean-Michel Basquiat* (New York: Whitney Museum of American Art, 1992).

Mathews, Thomas F., *Byzantium. From Antiquity to the Renaissance* (New York: Abrams, 1998).

McLaughlin, Jack, *Jefferson and Monticello: The Biography of a Builder* (New York: Holt, 1988).

Meiss, Millard, *Painting in Florence and Siena after the Black Death* (Princeton: Princeton University Press, 1978).

Meredith, Roy, *Mr. Lincoln's Camera Man, Mathew B. Brady* (New York: Dover, 1974).

Merrill, Linda, *A Pot of Paint. Aesthetics on Trial in Whistler v. Ruskin* (Washington DC and London: Smithsonian Institution Press, 1992).

Meyer, Ursula, *Conceptual Art* (New York: E.P. Dutton, 1972).

Mitchell, W.J.T., *What Do Pictures Want?* (Chicago: University of Chicago Press, 2005).

Newhall, Beaumont, *The History of Photography: From 1839 to the Present* (New York: Museum of Modern Art, 1999).

Nochlin, Linda, *Realism* (Harmondsworth: Penguin Books, 1971).

—— *The Body in Pieces: The Fragment as a Metaphor of Modernity* (London: Thames and Hudson, 1994).

O'Connor, Francis V., *Jackson Pollock* (New York: Museum of Modern Art, 1967).

O'Gorman, James F., *Three American Architects: Richardson, Sullivan, and Wright, 1865–1915* (Chicago: University of Chicago Press, 1991).

Onians, John, *The Bearers of Meaning: The Classical Orders in Antiquity, the Middle Ages and the Renaissance* (Princeton: Princeton University Press, 1985).

Osborne, Robin, *Archaic and Classical Greek Art* (Oxford and New York: Oxford University Press, 1998).

Panofsky, Erwin, *Gothic Architecture and Scholasticism* (New York: World, 1957).

—— *Early Netherlandish Painting: Its Origin and Character* (2 vols.) (New York: Harper and Row, 1971).

Partridge, Loren, *The Art of Renaissance Rome, 1400–1600* (New York: Abrams, 1996).

Passeron, Roger, *Daumier*, trans. Helga Harrison (New York: Rizzoli, 1981).

Pater, Walter, *The Renaissance: Studies in Art and Poetry* (Berkeley: University of California Press, 1980).

Paul, Christiane, *Digital Art* (New York: Thames and Hudson, 2008).

Petzold, Andreas, *Romanesque Art* (New York: Abrams, 1995).

Plato, *The Republic*, trans. Allan Bloom (New York: Basic Books, 1991).

Pomeroy, Sarah B., *Goddesses, Whores, Wives, and Slaves: Women in Classical Antiquity* (New York: Shocken Books, 1995).

Powell, Richard J., *Black Art and Culture in the Twentieth Century* (London: Thames and Hudson, 1997).

Praz, Mario, *The Romantic Agony* (New York: Oxford University Press, 1983).

Preziosi, Donald and Louise A. Hitchcock, *Aegean Art and Architecture* (Oxford and New York: Oxford University Press, 1999).

Quirke, Stephen and Jeffrey Spencer, *The British Museum Book of Ancient Egypt* (London: British Museum, 1992).

Ramage, Nancy H. and Andrew Ramage, *Roman Art: Romulus to Constantine* (Upper Saddle River NJ: Prentice-Hall, 2005).

Reff, Theodore, *Manet, Olympia* (New York: Viking 1977).

Richardson, John, *A Life of Picasso. I, 1881–1906* (New York: Random House, 1991).

—— *A Life of Picasso. II, 1907–1917* (New York: Random House, 1996).

—— (with Marilyn McCully), *A Life of Picasso. III, 1917–1932* (New York: Knopf, 2007).

Rorimer, Anne, *New Art in the 60s and 70s: Redefining Reality* (New York: Thames and Hudson, 2001).

Rose, Barbara, *Jackson Pollock: Drawing into Painting* (New York: Museum of Modern Art, 1980).

Rosenberg, Harold, *The De-Definition of Art: Action Art to Pop to Earthworks* (Chicago: University of Chicago Press, 1983).

Rosenblum, Robert, *Transformations in Late Eighteenth-Century Art* (Princeton: Princeton University Press, 1970).

—— *Cubism and Twentieth-Century Art* (New York: Abrams, 2001).

Roth, Leland M., *Understanding Architecture: Its Elements, History, and Meaning* (New York: HarperCollins, 1993).

Sandler, Irving, *The Triumph of American Painting: A History of Abstract Expressionism* (New York: Harper and Row, 1970).

—— *American Art of the 1960s* (New York: Harper and Row, 1988).

—— *Art of the Postmodern Era: From the Late 1960s to the Early 1990s* (New York: HarperCollins, 1996).

Schapiro, Meyer, *Late Antique, Early Christian, and Medieval Art* (New York: George Braziller, 1979).

Schwarz, Arturo, ed., *The Complete Works of Marcel Duchamp* (2 vols.), 3rd edition (London: Greenridge, 1997).

Scully, Vincent, *The Earth, the Temple, and the Gods: Greek Sacred Architecture* (New Haven: Yale University Press, 1979).

Shiff, Richard, *Cézanne and the End of Impressionism: A Study of the Theory, Technique, and Critical Evaluation of Modern Art* (Chicago: University of Chicago Press, 1984).

Smith, Paul, *Impressionism: Beneath the Surface* (New York: Abrams, 1995).

Smythe, Craig Hugh, *Mannerism and Maniera* (Vienna: IRSA, 1992).

Snyder, James, *Northern Renaissance Art: Painting, Sculpture, the Graphic Arts from 1350 to 1575* (Upper Saddle River NJ: Prentice-Hall, 2005).

Stang, Ragna, *Edvard Munch: The Man and His Art*, trans. Geoffrey Culverwell (New York: Abbeville, 1988).

Steinberg, Leo, *Other Criteria: Confrontations with Twentieth-Century Art* (New York: Oxford University Press, 1972).

—— *The Sexuality of Christ in Renaissance Art and in Modern Oblivion* (Chicago: University of Chicago Press, 1996).

—— *Leonardo's Incessant Last Supper* (New York: Zone Books, 2001).

Stewart, Andrew, *Greek Sculpture: An Exploration* (New Haven: Yale University Press, 1990).

Stokstad, Marilyn, *Medieval Art*, 2nd edition (Boulder CO: Westview, 2004).

Sullivan, Louis, *The Autobiography of an Idea* (New York: Dover, 1956).

Taylor, Brandon, *Avant-Garde and After: Rethinking Art Now* (New York: Abrams, 1995).

Townsend, Chris, ed., *The Art of Rachel Whitread* (London: Thames and Hudson, 2004).

Turner, Richard A., *Inventing Leonardo* (Berkeley: University of California Press, 1993).

—— *Renaissance Florence: The Invention of Art* (New York: Abrams, 1997).

Warhol, Andy, *America* (New York: Harper and Row, 1985).

Weiss, Jeffrey S., *The Popular Culture of Modern Art: Picasso, Duchamp, and Avant-Gardism* (New Haven: Yale University Press, 1994).

Williamson, Paul, *Gothic Sculpture, 1140–1300* (New Haven: Yale University Press, 1995).

Wilson, Christopher, *The Gothic Cathedral: The Architecture of the Great Church* (New York: Thames and Hudson, 2000).

Wittkower, Rudolf and Margot, *Born Under Saturn* (New York: Norton, 1963).

Wittkower, Rudolf, *Bernini: The Sculptor of the Roman Baroque* (London: Phaidon, 1997).

Zanker, Paul, *The Power of Images in the Age of Augustus*, trans. Alan Shapiro (Ann Arbor: University of Michigan Press, 1988).

Index

Note: Page numbers for illustrations are shown in italics.